IMPRESSIONIST
NEW YORK

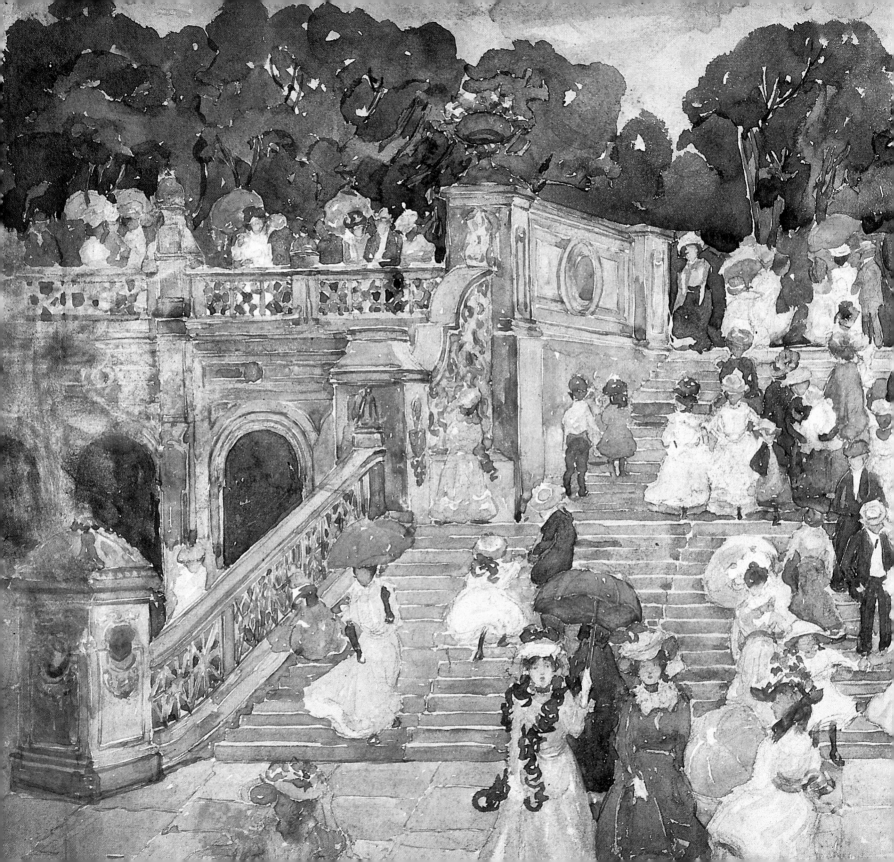

IMPRESSIONIST NEW YORK

WILLIAM H. GERDTS

ABBEVILLE PRESS PUBLISHERS
New York London Paris

To Milton W. Brown

Front cover: Detail of Childe Hassam, *A Spring Morning*, c. 1890. See plate 18.
Back cover: Colin Campbell Cooper, *Lower Broadway in Wartime*, 1917. See plate 39.
Frontispiece: Detail of Maurice Prendergast, *The Mall, Central Park*, 1901. See plate 104.

Editor: Nancy Grubb
Designer: Joel Avirom
Production Editor: Owen Dugan
Picture Editor: Kim Sullivan
Production Manager: Simone René

First edition

Library of Congress Cataloging-in-Publication Data
Gerdts, William H.
Impressionist New York / William H. Gerdts
p. cm.
Includes bibliographical references and index.
ISBN 1-55859-328-4
1. New York (N.Y.) in art. 2. Impressionism (Art)—United States. 3. Painting, American.
4. Painting—19th century—United States. 5. Painting—20th century—United States.
6. Architecture in art. 7. Buildings in art. 8. New York (N.Y.)—Buildings, structures, etc. I. Title.
ND1460.N48G47 1994
758'.77471'0973—dc20 94-5034

CONTENTS

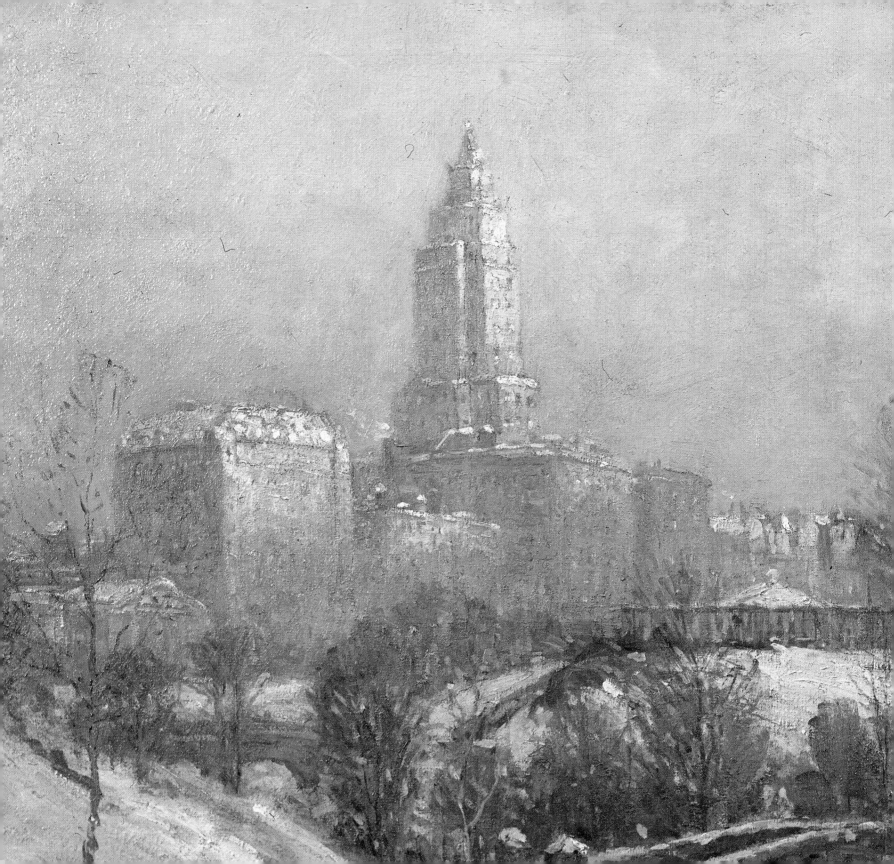

INTRODUCTION

❧

The concept of "the New New York" was widespread in American writings at the turn of the last century. It was addressed, as well, by numerous artists of this period, who were answering a call for the portrayal of modern urban life.[1] Such calls appeared at a time when the aesthetics of Impressionism were paramount in the United States and, indeed, in much of the world. Other American cities—Boston in particular—also were addressed by Impressionist artists, but these tended to be fairly occasional representations. In contrast, the New New York, from its towering skyscrapers to its popular beaches, from its gritty waterfront to its pleasure parks, became the subject of a great many canvases by Impressionist painters. The attraction of Impressionist artists to the city's complexity and modernity was recognized in 1905 by H. G. Dwight, who wrote, in "An Impressionist's New York": "This situation, and the way in which it is carried, make for the impressionist the singular interest of New York. The place represents a mingling of traditions so complex as to constitute in itself an absence of tradition, as to make its builders the creators of tradition. And it forces the observer to see in modernity—poor noisy, untoned, inchoate, incoherent modernity—its own value as the factory of the future."[2]

It has become commonplace in recent years to contrast the readiness of the French Impressionists to portray the urban realities of modern Parisian life with the American artists' avoidance of such gritty modernity.[3] Yet, while New York's growth during the post–Civil War period was more haphazard than the "Haussmannization" of Paris during that period,[4] it was no less radical, and a number of American

1. Detail of Colin Campbell Cooper, *Central Park*, c. 1927–31. See plate 111.

Impressionist painters did, in fact, follow the lead of Edgar Degas, Edouard Manet, Claude Monet, Camille Pissarro, and Auguste Renoir in recording that urban upheaval, underscoring their identification as painters of the modern world. They did this selectively, of course. For instance, New York probably had more concert halls and cabarets—the equivalent of the Parisian *café-concerts*—than Paris in the 1870s and 1880s, but they are notably absent from the American art of the period, Impressionist or otherwise.[5]

The images presented here are frankly celebratory, and the painters seem to have sincerely subscribed to the notion of American progress, glorifying both the technological achievements of the age and the vitality of the new metropolis.[6] At the same time, they were mindful of their patrons; images of towering buildings, fashionable avenues, and sunlit urban retreats were far more likely to find buyers than shadowy back alleys or sordid scenes of prostitute-filled cafés. Thus, the Americans emulated only *some* of the preferences of their Parisian colleagues—those that bespoke the greatest optimism.

A word concerning the pictures reproduced here: this volume concentrates on the appearance of the city itself rather than its inhabitants, who were relatively incidental to the American Impressionists proper. Those inhabitants did, however, become dominant considerations of the later generation of Impressionists—the artists often referred to as the Ash Can School. The latter are included here, though only in regard to their continuing documentation of the facade of the city (see chapter 2).

A great deal of information about the structures that the artists represented is included here. Many of these edifices no longer survive, and whether extant or not, their relevance has often been lost to present-day audiences. But such significance was very much in the public consciousness at the time these paintings were first exhibited. Many of these buildings were major architectural achievements, feats of engineering, or structures of spiritual and psychological significance that were included in these urban scenes because of their import for the artists, critics, and art lovers alike. And in many cases, the interiors of these buildings were of artistic distinction. Recent murals decorated many of the churches and hotels pictured here, while commercial structures and even saloons housed paintings and sculptures of great merit and fame. For instance, Alexander T. Stewart's dry-goods store on Broadway between Ninth and

The analogy between the color of New York streets and that of the canvases of the French impressionists . . . obtrudes itself upon one at every turn. There are Monets all along Sixth Avenue. The water fronts present a succession of Boudins. The truncated compositions of Degas, especially applied to figures, strike one unexpectedly at the turn of a street. The popular types recall Manet in character. . . . Thus it really seems as if that genuine New York school of art, which shall be evolved from its streets and public life . . . will be based on the principles taught by the French impressionists. The same intensity, even crudity of color; the same prevalence of primary hues; the same lack of tone; the sharp, crisp atmospheric quality and the general feeling of uncompromising solidity and body which form the attributes of those ultra-modern compositions, are to be found in the artistic scheme of the New York streets. This affiliation between the future art of New York and the contemporary extremist art of Paris may not be patent to the general eye; but the student of the principles of aesthetic evolution can readily deduce this conclusion from his observation.

Charlotte Adams, "Color in New York Streets," *Art Review* 2 (September–November 1887): 17–19.

Tenth Streets housed a sculpture gallery with works by Thomas Crawford, Harriet Hosmer, Hiram Powers, Randolph Rogers, and numerous European sculptors. William Harnett's *After the Hunt* and Jean-Louis-Ernest Meissonier's *Quarrel* were heralded attractions at Theodore Stewart's Warren Street saloon, as was Adolphe-William Bouguereau's *Nymphs and Satyr* at the Hoffman House Café at Madison Square and Twenty-fourth Street. When these buildings appeared in paintings of the period, the public would have been aware of their cultural significance, inside and out.

The identification of some of the structures and sites pictured in this volume is uncertain; some buildings are presented from unusual vistas or oblique angles, and even basically realist artists often distorted perspectives and spatial relationships. In addition, the traditional identifications are not always reliable; just before submitting this manuscript I found conclusive evidence that one of William Merritt Chase's best-known, most reproduced Brooklyn pastels, hitherto known as *Gravesend Bay*, is actually *Afternoon by the Sea* (plate 150). Such confusions may lurk elsewhere. But, of course, whatever the title or the identification, the pictures remain a vital reminder of the New New York.

1

THE NEW NEW YORK

The New New York (1909), by John C. Van Dyke, reflected the contemporary perception that the American metropolis had undergone profound changes, beginning about 1880.[1] The book's fundamental objective was to make clear the vitality and the distinctiveness of the city, along with its lack of uniformity which, initially at least, produced a sense of chaos.[2] As Van Dyke recognized, "The checkerboard 'blocks,' the recurrent regularity of streets . . . point to something planned; but the buildings are eruptive and the whole city abnormal—something again that apparently just 'happened.'"[3]

Van Dyke's was the most prominent of many studies of New York that appeared from the mid-1880s through the mid-1910s. In addition to other books, there were myriad articles, often illustrated by leading painters and photographers, analyzing the city's neighborhoods; celebrating its appearance during various times of day and various seasons; glorying in its ethnic diversity; identifying its great structures; lauding its uniqueness, modernity, and cosmopolitanism; and predicting its future. Social inequity, materialistic opportunism, crime, and depravity were recognized by all who wrote about New York during this period, but most would have joined Robert Shackleton in 1917 when he concluded, "Never in history has there been such a magnificent city."[4] Likewise, while authors such as Henry Adams and Henry James identified the city with alienation and disorder, other writers of the period, such as Frederic C. Howe in *The City: The Hope of Democracy* (1905), viewed the new urban entity as the embodiment of positive American values.[5]

2. Detail of Colin Campbell Cooper, *Cliffs of Manhattan*, 1903. See plate 3.

Van Dyke recognized that the physical appearance of New York was determined by the rights of each individual to do as he or she pleased, and he attributed the lack of architectural conformity to the fundamental nature of democracy. Colin Campbell Cooper's *Cliffs of Manhattan* (plate 3), possibly painted almost simultaneously with the publication of Van Dyke's book,[6] vividly reflects the architectural tumult of soaring sky-scrapers, often peaked and pergolaed at their terminals, side by side with older, low-lying, flat-roofed structures. His view looks north from the vicinity of the Mutual Life Insurance Company at Nassau, Liberty, and Cedar Streets in lower Manhattan; the Lorsch Building may be the isolated tall structure in the center; and to the left is the Sheldon Building at John and Nassau Streets. The two-turreted skyscraper at the far left may be the Park Row (or Syndicate) Building (1899), designed by R. H. Robertson.

The skyscraper, of course, was the most prominent visual feature of the new city.[7] With the invention of the elevator in 1852 by Elisha Graves Otis, its earliest appear-

3. Colin Campbell Cooper (1856–1937). *Cliffs of Manhattan*, 1903. Oil on canvas, 36 x 46 in. (91.4 x 116.8 cm). The City of Santa Barbara; Gift of the Artist.

New York may indeed be jagged, in her long leanness, where she lies looking at the sky in the manner of some colossal hair-comb turned upward and so deprived of half its teeth that the others, at their uneven intervals, count doubly as sharp spikes.

Henry James, *The American Scene*, ed. Leon Edel, from the 1907 London and American editions (Bloomington and London: Indiana University Press, 1968), pp. 139–40.

ance in 1857 in E. V. Haughwout's store at 488 Broadway, and its installation in the Equitable Life Assurance office building in 1868—followed by the production of the steel I-beam and the introduction of total steel-frame construction in Bradford Gilbert's Tower Building, both in 1889—the appearance of the city changed startlingly. Year by year, new structures outdistanced one another vertically, often with commanding observation decks from which the public could marvel at the urban panorama. The Washington Building, erected by Cyrus Field at 1 Broadway in 1882, was sometimes referred to as "the first skyscraper," and for several years it was the tallest office building in the world. As late as 1892 Trinity Church (1846) was still the tallest structure in the city; the Manhattan Life Insurance Building at 66 Broadway, completed by 1894, was the first structure to rise above the cross atop Trinity's steeple. Less than twenty years later the Woolworth Building became the tallest building in the world at 792 feet (241 meters).[8]

The skyscrapers had their detractors, including professional architects such as Ernest Flagg, architectural critics and historians such as Montgomery Schuyler, artists such as F. Hopkinson Smith (who condemned them as "the greatest monstrosity of our time"), and writers such as Henry James, who found the skyscrapers to be "like extravagant pins in a cushion already overplanted . . . impudently new," and later, "grossly tall and grossly ugly."[9] For some, skyscrapers were boring, impersonal, and unsafe—"invitations to catastrophe"[10]—depriving those below of light and air. Numerous articles by cultural historians recommended various old picturesque districts of the city as an antidote to the grandiose new high-rise structures.[11] By the end of the new century's first decade, critical opinion had become increasingly favorable to the skyscraper, and writers were applauding the beauty both of the structures and of their painted images. New York was a "City of Towers," and those structures were accepted as being as characteristic "as the minarets of a Mohammedan city, as the bell-towers of Russia, as the pillar-towers of India, as the peels of Scottish fortresses, as the pagodas of China, or as the campaniles of Italy."[12]

In addition to portraying the tall structures themselves, either individually or as a panorama, artists working in all media were fascinated by the spectacle of skyscraper construction. F. Hopkinson Smith documented such a scene in *The Skyscraper* (plate 4), as did Alfred Stieglitz in his 1910 photogravure *Old and New New York* (plate 5), both

set in lower Manhattan. Childe Hassam's *Hovel and the Skyscraper* (situated just off Sixty-seventh Street, where Hassam had his studio at the time) celebrates the glory of urban progress (plate 6). Workmen go about their tasks in relative safety and with minimum discomfort; the pulleys and other construction equipment and the rising steel frame are contrasted not with derelict older buildings but with the broad expanse of Central Park. In fact, there is neither a hovel nor a skyscraper here. The former refers to the old, low-slung riding stables then at the West Sixty-seventh Street entrance to the park, which catered to well-to-do city residents, two of whom are seen riding in the snow; the "skyscraper" was actually a new parish house for a church a block farther up, on Central Park West.[13] Painters and photographers delighted in presenting in all seasons the contrast between the older residential quarters of the city and the new, soaring commercial structures, as Stieglitz did in *The Street—Design for a Poster* (plate 7).

Aesthetic issues regarding the portrayal of skyscrapers arose from the very beginning. Louis Sullivan asked, "How shall we impart to this sterile pile, this crude, harsh, brutal agglomeration, this stark exclamation of eternal strife, the graciousness of those higher forms of sensibility and culture that rest on the lower and fiercer passions."[14]

ABOVE, LEFT
4. F. Hopkinson Smith (1838–1915). *The Skyscraper*, from Smith's *Charcoals of New and Old New York*, 1912.

ABOVE, RIGHT
5. Alfred Stieglitz (1864–1946). *Old and New New York*, 1910. Photogravure, 13⅛ x 10⅛ in. (33.3 x 25.7 cm). National Gallery of Art, Washington, D.C.; Alfred Stieglitz Collection.

OPPOSITE
6. Childe Hassam (1859–1935). *Hovel and the Skyscraper*, 1904. Oil on canvas, 34¾ x 31 in. (88.3 x 78.7 cm). Mr. and Mrs. Meyer Potamkin.

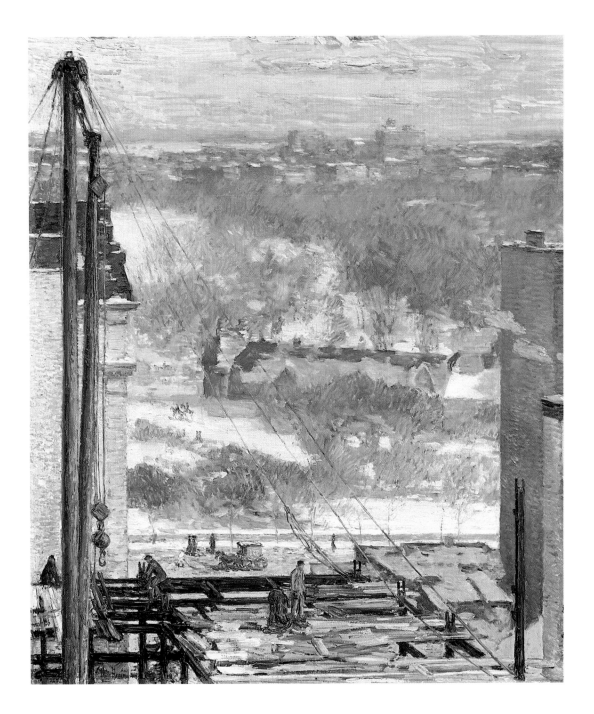

Writers of the late nineteenth century were constantly considering the high building in terms not of its style or its engineering, but of its visual expression of "modern needs, ideas, necessities."[15] Likewise, artists investigated various ways to express the appeal of these structures, whether singly or panoramically. One of the most successful of these, Colin Campbell Cooper, wrote specifically of "Skyscrapers and How to Build Them in Paint."[16] Many of the urban Impressionists, such as Cooper in *Cliffs of Manhattan* (plate 3), chose a high vantage point from which to survey the city. On the one hand, this was a new and uniquely pictorial vista, but on the other it was also becoming increasingly familiar to the urban public. Art patrons, after all, were spending their corporate lives in offices high above the streets, and even restaurant patrons were finding pleasure in the views from new aeries.[17]

The formats chosen for portraying the new vertical building construction were, more often than not, vertical. This may seem too obvious to need elucidation, but in fact it was quite antithetical to the earlier tradition of urban paintings; the cityscapes and townscapes by Francis Guy, Thomas Cole, and other painters of the nineteenth century almost inevitably utilized traditional landscape conventions within a horizontal format. And even contemporary city scenes by French Impressionist painters such as Monet and Pissarro were usually horizontal. But the American artists were responding to the uniquely vertical character of New York—what Henry James referred to as the "perpetual perpendicular."[18]

Depictions of Manhattan and beyond from the top of the great structures were complemented by those with a very different approach: the view of the city skyline from the waterfront and across the East and Hudson Rivers. Beginning in the 1890s

these perspectives were favored for periodical illustrations, and sometimes the skyline of the city was traced over a decade of change.[19] In such views as the 1905 illustration *The Jam of Marine Traffic around the Battery* (plate 9) and Stieglitz's *City of Ambition* (plate 89), the energetic diversity of the tall skyscraper construction is contrasted with and amplified by the vitality of marine activity in the harbor. The first use of the word *sky-line* as a pictorial reference seems to have been in the *New York Journal* for May 3, 1896, which included a panoramic drawing of "The Skyline of New York." Such viewpoints often yielded the image of a romanticized fairyland, unrelated either to previous cityscapes or to the human experience, as in Hassam's *Manhattan's Misty Sunset* (plate 10).

Thirteen years before Hassam painted his 1911 scene from Brooklyn, Manhattan had been encompassed within "Greater New York," with Brooklyn (as Kings), Queens, Staten Island (as Richmond), and the Bronx incorporated as borough subdivisions of the city on January 1, 1898. With this incorporation, New York City surged ahead of Chicago and Philadelphia as the nation's largest city, in both population and size. The erection of the Brooklyn Bridge, completed in 1883 after thirteen years of construc-

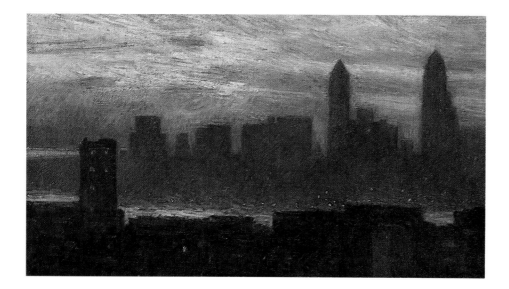

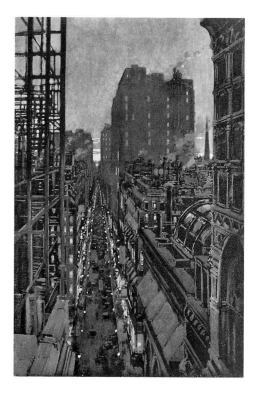

LEFT
10. Childe Hassam (1859–1935). *Manhattan's Misty Sunset,* 1911. Oil on canvas, 18 x 32 in. (45.7 x 81.3 cm). Butler Institute of American Art, Youngstown, Ohio.

BELOW
11. Fernand Lungren (1857–1932). *A City Cañon,* from "Places in New York," *Century,* February 1897.

tion, had effectively ended the isolation of the island of Manhattan, heretofore reachable from Long Island only by ferry.

Hassam's view of New York from the outside (plate 10) contrasted with that familiar to urban inhabitants within the city's deep canyons created by tall structures along narrow streets. These, too, were depicted by the artists, though less often in paintings than in graphics and illustrations, such as Fernand Lungren's *A City Cañon* (plate 11). Artists and writers frequently adopted the metaphors of cliffs, mountains, and canyons to describe the new urban landscape. Best known is Henry Blake Fuller's novel *The Cliff Dwellers* (1893), in which he likened Chicago's skyscrapers to mountains and the spaces between to canyons or plateaus.[20] Fuller pointed out that the higher the buildings rose, the deeper were the canyons between them, and by extension, the more they stood for ruthless competition and the less they related to the human element.

For the average city dweller the rooftops of their own dwellings often offered their only exposure to the sun and sky.[21] In his New York scenes John Sloan generally aimed to humanize the urban experience, and his primary concerns usually centered on the local inhabitants. *Twenty-third Street, Roofs, Sunset* (plate 12) was the earliest and most sweeping of his rooftop subjects. In it, the foreground rooftop—at 164 West

12. John Sloan (1871–1951). *Twenty-third Street,*
Roofs, Sunset, 1906. Oil on canvas, 24⅜ x 36¼
in. (62 x 92.1 cm). Joslyn Art Museum, Omaha,
Nebraska.

Twenty-third Street, where the artist had his studio apartment—is contrasted with the soaring Chelsea Hotel, in the middle distance, where the artist would later have a studio.[22] Here Sloan, not normally an artist associated with the celebration of New York City, invites the viewer to join his wife in the foreground in admiring technological advancement and the glorious urban panorama.

Artists were also attracted to the construction of Pennsylvania Station, which was completed in 1910. What compelled their interest was not so much the structure itself but the deep excavation into the bowels of the earth, often likened to quarrying and even to the digging of the Panama Canal. George Bellows is the artist most associated with depicting the Pennsylvania Station excavations, in a series of four magnificent paintings created between 1907 and 1909,[23] but other, more mainstream Impressionists also undertook the subject. Probably the best known is Ernest Lawson's *Excavation—Penn Station* (plate 13), a painting that hung for several years in James B.

13. Ernest Lawson (1873–1939). *Excavation—Penn Station*, c. 1906. Oil on canvas, 18½ x 24¼ in. (47 x 61.6 cm). Frederick R. Weisman Art Museum, University of Minnesota, Minneapolis; Bequest of Hudson Walker from the Ione and Hudson Walker Collection.

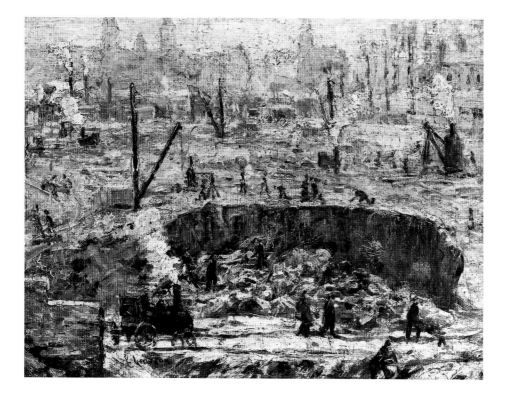

Moore's Café Francis.[24] Seen as the epitome of the new awareness of national and individual power, the painting was extolled by the writer Bayard Boyesen as conveying "the romance of nature and man in their eternal conflict expressed with the rugged joy of one who realizes the exigencies and hardships of life only as a challenge to his understanding of his greatness."[25]

One could view as the three most potent emblems of the period the Brooklyn Bridge, which opened the era of the New New York, and the Woolworth Building and Pennsylvania Station, which closed it. They appeared to stretch the once enclosed urban mass in three directions: laterally, toward the heavens, and deep into the earth. All three were also concerned with the swift movement of people and goods, whether on elevators, in railroad cars, or in the new motorized vehicular traffic that was replacing the picturesque horse-drawn carriages.

Writers were becoming conscious of a new spectrum of colors in the city; tender grays had given way to a glittering metallic atmosphere, along with the bright colors of signboards, shop-window displays, painted streetcars and omnibuses, architectural decoration, and the green and scarlet ironwork on the elevated railroads and throughout public construction in the city. Charlotte Adams noted in 1887 that "the former cold and barren monotony of the streets has given place, by degrees, to a system of color which now makes the public thoroughfares of the City colossal kaleidoscopes."[26]

The vividness of the new city was even more apparent by night. The arc light, invented by Charles Francis Brush, was installed on Broadway in late 1879. By July 1880, six-thousand-candlepower lamps were placed atop 160-foot (forty-meter) poles in Madison and Union Squares, and by that December, Broadway was illuminated from Fourteenth to Twenty-sixth Street.[27] Thomas Edison's alternative electric lamps were introduced at the same time, first in private homes and then along the streets and avenues. Electric signs first appeared in 1891, and it was reported by 1906 that "in Manhattan Island there are some three thousand electric signs . . . and no less than one hundred thousand lights are set sparkling each night all over the island."[28] By 1912 Ezra Pound wrote about the city: "No urban nights are like the nights there. . . . It is then that the great buildings lose reality and take on their magical powers. They are immaterial; that is to say one sees but the lighted window."[29]

The effect of the light in the squares of the Empire City can scarcely be described, so weird and so beautiful is it. From the tall poles light was thrown down upon the trees in such a way as to give a fairy-like aspect.

A British writer, 1882, in Clarence Pearson Hornung, *The Way It Was, 1850–1890* (New York: Schocken, 1977), p. 56.

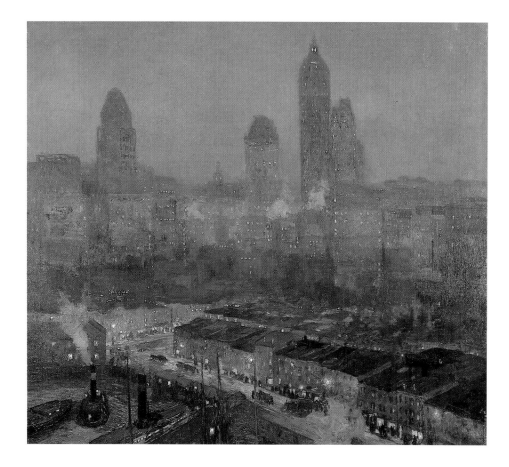

An early view of the effects of night illumination on Madison Square is vividly captured in Hassam's watercolor *Rainy Night under the Electric Light* (plate 15). Numerous other painters responded to the spectacle of the electrically illuminated city, but none was more inspired than the Pennsylvania Impressionist Edward Redfield, who temporarily abandoned his predilection for rural landscapes to paint several panoramic New York views in 1909. *Between Daylight and Darkness* (plate 14) is the most spectacular of these nocturnal views, which were among the largest New York City panoramas of the period. Ferries and tugs in the harbor are fronted by low-lying structures in the foreground, and a fantasy of tall skyscrapers in the distance culminates in the then tallest structure in the city, the domed Singer Building, constructed only a year

14. Edward Redfield (1869–1965). *Between Daylight and Darkness*, 1909. Oil on canvas, 50 x 56 in. (127 x 142.2 cm). Private collection.

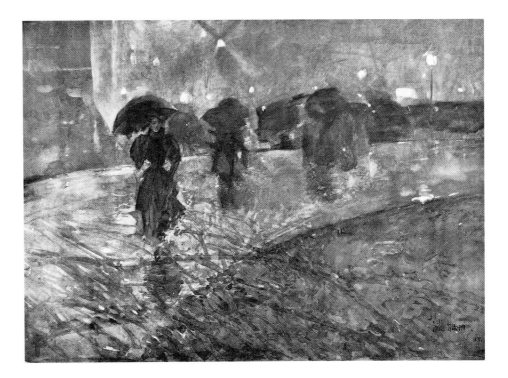

15. Childe Hassam (1859–1935). *Rainy Night under the Electric Light,* from Hassam's *Three Cities,* 1899.

16. Artist unknown. *The Enchanted City,* from *Harper's Weekly,* February 8, 1913.

before.[30] As much the subject of the picture as the city structures is the overall pattern of bright illumination against the darkened buildings—mostly small, flecked touches of yellow from windows and a few more dramatic bursts from the streetlights along the waterfront.

Photographers in this period were even more attracted to these soaring patterns of light. In a photographically illustrated article, Edward S. Martin wrote of "the high curving bridges, very striking and beautiful, with their unobstructed outlines marked by the glow of the electric bulbs" and "those shafts and huge blocks of gleaming holes, reaching far above their neighbors." For Martin, the lights of Manhattan were "stunning when too near, but soothing and inspiring from afar."[31] Photographers were able to capture such mysterious, often almost visionary effects as they appeared in skyscrapers such as the Woolworth Building, which dominates *The Enchanted City* (plate 16). Scenes such as this photograph and Redfield's painting truly document the New New York.

THE ARTISTS

For most of the nineteenth century, artists and patrons alike sought to retreat from the city into the pastoral or wilderness landscape. But from the 1880s on, industrialization and urbanization offered the artist whole new fields of subjects. This was especially true of those American painters who, just at this time, were inspired not only formally but also thematically by the Parisian scenes of Monet, Manet, Pissarro, and their colleagues. And after their years of artistic training and practice in France, these Americans found in the dynamism of New York City life and the soaring new urban edifices not only comparable but even more impressive subject matter.[1]

Childe Hassam, considered the greatest exponent of Impressionism in America, was the American painter who most devotedly addressed himself to depicting the metropolis over the course of his long career.[2] On his return late in 1889 from his second and most significant journey to Europe (where he adopted the strategies of Impressionism), Hassam settled in New York at 95 Fifth Avenue, a short distance from Union Square.[3] Immediately he began to produce images of the city in diverse weather conditions, at various times of the day, and in different seasons. Hassam's New York pictures were viewed by critics as equivalent—and usually superior—to the Parisian street scenes by those Europeans with whom he was often compared—Giuseppe de Nittis, Jean Béraud, and occasionally Edouard Manet.[4] Thus, Hassam was seen as nationalizing French Impressionism.

Hassam's fascination with the city seen in the rain or during a snowstorm sometimes makes it difficult to identify an actual location, as in his *Late Afternoon, New York:*

Of the thousands who dwell in the thick of it all nearly every one hies him to the palisades or the still, open places when he would speak to us on canvas. Only a handful have sensed the fact that the vital message of the age is flashed forth in the incandescent signs on Broadway. . . . These few painters are artistic pioneers.

Louis Baury, "The Message of Manhattan," *Bookman* 33 (August 1911): 592.

17. Detail of Childe Hassam, *Late Afternoon, New York: Winter,* 1900. See plate 24.

Winter (plate 24). Hassam took his subjects from throughout Manhattan—from lower New York to the city's bridges, parks, and squares, and along its major avenues—so that a review of his urban scenes chronicles thirty years of change in the city's habits and appearance.

Hassam's urban views divide about equally between scenes perceived from on high and those at street level. Many of his works created in the early twentieth century concentrate on commercial districts seen from the windows of tall buildings, contrasting with earlier pictures, such as *A Spring Morning* (plate 18), which often focus on the residential sections of New York. *A Spring Morning* depicts elegantly dressed women on the steps of a townhouse on Twentieth Street near Fifth Avenue, close to Hassam's studio; on Sixth Avenue, beyond the Church of the Holy Communion, can be seen the gold-domed Sixth Avenue store of Hugh O'Neill, who owned and may even have commissioned this work.[5]

Critics identified Hassam with New York City amazingly quickly. In 1891 a writer noted: "When he wants a subject to paint, Mr. Hassam looks about him, and does not get out his sketches in Normandy or Holland. More than that he does not have to go to Niagara or the Rocky Mountains. . . . He simply looks out of his window upon the city streets, up Broadway or Madison Avenue in New York."[6] Hassam underscored his association with city subjects in an interview with A. E. Ives, in which he admitted that he did "not always find the streets interesting . . . [and would wait], if it were a street scene, till the vehicles or people disposed themselves in a manner more conducive to a good effect for the whole." After expressing his preference for a colorful blue atmosphere, as opposed to more traditional tonal browns of the "molasses and bitumen school," he described his methodology. If buildings were important to the painting, the background was painted first, but if a picturesque foreground group appeared—figures or vehicles—he would add them immediately. He eschewed photography; benefiting from the new electric lights, he would draw figures and shadows in a sketchbook at night, noting the colors in crayons. Hassam identified himself as a true historical painter, not one concerned with past events that were foreign to him, but "one who paints the life he sees about him, and so makes a record of his own epoch."[7]

Hassam's New York scenes appeared not only in oils, watercolors, etchings, and lithographs but also reached a mass audience as illustrations for articles on the city that

One is delighted at the actual picturesqueness of New York streets after looking at his work. Mr. Hassam's studies . . . are made from cab windows, after the manner of De Nittis and Béraud, who transferred "Tout Paris" to the walls of the salon.

"Life in the Studios," unidentified newspaper clipping, Childe Hassam Papers, Archives of American Art, Smithsonian Institution, Washington, D.C.

18. Childe Hassam (1859–1935). *A Spring Morning*, c. 1890. Oil on canvas, 27½ x 20 in. (70 x 50.8 cm). Berry-Hill Galleries, New York.

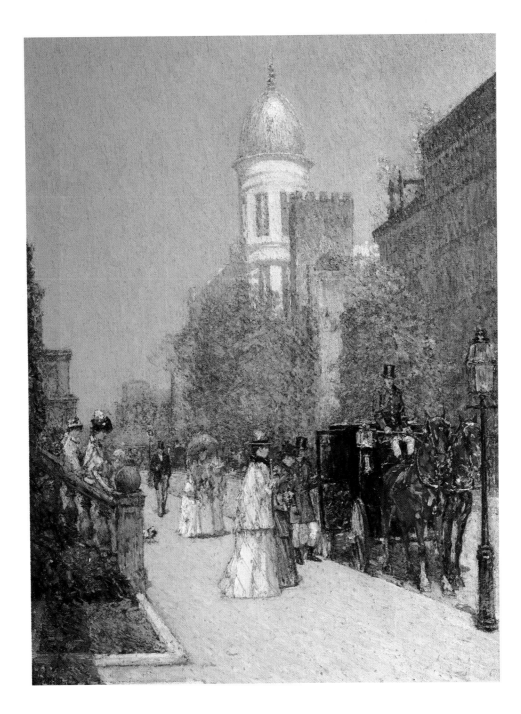

were published in periodicals throughout the 1890s.[8] Though some of his earlier Parisian pictures had garnered much acclaim, in 1913 he affirmed that "New York is the most beautiful city in the world. . . . Even London, which I consider infinitely more beautiful than Paris, has nothing to compare with our own Manhattan Island when seen in an October haze or an early twilight mist from Brooklyn Bridge."[9] And it was the *New* New York that appealed to Hassam: "The old part, the Bowery, etc., is not so interesting as the new. The old part is picturesque, but it is not picturesque in an original way. The new part is unlike any other place. It is distinguished, vital and picturesque in its own way. It has character and force, and that is why I like it."[10]

In 1899 Hassam confirmed this preference in his major publication, *Three Cities*— a folio volume of reproductions of views he had created of Paris, London, and New York. New York came first, with scenes on Fifth Avenue and Broadway, at Madison and Union Squares, on Riverside Drive, and down at City Hall Park. Many of these were reproductions of elaborate oil paintings; in contrast, the London and Paris scenes were often based on sketchy drawings of individuals and groups of figures; the European cities themselves, Paris especially, were little featured.[11]

Hassam's earliest biographer noted: "As time passed, he loved his adopted city more and more . . . for what he found of beauty in its daily life, its street scenes, vistas, parks, and countless horizons. . . . He came to look upon New York as the most fascinating city on earth."[12] Critics noted that in the early twentieth century Hassam turned away to some extent from his urban concentration, but New York continued to occupy his interest and sometimes in very original ways. His Window series of the 1910s alludes to the modern city primarily through glimpses of tall buildings seen from the hermetic domestic interiors that are the ostensible subjects of such paintings as *New York Window* (plate 19). Here, the listless woman is silhouetted against a curtained window through which the skyscrapers of the dynamic (and, by implication, masculine) urban world can be glimpsed, bathed in sunlight. The setting, too, is on high—in one of those very same modern structures.

Hassam's New York paintings were regarded in their own time not only as pictorializations of urban modernity but also as nationalistic expressions. As Bayard Boyesen noted of his paintings of New York life in 1908, the "charm, the grace, the poignantly sweet lyricism of his pictures is apt to blind one to his Americanism."[13]

19. Childe Hassam (1859–1935). *New York Window,* 1912. Oil on canvas, 45½ x 35 in. (115.6 x 88.9 cm). The Corcoran Gallery of Art, Washington, D.C.; Museum Purchase, Gallery Fund.

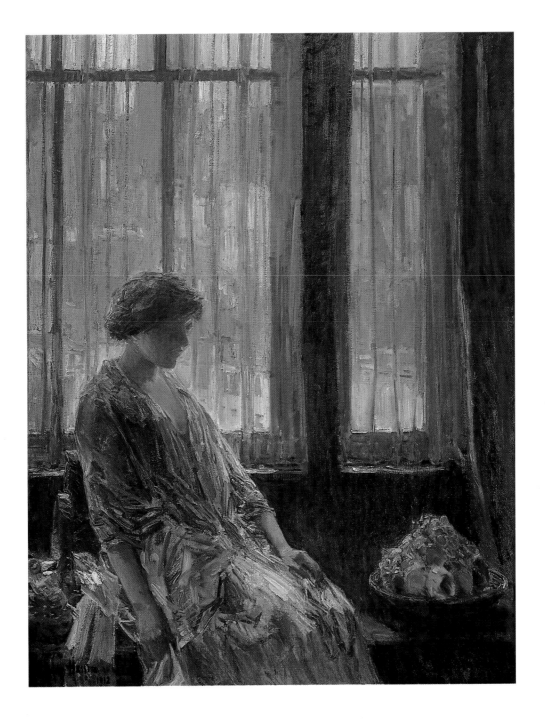

That Americanism reached its apogee in Hassam's series of flag pictures, among the artist's most acclaimed works, both in his lifetime and today. In 1919, at the time of the second New York exhibition of the series, one writer commented, "He shows us that our city is more marvelous than an Arabian night's dream, as exquisite as the petals of a rose," and, at the same time, that "America speaks in these canvases." The writer's summation must certainly have gratified Hassam, given his claim to be a modern his-

20. William Merritt Chase (1849–1916). *Afternoon in the Park,* 1890. Pastel on paper, 19 x 15³⁄₈ in. (48.3 x 38.9 cm). Deborah and Edward Shein.

If you want to know of good places to sketch in the vicinity of New York . . . I think I could easier tell you where they are not than where they are.

William Merritt Chase, in
A. E. Ives, "Suburban Sketching
Grounds," *Art Amateur* 25
(September 1891): 80.

He [Cooper] settled in New York and quickly discovered that Manhattan Island has as much of the striking and the picturesque as the Old World towns among which he had been roaming. What is more, the monster buildings he saw around him, a distinctive New World product, offered an undreamt of field of opportunities. . . . They had not the flavor of antiquity, but they had . . . the suggestion of sublimity, the spirit of progress and promise, the manifestation of a surging, restless, all-attempting, all-achieving life essentially American.

Willis E. Howe, "The Work of
Colin C. Cooper, Artist," *Brush
and Pencil* 18 (August 1906):
76–77.

torical painter: "Historical paintings are apt to record the minutest detail of costume or buckle, of house or battlefield in a photographic way. Childe Hassam has painted the spirit rather than the letter of history."[14]

Though Theodore Robinson, Julian Alden Weir, and many other Americans identified with the Impressionist movement painted the city occasionally, none concerned himself with New York to the extent that Hassam did. However, William Merritt Chase did achieve acclaim for his pictures of parks and other recreational sites in Manhattan and Brooklyn (see plate 20, for example).[15] The impetus for his urban park scenes, quite unusual in America, may have come from work by two renowned American expatriates: John Singer Sargent's views of the Luxembourg Gardens in Paris and James McNeill Whistler's views of the Cremorne Gardens in London.

An 1891 article referred to Chase as "the first metropolitan artist to appreciate the hitherto almost untouched field of landscape in and about the city."[16] The previous year a critic had identified his urban scenes as the counterpart of those by the French Impressionists: "This treatment of essentially local subjects has practically been introduced by Mr. Chase in this country. The French painters do something similar, so far as Paris is concerned."[17]

A later painter who devoted much of his career to interpreting New York City in an Impressionist mode was Colin Campbell Cooper. The Philadelphia-born Cooper went abroad in 1886, a sojourn that initiated his lifelong love affair with architectural themes. In Europe he was drawn especially to Gothic buildings, but after settling in New York in 1902, he turned to the skyscraper and other architectural symbols of modernity.[18] Cooper specialized in images of contemporary New York until the death of his wife, Emma Lampert Cooper, in 1920; the following year he established his permanent home in Santa Barbara, California.

Though at times concentrating on individual tall buildings, Cooper preferred to contrast them with the deep canyons of the streets between, as in *Wall Street* (plate 74), or to present such panoramas as *Cliffs of Manhattan* (plate 3). In such panoramic works Cooper appears to have subscribed to Hassam's dictum that "any skyscraper taken alone and examined in all its hideous detail is a very ugly structure, indeed, but when silhouetted with a dozen or more other buildings against the sky it is more beautiful than many of the old castles in Europe."[19]

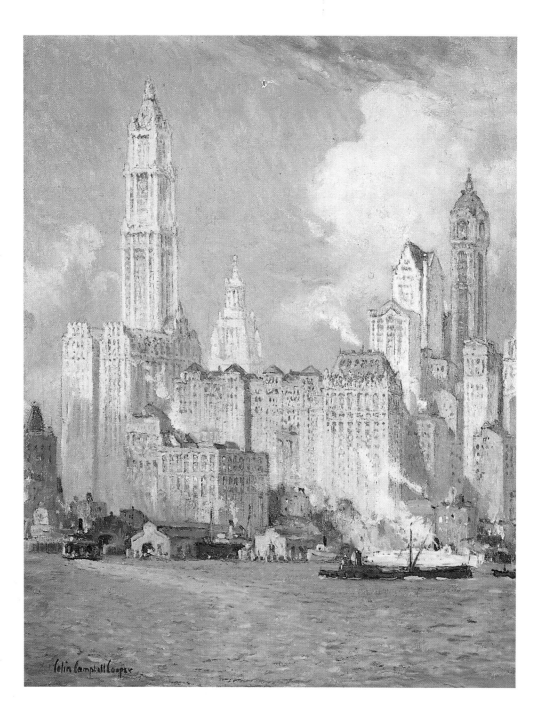

Colin Campbell Cooper

William Glackens, Ernest Lawson, and Maurice Prendergast are the three members of the group of early twentieth-century urban realists known as the Eight who are generally acknowledged to have utilized the strategies of Impressionism. However, the group as a whole has traditionally been perceived as antithetical to both the formal and the ideological conceptions of Impressionism. The rest of the Eight—John Sloan, George Luks, and Everett Shinn (all originally Philadelphia newspaper artists), led by their mentor, Robert Henri—are generally viewed as having introduced an audacious new realism into their New York subjects, spurning and supplanting the elegance and "prettiness" of so much American Impressionist painting. (Arthur B. Davies was the eighth and most anomalous member.)

By introducing these painters (later dubbed the Ash Can School) into the context of Impressionist interpretations of New York, I am challenging the traditional view of their work as contrary to Impressionism. One writer has noted that at the closing of their 1908 exhibition "'The Black Gang' believed that they had triumphed over the Academicians and the Impressionists."[20] It is true that the artists themselves spoke adversely of Impressionism. Sloan, for instance, referring to his paintings of about 1907, wrote that they "show my resistance of the impressionist influences."[21] While organizing a Sloan exhibition for the Whitney Museum of American Art in New York in 1952, Lloyd Goodrich wrote of Sloan: "Talking about his earliest paintings and about their dark palette, he said that he had a deep hatred of the impressionists; that he hated 'effects.' I asked him if he meant French impressionists. . . . He said it was more the whole spirit of impressionism, its sweetness, prettiness, the emphasis on effect. From what he said, it was evident that the dark palette of Henri, Sloan, and others was a conscious revolt against impressionism."[22]

That may be, but in fact the work of Henri, Luks, Sloan, and Shinn continued the American borrowing *from* French Impressionist concerns. True, the Eight did very consciously reject the elitist interests and aesthetics embodied in the early twentieth-century art of the Ten American Painters. For twenty years this group, formed late in 1897, held annual shows that received critical praise and garnered a great deal of patronage. But by 1904, when the Eight were first coming to public notice, the exhibitions of the Ten had taken on a distinctly conservative character, dominated by the elegant, upper-class figure painting of the Bostonians Frank Benson, Joseph DeCamp, and Edmund Tarbell.

21. Colin Campbell Cooper (1856–1937). *View of Wall Street* (study for *Waterfront of New York?*), n.d. Oil on canvas, 21 x 17 in. (53.3 x 43.2 cm). Courtesy Sotheby's, Inc., New York.

When French Impressionism first appeared in force in New York in the great show sent over to the American Art Association galleries in April 1886, the critics clearly preferred the landscapes, especially those by Claude Monet, to the figure paintings by Edouard Manet, Auguste Renoir, and Edgar Degas. The writer in *Art Age* stated:

> The figure subjects and the landscapes have in common their truth, their magnificent handling, their strength of color and, in some cases their intentional neglect of tone. But here the analogy ends. The complex problems of human life which make the figure subjects so terrible in their pessimism and seem to fill the air with cries of uneasy souls, have no part in the landscapes. These are wholly lovely with the loveliness of repose and the tenderness of charity. They are full of heavenly calm.[23]

And the reviewer for the *Critic* believed that "The tenderness and grace of impressionism are reserved for its landscapes; for humanity there is only the hard brutality of the naked truth. . . . One might say that the feminine principle of impressionistic art is embodied in its landscape and the masculine in its figures."[24]

This critical response, reinforced by the immense patronage that Monet reaped among American collectors, makes it not at all surprising that the American painters who came to espouse the new movement eschewed the themes and the manner of the figural Impressionists for the next two decades. Americans working in the Impressionist mode created pictures for a clientele who wanted the best of their own existence reflected in the works they hung on their walls, images that would serve as role models for themselves, their families, and their associates, enshrining the stereotypes of social position and social behavior particular to their class. But by the early years of the twentieth century Degas, Manet, and Renoir no longer appeared so disturbing; their works were seen and even collected more and more in this country, while new bugaboos—the Post-Impressionists and even Henri Matisse—had appeared. The Eight should be seen as an *extension* of the figurative Impressionists—not so radical as the modernists but ready to reinvestigate the tougher, more ugly, sometimes more pessimistic themes of the figurative French Impressionism that had been so emphatically rejected in New York in 1886.

These artists did, in fact, take Degas, Manet, and Renoir as their models. The *New York Times*, in fact, entitled its review of the 1904 National Arts Club show "Six

Impressionists: Startling Works by Red-Hot American Painters," and it noted that the pictures shown displayed "all the stages of impressionism."[25] Henri, who constantly directed his students to Manet, was called the "Manet of Manhattan."[26] Shinn is quoted as stating that he considered Degas "the greatest painter France ever turned out," and Albert Gallatin noted that not only did Shinn find his "inspiration and his manner in Degas's art," but that he had "learned to see things from Degas' point of view" and that also from Degas "he has learned to draw."[27] A few years later Gallatin wrote: "Degas had many cohorts behind him. . . . Uncounted legions of artists have learned invaluable lessons from his masterly pastels and paintings. William J. Glackens, a young American painter and illustrator, although from Manet, it is true, he has also derived many of his inspirations, is one of these latter artists."[28]

The works of the Eight are only selectively included here, since so many of their canvases are concerned with the people of New York rather than with the appearance of the city itself. But the latter was also an interest, to some degree, of almost all these painters, spurred on not only by Henri's philosophy of art for life's sake but also by the example of his own New York scenes. Henri had enjoyed his first great success when the French government purchased *La Neige* (Musée d'Orsay, Paris) from the Salon de la Société des Beaux-Arts in 1899. On his return to America in 1900 he settled in New York, and for the next several years Henri devoted much of his attention to paintings of Manhattan. During his short period as a New York urban realist, he portrayed the city at all seasons, from a number of winter views of the East River to hot summer evenings there. In all these cases, despite the grittiness of his industrial subject matter, his pictures speak of the ongoing development of New York. In April 1902 Henri showed some of his New York pictures—including *Snow in New York* (plate 22), painted that March—in his second one-artist show at the Macbeth Gallery.[29] He abandoned urban subjects after 1902, perhaps because that show produced few sales, despite general critical acclaim.

Most of Henri's future colleagues among the Eight painted the city. George Luks's *Madison Square* (plate 23) is a surprisingly gentle rendition of a subject that had been favored earlier by Hassam, painted in a Tonalist, almost Whistlerian mode. Using a somber, close-keyed palette, Luks concentrated on the sparkling lights, motorized traffic, and reflections in the wet pavement of the tall surrounding build-

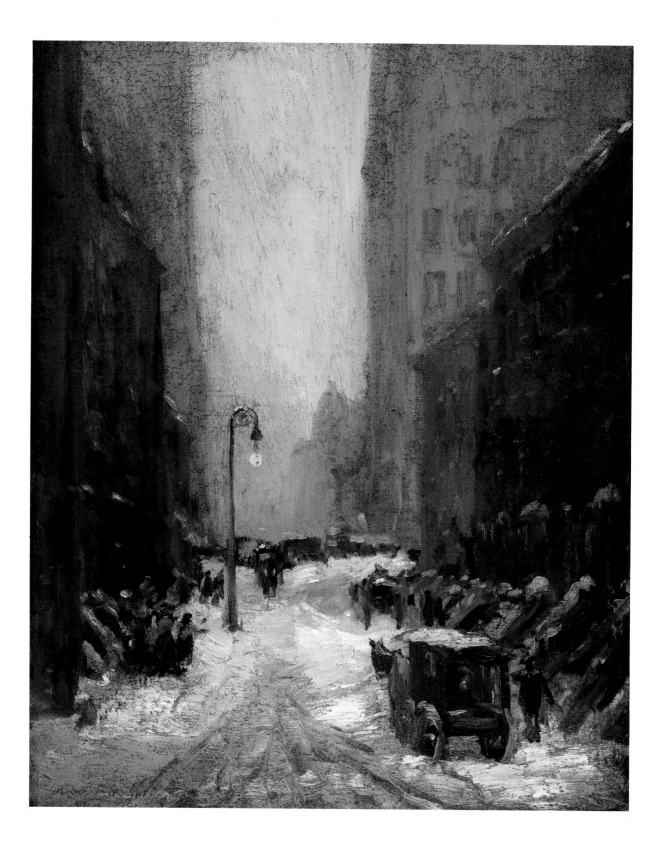

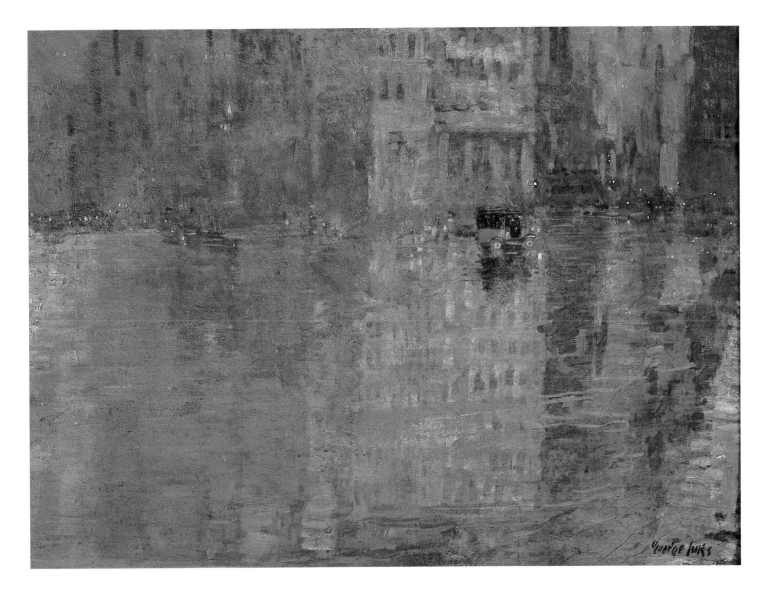

22. Robert Henri (1865–1929). *Snow in New York*,
1902. Oil on canvas, 32 x 25¾ in. (81.3 x 65.5
cm). National Gallery of Art, Washington, D.C.;
Chester Dale Collection.

23. George Luks (1866–1933). *Madison Square*,
c. 1915. Oil on canvas, 32⅛ x 44⅜ in. (81.5 x
112.5 cm). The Pfeil Collection, Chicago.

ings rather than on the structures themselves, which are cut off at the fourth or fifth story.

By the turn of the century, artists working in modes other than Impressionism were also investigating New York as appropriate subject matter. Tonalist painters—those working in a blurred, more muted manner, seeking evocative and even spiritual resonances—shifted their concern from the rural landscape to the city. Birge Harrison became the best known of these urban Tonalists, with his images of New York streets such as *Fifth Avenue at Twilight* (plate 32) and of skyscrapers such as the Flatiron Building, usually pictured in the rain, snow, or evening glow. Harrison concluded his seminal study *Landscape Painting* (1909) with a chapter entitled "The Future of American Art," in which he noted, "Our sky-scrapers have an unusual beauty of their own, and the sky-line of lower New York is far from being ugly or uninteresting."[30]

Artists, of course, did not always remain allied with a single aesthetic, however much the critics might champion one or the other. Harrison's urban scenes are not unlike some of Hassam's nocturnal images of the city, and in *Late Afternoon, New York: Winter* (plate 24) Hassam himself adopted many Tonalist strategies in order to evoke a poetic mood, thus allying himself with the Aesthetic movement and the dicta of James McNeill Whistler. The contemporaneous soft-focus Pictorial photography by such leaders in the field as Alfred Stieglitz and Edward Steichen also conformed to the Tonalist aesthetic, using this approach to mitigate the harshness of city life and the new, impersonal skyscrapers.[31]

By the second decade of the twentieth century a number of American painters who had subscribed to the strategies of European modernism were capturing the dynamics of the city in Post-Impressionist, Cubist, and especially Futurist terms, making paintings in which bridges and skyscrapers appear to fragment and almost explode. John Marin may be the earliest of these, with a series of city watercolors that began in 1910 and culminated in his depictions of the Brooklyn Bridge and the Woolworth and Municipal Buildings of the following years. Marin's rhetoric differed dramatically from Hassam's paeans of affection for the city. Marin wrote: "Are the buildings themselves dead? . . . If these buildings move me, they too must have life. Thus the whole city is alive. . . . I see great forces at work; great movements; the large buildings and the small buildings; the warring of the great and small. . . . While these

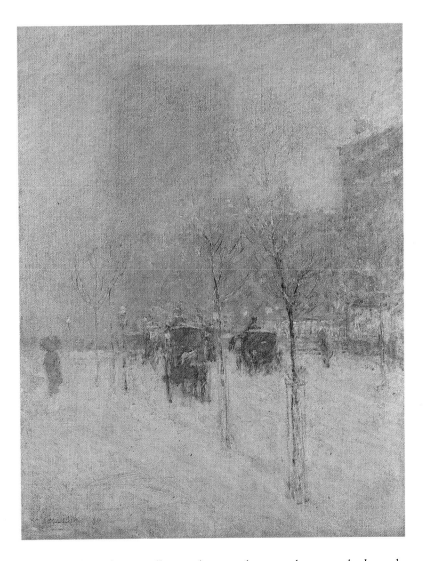

24. Childe Hassam (1859–1935). *Late Afternoon, New York: Winter,* 1900. Oil on canvas, 37 x 29 in. (94 x 73.6 cm). The Brooklyn Museum, New York; The Dick S. Ramsay Fund.

powers are at work pushing, pulling, sideways, downwards, upwards, I can hear the sound of their strife."[32]

Max Weber's New York pictures reveal even more directly the impact of Cubism and Futurism, beginning about 1911 with his *Brooklyn Bridge* (Joy S. Weber) and his 1912 *New York* (Museum of Fine Arts, Boston), which depicts the Liberty Tower from the Singer Building. What followed were kaleidoscopic interpretations of tall build-

ings, railroad terminals, department stores, and the dynamic *Rush Hour, New York* (National Gallery of Art, Washington, D.C.). Both Marin's and Weber's shattering of urban architectural forms in turn influenced the modernist drawings and watercolors by their friend Abraham Walkowitz, in which city streets and buildings are abstracted, beginning about 1914.[33]

The most famous modernist interpretations of New York City are the five Futurist-inspired panels of the New York Interpreted series (Newark Museum, Newark, New Jersey), painted by Joseph Stella in 1920–22; the artist had attacked the theme of urban dynamics as early as 1913 in *Battle of Lights, Coney Island* (Yale University Art Gallery, New Haven, Connecticut). Impressions of New York in modernist terms were also provided by such European artists as Francis Picabia and Albert Gleizes, who temporarily resided in the city during the 1910s.

These interpretations of New York based in whole or in part on Futurist dynamics are well known; less attention has been given to the work of those artists who emphasized the solidity and power of the city primarily in structural terms, a heritage from Cubism. Samuel Halpert is one such painter, but probably the finest impressions of this type—and the most overlooked—are those by Leon Kroll, such as his *Manhattan Rhythms* (plate 25). Kroll and Halpert had painted landscapes together in 1909–10 in Vernon, France, as members of a short-lived art community that was an offshoot of the well-known painters' colony across the Seine in Giverny.

Back in New York City later in 1910, Kroll turned away from the sparkling sunlight and broken brushwork of Impressionism in favor of the blocky forms that he found suitable for the buildings and other structures of the great city. He may have been propelled in this direction by his success at the National Academy of Design Winter Exhibition of 1911 with his painting *Brooklyn Bridge* (Mr. and Mrs. Sigmund Hyman), which was tremendously admired by Kroll's new friend, George Bellows.[34] Kroll's New York paintings appear to have continued through about 1919; he later painted softer, more idyllic scenes in Central Park in the 1920s.[35] Halpert did not return from Paris until 1912, and although his first New York subjects, such as *Brooklyn Bridge* (1913; Whitney Museum of American Art), share the strong geometry of Kroll's paintings, they are far more simplified, informed by the Post-Impressionist art of Paul Cézanne, Albert Marquet, and Henri Matisse.

Midst din, crash, outwearing, outliving of its iron and steel muscles and sinews . . . I gazed and thought of this pile throbbing, boiling, seething, as a pile after destruction, and this noise and dynamic force created in me a peace the opposite of itself.

"On the Brooklyn Bridge," Max Weber Papers, Archives of American Art, Smithsonian Institution, Washington, D.C.

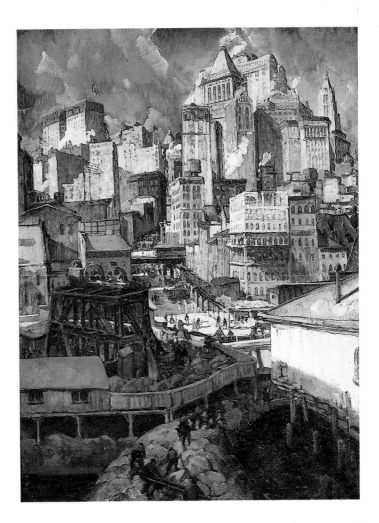

25. Leon Kroll (1884–1974). *Manhattan Rhythms,* c. 1915. Oil on canvas, 48¼ x 36¼ in. (122.6 x 92.1 cm). The Gerald Peters Gallery, New York.

Modern urban imagery appeared not only in the form of paintings, but also in photography and in the graphic media as well. In addition to individually issued plates and photographs used to illustrate articles on urban themes, portfolios of photographic views of the New New York were published, some by photographers of great renown. These included Alfred Stieglitz's early *Picturesque Bits of New York* (1897) and Alvin Langdon Coburn's *New York* (1910), in which the soft-focus effects, based on a Tonalist aesthetic, subdue the city's rigid forms. Tonalist effects also characterize F. Hopkinson Smith's *Charcoals of New and Old New York* (1912), in which the velvety

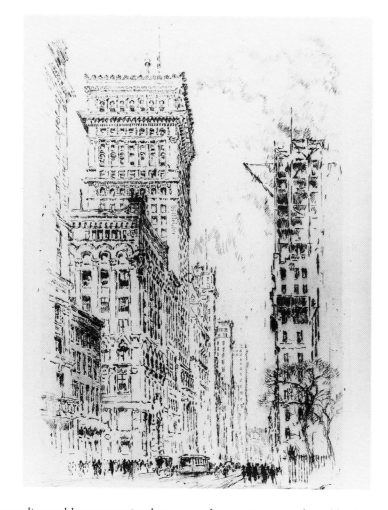

graphic medium adds a romantic glow not only to intimate park and backyard scenes but even to the skyscrapers and the city skyline.

Impressionist interpretations of the city appear in the occasional urban prints by painters such as Hassam and in the etchings and lithographs by such specialists as John Taylor Arms, Henry Deville, Charles F. W. Mielatz, and especially, Joseph Pennell. Pennell was the period's most renowned graphic recorder of the urban scene, and New York loomed large in his oeuvre. One writer noted, "The significance of his etchings is not limited to their fresh beauty as pictures or their charm as a revelation of hith-

26. Joseph Pennell (1857–1926). *The Golden Cornice, I,* 1904. Etching, 10⅝ x 7 in. (27.2 x 17.8 cm). Prints and Photographs Division, Library of Congress, Washington, D.C.

erto undiscovered enchantment; he has gone beyond this and proved . . . that New York has, in her first architectural honesty, redeemed herself from ugliness."[36] After devoting much of his earlier life as an expatriate to illustrating European monuments of the past, Pennell returned to the United States at the time of the Louisiana Purchase Exposition held in Saint Louis in 1904, where he was on the jury of awards. Colin Campbell Cooper was a fellow juror, and Pennell was inspired by Cooper's recent turn to skyscraper subjects to undertake that theme, as well as other New York subjects, in hundreds of etchings and lithographs beginning that year.[37]

As Edward Bryant has written, Pennell was interested not in the sociology of the city or in the human comedy but in its buildings.[38] In addition to his hundreds of individual prints, Pennell expressed his vision of the great city in periodical articles and in his books *Lithographs of New York* (1905) and *The Great New York* (1912). His books featured such prints as his etching *The Golden Cornice, I* (plate 26), from his first New York series of 1904—a soaring view from the street below of the American Surety Building, built in 1894–95 at 100 Broadway; this was a building that triggered a good deal of controversy about its pictorial qualities.[39] Pennell ameliorated the harshness of the angular architecture with his scintillating light, jagged calligraphy, and interrupted line, introducing steam and cloud effects to break up the solid structures. His title was not only descriptive but also allied his interpretation of the building with architectural traditions harking back to classical times, as well as suggesting wealth, color, and by implication, a quality of sparkling light that intimated Impressionist effects even in a black-and-white etching.

On Pennell's next extended sojourn in America, in 1908, he created a second set of New York prints, technically even more innovative with his investigation of mezzotint engraving; he was hailed as the "discoverer, one might say the inventor of the sky-scraper beautiful."[40] It was almost inevitable that Pennell would become the illustrator of John C. Van Dyke's *New New York* (1909). Referring to New York as "The Unbelievable City," Pennell acknowledged, "It has been the fashion to say, until lately, that there was no subject, no inspiration, no art atmosphere in America; when it is full, overflowing, irresistible—so great that one can only touch the fringe of it— New York."[41]

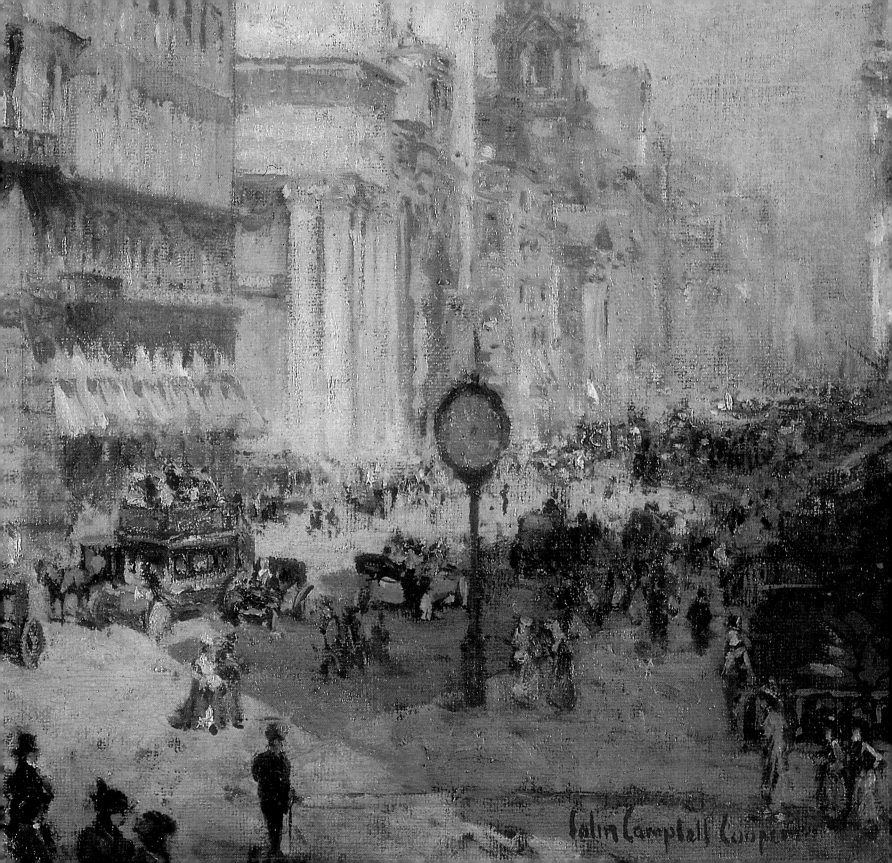

Colin Campbell Cooper

3
※

THE GREAT THOROUGHFARES:
FIFTH AVENUE AND BROADWAY

The Impressionist painters concentrated much of their urban observation on the streets and avenues of Manhattan. The shorter, narrower, and often quieter cross streets occasionally exacted their attention, but it was the great long avenues with their disparate crowds of casual strollers, busy workingmen and -women, and vehicles of all kinds that excited and held their vision. At the same time, these artists also recorded the changing appearance of these thoroughfares, both as they were traversed from south to north and over the decades that the painters recorded them. The artists focused on Broadway and particularly Fifth Avenue, beginning with the grandeur of Washington Square and ending at the Harlem River and 143d Street.

Fifth Avenue took its name from its position in the 1811 Commissioners Map, a plan of parallel arteries, though the avenue was not opened until 1824 and then only to Thirteenth Street.[1] Only gradually did it reach Harlem, and only in the 1870s was it graded for pedestrian and vehicular traffic.[2] Gradually, however, Fifth Avenue came to be compared to the rue de la Paix and the boulevard Saint-Michel, and it was even seen to surpass these Parisian avenues; Hassam claimed, "There is no boulevard in all Paris that compares to our own Fifth Avenue."[3]

The heterogeneous nature of the avenue seemed its outstanding feature; in 1915 Simeon Strunsky noted: "In the entire length Fifth Avenue is not one thing, but every-thing—a symbol, a compendium, a cross section of the national life. . . . It is a study in progressive sociology with mansions and factories, libraries, museums, vacant lots,

27. Detail of Colin Campbell Cooper, *Fifth Avenue, N.Y.C.,* c. 1906. See plate 34.

hospitals, parks, and slums. While other streets of New York have their own character as well as length . . . Fifth Avenue alone has significance."[4]

Civic historians and critics have disputed the efficacy of the 1811 Commissioners plan, which replaced growth along natural contours with a utilitarian, commercial grid that forced vertical expansion.[5] Others, such as Strunsky, viewed the "cutting straight across things" as exhibiting a "unique combination of destiny and democracy," resulting in the "creation of Fifth Avenue as the longest and straightest of the world's great boulevards."[6] The avenue's significance as the central spine that divides the numbered streets into their east and west components added symbolic resonance.

Fifth Avenue attracted Childe Hassam almost immediately after he settled in New York late in 1889, and by 1918 it was noted that he "has been Fifth Avenue's historian for years."[7] Hassam's *Fifth Avenue at Washington Square* (plate 28) captures the relaxed gentility of the lower part of the avenue. Much of Hassam's painting, especially at this period in his career, was devoted to expressing traditional American subjects and values in the most modern of aesthetics, and his New York scenes are no exception. This *is* the old New York.

One writer noted in 1899:

> The fashionable life of the metropolis once had its center here, and although the neighborhood still retains much of its old-time character, and nothing of natural beauty seems lacking to make it desirable as a residence, the tide of fashion has receded northward. The big houses that form the avenue's corners are maintained in the same style as of yore, the grassplots in the front and to the side of them are swept and shaven, the white steps immaculate and the window panes polished.[8]

Hassam emphasized this sense of pristine order in *Fifth Avenue at Washington Square.* On what was likely a June morning—the trees are in full leaf and the sun shines from the east—an elegant woman strolls with a parasol, a child plays with a hoop, and a top-hatted man is about to pass a nursemaid, while another man walks his dog on the avenue, between the stoops of private homes at the right and a street full of carriages.

In a view made farther north, New York's most majestic house of God figures prominently in Hassam's watercolor *Sunday on Fifth Avenue* (plate 29), undated but probably painted around 1890–91, at much the same time as his *Fifth Avenue at Washington*

Cut off from the residential district to the northward by the river of traffic that flows along Fourteenth Street, the lower end of Fifth Avenue forms a picturesque oasis, where the aristocratic air of old Knickerbocker stateliness lingers amid a commonplace environment. The six blocks between Washington Square and Thirteenth Street are a unique corner of New York. Their architecture is that of a generation that has now passed away. . . . Roomy and well proportioned structures of red brick, they have a simple dignity that is far more impressive and pleasant than the showiness of many more ambitious and elaborate products of the modern builder. The trees that line the street, and the greenery of Washington Square, help to make this one of the most picturesque points of Fifth Avenue.

Richard H. Titherington, "Picturesque Points on Fifth Avenue," *Munsey's Magazine* 6 (November 1891): 125–26.

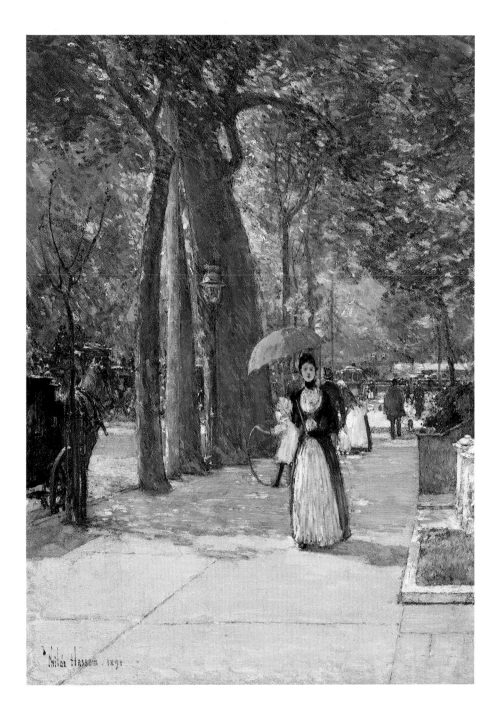

28. Childe Hassam (1859–1935). *Fifth Avenue at Washington Square,* 1891. Oil on canvas, 22 x 16 in. (56 x 40.6 cm). Thyssen-Bornemisza Collection, Lugano, Switzerland.

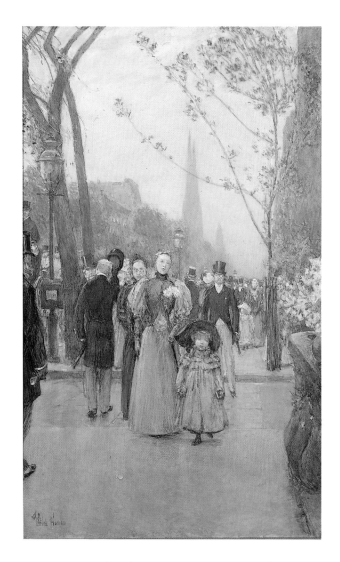

The churches close their services near about the same hour, and then each pours its throng of fashionably dressed people into the avenue. The congregations of distant churches all find their way to the avenue, and for about an hour after church the splendid street presents a very attractive spectacle.

James D. McCabe, *Lights and Shadows of New York Life; Or, The Sights and Sensations of the Great City* (Philadelphia: National Publishing Co., 1872), p. 446.

Square. The scene represents a Sunday morning promenade after church, so that Saint Patrick's presence in the background is not merely topographical but also explains why the men, women, and children are wearing their finest regalia. The figures move in a slow, steady procession, and one man tips his hat to another. Hassam's painting documents the popularity of promenading on Fifth Avenue, a custom that goes back to the early nineteenth century and is still with us today. The traditions of the English

29. Childe Hassam (1859–1935). *Sunday on Fifth Avenue,* c. 1890–91. Watercolor on paper, 30½ x 19 in. (77.5 x 48.3 cm). Courtesy James Graham and Sons, Inc., New York.

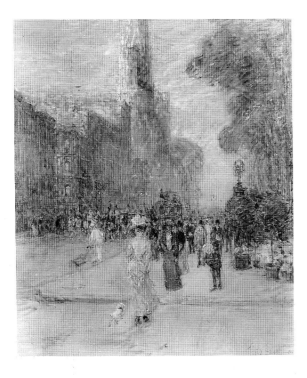

Church Parades, which took place in London's Hyde Park on Sunday afternoons, had been transplanted to New York by the wealthy parishioners of Grace Church (on Broadway at Tenth Street); the march gradually moved northward until it extended as far as Fifty-seventh Street.[9] This painting was the basis for one of Hassam's illustrations for Mariana G. Van Rensselaer's article "Fifth Avenue"; as she reminisced, "On Sundays, after church-time, the sauntering was very general. If you knew any one worth knowing in New York, you were pretty sure to find him on the avenue then."[10]

Saint Patrick's appears again in Hassam's *Fifth Avenue from Fifty-sixth Street Looking toward Saint Patrick's* (plate 30), but this is clearly a business day, with a white-garbed street cleaner working at left while busy, fashionably dressed pedestrians attend to their affairs, shop, and walk their dogs. The entrance to the Fifth Avenue Presbyterian Church (1875) would be at the right, with a small landscape pocket with overhanging trees behind.

Van Rensselaer noted, "Business has got a firm foothold here [at Fourteenth Street] . . . and is gradually creeping up and up, until who can say how soon the whole of Fifth Avenue as far as the Park may be a commercial street?"[11] That commercial development did not at first attract artists nor did the great houses that were erected beginning in the late 1870s, both in the Fifties above Saint Patrick's Cathedral (such as

49

ABOVE
30. Childe Hassam (1859–1935). *Fifth Avenue from Fifty-sixth Street Looking toward Saint Patrick's*, 1900. Oil on canvas, 24 x 20 in. (61 x 50.8 cm). Private collection.

RIGHT
31. Photographer unknown. *Panorama of New York, Looking North along Fifth Avenue from the Tower of Saint Patrick's Cathedral*, 1888. Photogravure.

Richard Morris Hunt's great 1881 château for William K. Vanderbilt at Fifty-second Street) and bordering Fifth Avenue along Central Park, referred to as Millionaires' Row. As one writer noted in 1905, "residentially Fifth Avenue has moved from Washington Square to the Plaza."[12]

When turn-of-the-century Tonalist painters, such as Paul Cornoyer and Birge Harrison, began to focus on the stretch of Fifth Avenue in the neighborhood of the Grand Army Plaza, they often softened the taller buildings with the glow of twilight or moonlight or veiled them with rain or winter snow. Such temporal elements seemed not only to soothe the harshness of both commerce and sharp-edged modern construction but also to introduce more natural aspects of the urban *landscape*. In describing Harrison's urban scenes, Charles L. Borgmeyer noted that "the moment selected is that of early twilight, when the lights are just twinkling out and the hard edges of the buildings are lost or softened in the evening haze."[13] The often single-toned colorism—a Whistlerian, nocturnal blue was the color of preference—introduced a moody nostalgia into such scenes, gently romanticizing these urban interpretations. Critics praised Harrison's New York as "a city of dreams, a poetical spell, of haunting fascination."[14] In *Fifth Avenue at Twilight* (plate 32), dusk, rain (the streets are wet), and the evocative season of winter (the trees are leafless) shroud a view down the avenue from the Plaza, with Saint Patrick's seen in the distance at the left and the spire of the Fifth Avenue Presbyterian Church, with the Gotham Apartment-Hotel behind, at the right.[15]

Other painters took advantage of brilliant sunlight to celebrate the full magnificence of the avenue, with its office buildings, restaurants such as Sherry's and Delmonico's (both at Forty-fourth Street), hotels, churches, and cultural institutions. This was the "newer Fifth Avenue, which has risen in marble and Indiana limestone from the brownstone and brick of a former age, the Augustan Fifth Avenue which has replaced that old Lincolnian Fifth Avenue."[16] This new urban spirit is nowhere better seen than in the New York canvases by Colin Campbell Cooper, such as *Fifth Avenue, N.Y.C.* (plate 34)—a view looking north from Thirty-second Street and focusing on the Waldorf-Astoria Hotel, designed by Henry Janeway Hardenbergh in German Renaissance style between Thirty-third and Thirty-fourth Streets; this was subsequently the site of the Empire State Building, after the hotel was demolished in 1929.

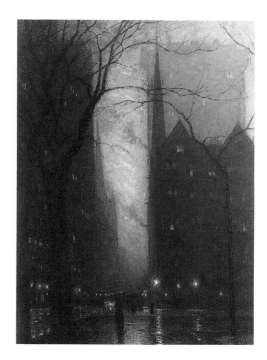

ABOVE
32. Birge Harrison (1854–1929). *Fifth Avenue at Twilight,* 1910 or earlier. Oil on canvas, 30 x 23 in. (76.2 x 58.4 cm). The Detroit Institute of Arts; City of Detroit Purchase.

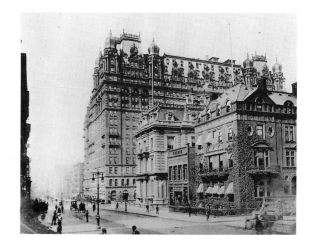

At one end is venerable Washington Square, the beautiful Washington Arch, and the dignified homes of some of New York's oldest families. At the other end, 143rd Street and the Harlem River is a quasi-public dump littered with unsightly debris. Within the seven miles that lie between, may be found some of the most beautiful homes in the world and unkempt double-decker tenements; building after building given to the manufacture of wearing apparel, or containing the headquarters or agencies of almost every known industry; luxurious and expensive hotels, and some of the most beautiful churches and clubs, and pushing up to the very doors of the stately residences are some of the finest shops and art galleries in the world.

Fifth Avenue Glances (New York: Fifth Avenue Bank of New York, 1915), pp. 9–10.

OPPOSITE

33. Photographer unknown. *The Waldorf-Astoria*, 1898. Photogravure. The New-York Historical Society.

RIGHT

34. Colin Campbell Cooper (1856–1937). *Fifth Avenue, N.Y.C.*, c. 1906. Oil on canvas, 39 x 27 in. (99 x 68.6 cm). The New-York Historical Society.

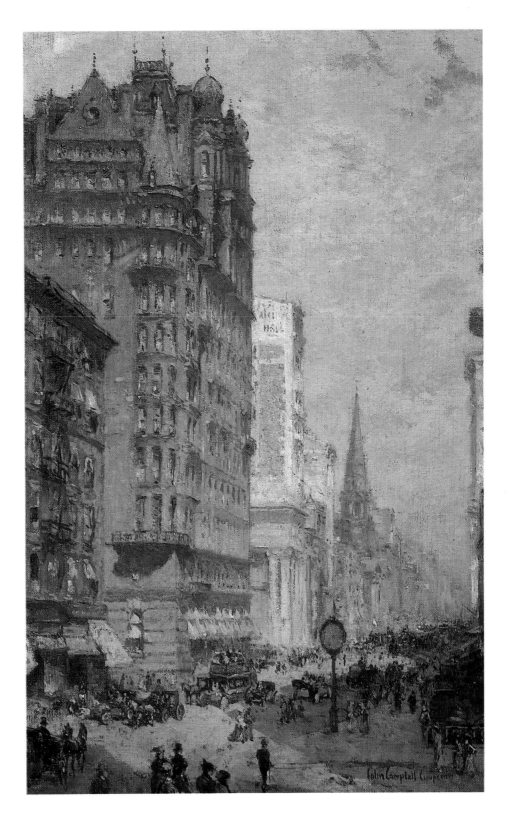

Cooper's painting actually concentrates on the "older" Waldorf Hotel, built by William Waldorf Astor on the site of his father's house; the adjoining Astoria Hotel was constructed four years later by his cousin John Jacob Astor. It was named the Astoria after the community established by their ancestor, the first John Jacob, who had created the family fortune with his fur-trapping empire. Farther up, on Thirty-seventh Street, is the Brick Presbyterian Church (1858), designed by Leopold Eidlitz.

This is a different world from the sedate and measured images of the avenue that Hassam had painted in the early 1890s. Now the buildings soar high above the swarming multitude of pedestrians and horse-drawn and motorized vehicles. By 1909 John C. Van Dyke could point out that "the better class of shops no longer follow Broadway but Fifth Avenue. . . . What the avenue is destined to become everyone knows since the Altman store was erected between Thirty-Fourth and Thirty-Fifth streets."[17] This occurred in 1906, with the store catercorner across the avenue from the Waldorf-Astoria Hotel.

But the avenue was not all commerce. One of its grandest new buildings at the turn of the century was the New York Public Library, between Fortieth and Forty-second Streets, designed by Carrère and Hastings and built between 1897 and 1911 on the site of the old reservoir. Set back from the avenue, the new library was one of the city's first modern buildings to provide its own monumental setting, with landscaped terraces and broad steps.[18] In 1915 Edmund W. Greacen, who had developed his Impressionist aesthetic in the very rural environment of Monet's Giverny, painted *Fifth Avenue (Library with Lion, New York, Fifth at Forty-second Street;* plate 35), a view from on high on Fortieth Street, emphasizing the library's terrace and the famous pair of lions by Edward Potter rather than the building itself. A block up, dwarfed by the surrounding commercial structures, is seen the Temple Emanu-el (1868), designed by Leopold Eidlitz; it was demolished between 1927 and 1929.

Though by the early twentieth century Hassam had abandoned the intimate surrounds of lower Fifth Avenue, the avenue's great new commercial and institutional structures continued to fascinate him. As one writer noted in 1918: "Mr. Hassam migrated further north. . . . But the rains and the snows fall alike upon upper and lower Fifth Avenue, and soon Mr. Hassam grew quite at home in his new surroundings, and tackled most of the architectural motifs as soon as they were put up."[19] Fifth Avenue's

35. Edmund W. Greacen (1877–1949). *Fifth Avenue (Library with Lion, New York, Fifth at Forty-second Street)*, 1915. Oil on canvas, 36 x 40 in. (91.4 x 101.6 cm). Private collection.

modern commercial growth is celebrated in the best-known of all the Impressionist renderings of New York—Hassam's renowned Flag series of about thirty pictures, painted in response to America's involvement in World War I.[20] The earliest images in the series were inspired by the Preparedness Day Parade that took place on Fifth Avenue on May 13, 1916, almost a year before the United States joined the war. With America's entry into the war on April 6, 1917, Hassam turned his attention more decisively to views of the flags of the United States and its allies along and near Fifth Avenue; the last canvas in the series was painted in May 1919, on the return of the Seventy-seventh Division from Europe.

The paintings have rightly been recognized as reflecting Hassam's own patriotic stance, as well as the utilization of Impressionist strategies for nationalistic purposes. When one of the group was on display at New York's Macbeth Gallery in June 1918, five months before the first showing of the Flag series as a whole, a critic commented: "One gets from it the idea of the city, a place built by men for their satisfactions and activities, to be defended with passion from a destructive enemy. No fairer sight than the blonde wide lane of Fifth Avenue, with its innumerable banners, can well be imagined."[21] Hassam was hardly alone in creating war-related images, though only he appears to have produced a series of such representations, which took some inspiration from Monet's very different serial images of grain stacks, poplars, and Rouen Cathedral; Monet's own flag paintings, such as *Rue Montorgueil, Festival of June 30, 1878* (Musée d'Orsay, Paris), also offered iconographic and compositional precedent.[22]

Hassam's paintings also document the appearance of Fifth Avenue at that time, though in some cases individual buildings and even specific locations on the avenue are difficult to identify. In others, such as *Avenue of the Allies, 1918* (plate 36), Hassam has very carefully designated the site: the picture was painted at Fiftieth Street, at the foot of Saint Patrick's Cathedral; Saint Thomas' Church (with the Gotham Apartment-Hotel behind) is featured in bright sunlight across the avenue and up three blocks at the left. *Avenue of the Allies, 1918* is one of the most site-specific of the entire series, and one of a number inspired by the Fourth Liberty Loan Drive. This was the most elaborate of all the Liberty Loan Drives, and it inspired a tremendous amount of artistic activity. Each block, from Twenty-sixth to Fifty-eighth Street, was devoted to one of the twenty-two Allies, with a number of blocks selected for the display of combined Liberty Loan and United States flags. In front of Saint Patrick's and the Public Library, flags and standards of all the associated nations were on view; Hassam indicated this but did not allow the flag display to obtrude over the architecture of the avenue. Hassam's inclusion of religious references here, embodied in monumental and enduring institutions, suggests both heaven's support of the war effort and the moral virtuousness of modern New York life.

Some paintings in the Flag series are more tightly rendered while others are extremely painterly; in some, such as *Avenue of the Allies, 1918*, the viewpoint is at ground level, while others are from on high. Nevertheless, they almost all bespeak a shift in approach from Hassam's early pictures painted around Washington Square: now the

36. Childe Hassam (1859–1935). *Avenue of the Allies, 1918*, 1918. Oil on canvas, 36 x 28 in. (91.4 x 71.1 cm). Private collection.

OPPOSITE

37. Childe Hassam (1859–1935). *Fifth Avenue,* 1919. Oil on canvas, 23¼ x 19¼ in. (59 x 48.9 cm). The Cleveland Museum of Art; Anonymous Gift.

ABOVE

38. John Marin (1870–1953). *Movement, Fifth Avenue,* 1912. Watercolor on paper, 17 x 13¾ in. (43.3 x 35 cm). The Art Institute of Chicago; Alfred Stieglitz Collection.

multitudinous figures are mere ideographs, dominated by the immense architectural towers soaring above them. This is even more exaggerated in Hassam's *Fifth Avenue* (plate 37), in which seemingly hundreds of pedestrians and vehicles (including the green double-decker buses that had been introduced on Fifth Avenue in 1907 and were a favorite motif of Hassam's) move inexorably up and down the avenue, hemmed in by the surrounding stone monoliths.[23] The suggestion of greater fragmentation of both form and design, though still firmly within Hassam's individual conception of Impressionism, also relates to the more modern aesthetics of such artists as John Marin. Hassam, however, never adopted the distortion, fracturing, or multifaceted viewpoint derived from Cubist and Futurist aesthetic innovations that one finds in such views of the avenue as Marin's *Movement, Fifth Avenue* (plate 38).

To some urban writers, such as Simeon Strunsky, Fifth Avenue's rivals were Eighth and Tenth (or Amsterdam) Avenues, both longer thoroughfares.[24] But Broadway, too, was one of the longest "modern" thoroughfares in the world at the turn of the century; often, like Fifth Avenue, it was dubbed the "greatest street in the world," and it, too, attracted the artists.[25]

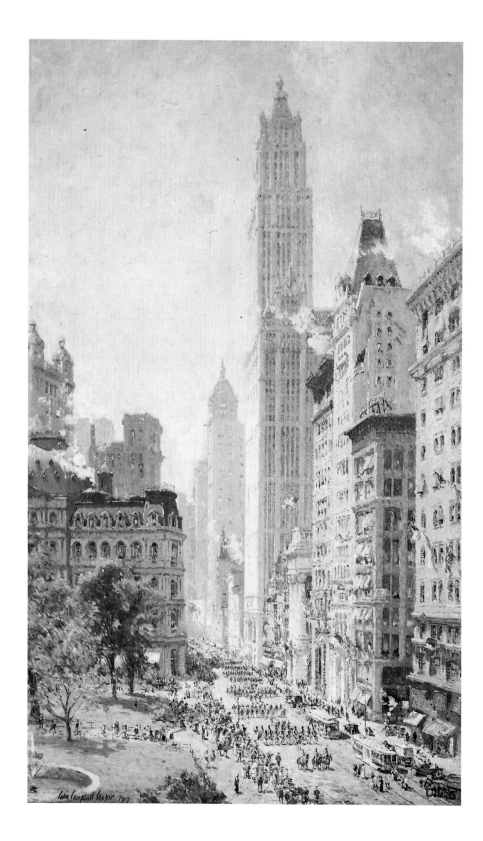

The heart of New York is Broadway. It is not only the heart, but the brain, the spinal column, the great nerve-centre, the chief artery. As New York is the world in microcosm, Broadway is the epitome of the whole city.

James W. Shepp and Daniel B. Shepp, *Shepp's New York City Illustrated* (Chicago and Philadelphia: Globe Bible Publishing Co., 1894), p. 65.

39. Colin Campbell Cooper (1856–1937). *Lower Broadway in Wartime*, 1917. Oil on canvas, 57½ x 35¼ in. (146 x 89.5 cm). Pennsylvania Academy of the Fine Arts, Philadelphia; Joseph E. Temple Fund.

Broadway was a far older street than Fifth Avenue. It had begun in 1642 as the Dutch Heere Street—also known as Broad Wagon Way, the Common Highway, and Great Public Road—and by the end of the seventeenth century it already traversed the whole of Manhattan Island; by the end of the next century this "post road" extended to Greenbush in Rensselaer County, across the Hudson River from Albany. But the artists of our period concentrated their activity on Broadway from its beginning at Bowling Green at the southern tip of Manhattan up to around Forty-second Street.

In 1891 Richard Harding Davis divided this section of Broadway into three segments: the business district, from Bowling Green or Steamship Row to about Tenth Street; the shopping district, from there to Twenty-third Street; and the fashionable promenade district, from Twenty-third to Forty-second Street.[26] Each had its distinct clientele and each a different mood. The most southerly section had known expensive townhouses in the early part of the nineteenth century, but by the end of the century this fashionable area was in decline and the steamship companies took over. In addition to the shipping business, this section featured foreign consulates, boardinghouses for recent immigrants, money-exchange shops, and businesses catering to sailors, both national and international. In 1899 Steamship Row was bought by the United States government, and the following year the entire block was demolished. Construction on the government Custom House, designed by Cass Gilbert, was begun in 1901, and the structure was dedicated in 1907.

The heart of New York's business district began several blocks north of Steamship Row, and tall buildings began to overwhelm the old landmark, Trinity Church. The greatest structure to rise during our period was also one of the latest: Cass Gilbert's Woolworth Building (1913), situated on the west side of City Hall Park. It was across from Newspaper Row, where almost all of the city's dailies—including the *Sun, Tribune, Times, Evening Mail, World, American, Globe,* and *Staats-Zeitung*—were printed in the nineteenth century.

Though hardly comparable to Fifth Avenue in terms of wartime parades and celebrations, a flag-bedecked Broadway did play host to military processions and the crowds that came to witness them. Colin Campbell Cooper featured the Woolworth Building, at the time the tallest building in the world, in *Lower Broadway in Wartime* (plate 39). R. H. Robertson's two-turreted Park Row Building (1899) seals off the composition

at the left; next to it is George B. Post's Saint Paul Building (1899); across Broadway is Napoleon LeBrun's Home Life Insurance Company (1894), with its peaked mansard; next is the heavy, projecting cornice of the Postal Telegraph Cable Company Building at Murray Street. Farther down Broadway rises Ernest Flagg's forty-seven-story Singer Building at 146 Broadway (1908), which was the city's tallest for a short time until the construction of the fifty-two-story Metropolitan Life Tower at Madison Avenue and Twenty-fourth Street, in 1909, and then the Woolworth Building. The soaring vertical thrust of the skyscrapers is countered both by the verdant park at lower left and by the steam clouds throughout the picture that break up the sharp architectural lines.[27] Cooper celebrated the New New York, which gleams in bright sunlight, while behind the park the older, squat, enormous City Hall Post Office (built in Second Empire style by A. B. Mullett in 1875) is in shadow, its cupola almost hidden by the steam.

In his earlier *Broadway from the Post-Office* (plate 40), made before the construction of the Woolworth Building, Cooper concentrated on the narrower chasm of Broadway, where sunlight barely filters through among the skyscrapers, dominated here by the Singer Building though again eased by the ubiquitous steam clouds. This is the Broadway so frequently referred to as a "cañon." The extreme verticality of both of Cooper's pictures underscores the vertical growth along the thoroughfare. Discussing his images such as *Broadway from the Post-Office*, Cooper used the musical analogies that were then rife in aesthetic theory: "Here in New York it [the meter] is tuned to a quicker, more strident music. . . . Yes, in the last analysis, the supreme thing that New York says to me is: 'I sing.'"[28]

By the second half of the nineteenth century Broadway from Fourteenth to Twenty-third Street was the heart of Ladies Mile. It was the center for hotels, theaters, galleries, and clubs, and for the major retail outlets—Brooks Brothers, Lord and Taylor Drygoods, W. J. Sloane Carpets, Arnold Constable, and many others. By the early twentieth century many of these prestigious companies had abandoned Broadway for Fifth Avenue: in 1914 Arnold Constable, built in 1868–69 at 881 Broadway at East Nineteenth Street, moved to Fifth Avenue near Fortieth Street; and Lord and Taylor, completed in 1872 at 901 Broadway at Twentieth Street, moved to Thirty-eighth Street.[29] A photograph of Broadway and Twenty-third Street (plate 41), taken about 1890, documents both the small businesses just below Twenty-third Street and the old,

40. Colin Campbell Cooper (1856–1937). *Broadway from the Post-Office*, from Louis Baury, "The Message of Manhattan," *Bookman*, August 1911.

There are tall buildings to the east—tall clean buildings that smile in the sunlight. . . . There are lower buildings to the west—lower and gloomier, and always shadowed by the elevated tracks. On all sides are the streets and sidewalks, never really clean, and generally disgracefully dirty.

David Graham Phillips, "The Union of Sixth Avenue and Broadway," *Harper's Weekly*, March 21, 1891, p. 210.

enormous Fifth Avenue Hotel on the corner of Broadway and Twenty-third Street, built on the site of Franconi's Hippodrome, a circus.

When the hotel was built, in 1859, it was thought too far uptown to be successful. But by the late 1890s the office towers and tall manufacturing buildings were moving in on the area's luxury trade and amusement center, a progression that culminated in the construction of Daniel Burnham's twenty-story Flatiron Building (1902) at the intersection of Broadway and Fifth Avenue at Twenty-third Street. That building itself offered a panoramic vista of the great avenues, enabling one to look steeply down on the now very squat Fifth Avenue Hotel and on "things that you would take for beetles, others that seem to you ants. The beetles are cabs; the ants are beings."[30] The hotel trade, too, moved up Fifth Avenue with skyscraper hostelries like the Waldorf-Astoria, and the Fifth Avenue Hotel was demolished in 1908.[31]

Farther north, at the intersection of Broadway and Sixth Avenue at Herald Square, the elevated railroad was fully operational by 1890, and it brought squalor and gloom to the area (plate 42). Such subject matter was vividly recorded in the illustrated periodicals and newspapers, but it was not, of course, the substance of Impressionist

61

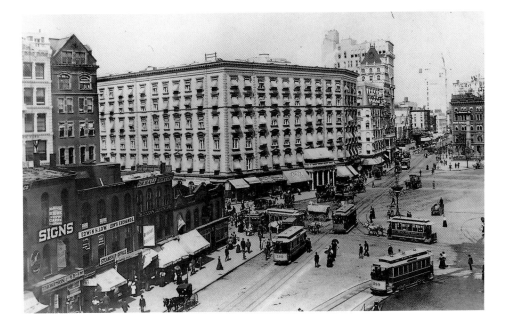

41. Photographer unknown. *Broadway and Twenty-third Street*, c. 1890. Photogravure. The New-York Historical Society.

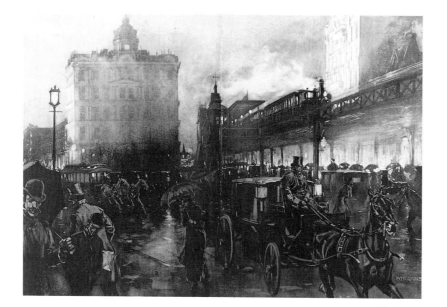

painting.[32] By the turn of the century, painters directed their attention to the course of Broadway between the two "flatirons"—the Flatiron Building at Twenty-third Street and the Times Building at Forty-second Street (constructed by Cyrus Eidlitz in 1904), which gave the meeting of Broadway and Seventh Avenue, formerly Longacre Square, its new name of Times Square. Known successively as "The Gay White Way" and "The Great White Way," this area became the center of the theater district. Richard Le Gallienne referred to it as the "storm center of New York's hedonistic activities, the metropolis of vitality, its well-loved theaters, its lordly hotels, and its grotesquely named lobster palaces, at night the glowing, incandescent heart of the city."[33] In 1883 the Metropolitan Opera House, designed by J. C. Cady, went up at Thirty-ninth Street, and other new theaters and hostelries arose thereafter: Oscar Hammerstein erected his Olympia between Forty-fourth and Forty-fifth Streets in 1895, with a music hall, concert hall, and theater all housed under its roof; the Hotel Astor was constructed across Broadway in 1909, with the Knickerbocker Hotel at Forty-second Street opened to the public in 1906.

Writers such as John Corbin were especially struck by the vivid electric theatrical sign boards, with "Lights that extinguish the stars. . . . The cavernous maws beneath those blazing boards nightly suck in throngs of amusement seekers vaster than in any other of the world's thoroughfares."[34] Charles Battell Loomis noted that this area of

42. W. H. Crane. *Broadway at Sixth Avenue*, from David Graham Phillips, "The Union of Sixth Avenue and Broadway," *Harper's Weekly*, March 21, 1891.

43. Childe Hassam (1859–1935). *Broadway at Forty-second Street,* 1902. Oil on canvas, 26 x 22 in. (66 x 55.9 cm). The Metropolitan Museum of Art, New York; Bequest of Miss Adelaide Milton de Groot, 1967.

"Broadway, even at the best, is a madding whirl and roar of tangled vehicles and men," and he railed against the dangers of the cable cars, which constituted the "newest menace to the wayfarer on Broadway," having been introduced on the street in 1891.[35] Hassam's *Broadway at Forty-second Street* (plate 43) shows a similar fascination with the crowded streets illuminated by street lights, the glare from shop windows, and the lighted trolleys passing horse-drawn cabs. "The cable-cars," one writer noted, "are certainly trying enough to our susceptibilities in the daytime. But he who waits till nightfall . . . must be stolid indeed if he is not stirred, at least for the moment, by the spectacle of the clustering, moving, appearing, and disappearing lights in the broad avenue and in the open space at the foot of the hill where Broadway intersects Seventh Avenue."[36]

4

The Squares,
the Circles, and the Arches

Within Manhattan the Impressionists expended particular attention on some of the crossroads where the great avenues began or where they intersected the long diagonal of Broadway. Before and after the turn of the century, images multiplied of Washington Square; of Union Square, where Fourth Avenue (now called Park Avenue South) and Broadway meet; of Madison Square, the meeting of Broadway and Fifth Avenue; of Times Square, where Seventh Avenue crosses Broadway; and of Columbus Circle, the meeting of Broadway and Eighth Avenue.[1] Formally, these subjects allowed the painters far greater compositional invention and complexity than that afforded by a single avenue, which could be depicted only head on or obliquely. Also, the painters were often able to make effective counterpoint between sleek, hard architectural lines and softer, more colorful natural elements; differing effects of light and atmosphere among the buildings and the open plots of lawns and trees could be contrasted. These squares and circles involved great variety in their functions, in their architectural forms, and in their pedestrian and vehicular activity; and the artists sought to capture each one's distinct urban identity.

Washington Square, once a potter's field, owed its growth and character partly to the yellow fever epidemic of 1822, which accelerated the growth of the city northward, leading merchants such as the Griswolds, the Boormans, and the Rhinelanders to build on the north side of the square by 1831. By the end of the century the park was a promenade for the rich and a place to exercise their dogs; an oasis for the middle and lower classes and a place to bring their children; and a meeting ground for lovers.[2]

44. Detail of Paul Cornoyer, *Rainy Day, Madison Square, New York,* c. 1907–8. See plate 55.

The most distinctive element of the square was the Washington Arch, which was utilized by painters and photographers alike to identify the site and to distinguish both its appearance and its character from other urban crossroads. Childe Hassam's most renowned image of this region is, in fact, *Washington Arch, Spring* (plate 45), painted not far south from his studio at 95 Fifth Avenue.[3] This painting was Hassam's most complete expression of Impressionist aesthetics to date, combining his concern for up-to-date images of modern life with an abundance of bright color, full sunlight, and vigorous brushwork—all of which reinforce a composition that is at once animated and yet clearly controlled by the dominating geometric structures.

An elegantly dressed lady is the most prominent figure, walking past the well-tended flowering garden patches that border the stoops of the row houses. Behind her are several top-hatted gentlemen promenading up the avenue, along with a nurse pushing a baby carriage and taking her charge for an outing; the strong shadows cast by the sun in the east indicate an early morning time of day. This is a world of great order and neatness, with the spacious sidewalk opening up broadly and spreading over the entire front plane. The month is May, as was established when the picture was exhibited as *Fifth Avenue and the Washington Arch in May* at Doll and Richards Gallery, Boston, in February 1895. Hassam conveyed a sense of growth and renewal with the mature trees in the middle ground, behind which are several younger ones, and in front, a thriving sapling. The flickering brushwork and light, rococo palette justify contemporary references to Hassam as "a sort of Watteau of the Boulevards, with unlimited sparkle and gaiety, movement and animation. He suggests a crowd well; he gives you the color of the streets and the tone of the city."[4]

The scene is dominated by the Washington Arch, whose presence establishes the approximate date of the picture's creation even though it disputes the "1890" inscribed at lower right.[5] In fact, the arch did not exist in 1890. A temporary wooden arch painted white, financed by neighborhood residents such as William Rhinelander Stewart, had been designed by the architect Stanford White to commemorate in late April and early May 1889 the centennial of George Washington's inauguration, and therefore also to commemorate the inauguration of the democratic process in the nation. This arch spanned Fifth Avenue on the north side of Waverly Place (plate 46).[6] It lent such distinction to the site that a more solid and more Roman equivalent was begun on

I am ready to affirm that Washington Square has thus far led a reasonably conservative life. So, too, it has been with the lowest part of the avenue. . . . They are not the fashionable streets they were in my childhood; but "good people" still live in them, and the number is now increasing again year by year, desecrated dwellings being restored within and without, and a belief steadily gaining ground that, whatever may happen a little farther up in the avenue, this quarter-mile stretch will remain a "good residence neighborhood."

Mariana G. Van Rensselaer,
"Fifth Avenue with Pictures by
Childe Hassam," *Century Magazine*
47 (November 1893): 10.

45. Childe Hassam (1859–1935). *Washington Arch, Spring*, c. 1893 (signed 1890). Oil on canvas, 27⅛ x 22½ in. (68.9 x 57.1 cm). The Phillips Collection, Washington, D.C.

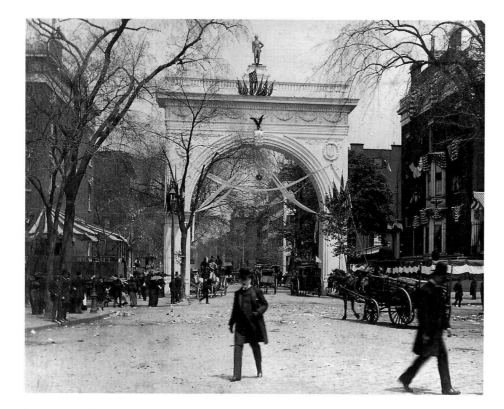

46. Photographer unknown. *The Washington Arch Decorated for the George Washington Inaugural Centennial Celebration*, 1889. Photogravure. The New-York Historical Society.

47. *Washington Arch*, from Arthur M. Barnes, "Washington Square," *Harper's Weekly*, July 14, 1894.

Decoration Day (May 31) of 1890. Construction was completed in April 1892 at a cost of 128,000 dollars, raised by a committee from public subscription, though the arch was not dedicated until May 4, 1895.[7] This permanent arch (plate 47)—which stands in Washington Square, facing the lower end of Fifth Avenue, fifty feet (fifteen meters) south of Waverly Place (now Washington Square North)—was one of the earliest monuments to reflect the new interest in monumental commemorative architecture throughout the city.

By the time Hassam had settled at 95 Fifth Avenue, at the end of 1889, the temporary arch had almost surely been removed, and ground was not broken for the permanent structure until the end of May the following year. Since Hassam's picture includes the north trophy panels on the arch, which were completed by February 1893, this work was probably painted in the spring of that year; this date accords better also with the picture's illustration in *Century Magazine* that November and its

exhibition in 1895. The arch not only anchors the pictorial composition, but it also underscores the sense of renewal in a section of the city that had been on the decline for some time and had only recently undergone refurbishment.

That renewal is highlighted by the small but telling detail of the street cleaner in a spotless white uniform in the left foreground; literally "cleaning up the neighborhood," he takes his place as part of the system of support for a traditionally elegant way of life, along with the liveried carriage drivers and the nurse with her pram. The concern with order, the denial and deletion of squalor, are characteristic of Hassam's assessment of New York, and such white-clad street cleaners appear often in his work throughout the city (see plates 6 and 30). Street cleaners had only recently been assigned the responsibility of working alone on individual streets, as seen in Hassam's paintings. The sweepers were reported in 1891 as "able-bodied, strapping fellows between the ages of twenty-five and forty years. They were of various nationalities, Irish, German and Italian. Some of those who were spoken to said that they preferred the new system to that of working in gangs. Under the new system every man was compelled to work diligently, as he was held responsible for the street to which he was assigned."[8]

Washington Square was a favorite painting ground for the next generation of American Impressionist and realist painters, including several members of the Eight. Everett Shinn (who lived on Waverly Place, just around the corner from the square) believed the square to be the most beautiful spot in New York City.[9] Shinn's colleague William Glackens lived at 29 Washington Square from 1911 and had a studio at number 50, on the south side of the square;[10] like Shinn, he painted the square many times. The less elitist, more democratic outlook of these painters is evident even in the vantage point chosen for such depictions as Glackens's *Italo-American Celebration, Washington Square* (plate 48). As in Hassam's later Flag series, American and Italian flags identify a patriotic commemoration (in this case, of Columbus Day), but the viewpoint here is not along elegant Fifth Avenue but across the square from the more bohemian southern border, near Glackens's studio. The subject is a celebration favored by the "common folk," while his strong, earthy palette and rough brushwork reinforce his populist interpretation. The arch dominates the composition, with the leafy trees almost obliterating the fine old aristocratic dwellings.

69

Whereas it used to be that every author used to have a heroine on the north side of [Washington] Square, it has suddenly become the custom to write of the southern half, with its connection with Latin Quarter life, and with the tenement dwellers sweeping up from the southward against it.

Robert Shackleton, *The Book of New York* (Philadelphia: Penn Publishing Co., 1920), p. 360.

Union Square was set aside as a park in 1811 and named Union Place because it was the meeting point of Bloomingdale Road (now Broadway) and Bowery Road (Fourth Avenue).[11] The square had a brief period as a residential district during the 1840s and 1850s, home to such distinguished citizens as Cornelius Roosevelt and Anson Phelps, and sprinkled with a few churches and small hotels. But by 1860 commerce had begun to intrude, first in the form of more hotels, then followed by restaurants—the world-renowned Delmonico's was right off the square on Fourteenth Street (between Broadway and Fifth Avenue) until 1876[12]—piano makers, and jewelry retailers; Union Square also housed the studios of many artists, musicians, and theater people. By the time the Impressionist painters focused attention on the square in the 1890s, prosperity had left, and the luxury trade was in decline, with the exception of the jewelry business. Low-paying clothing-manufacturing companies took occupancy in new high-rise buildings that offered cheap rent; the district also attracted daily hordes of shoppers and commuters. John C. Van Dyke distinguished between the shoppers at Union Square and those up on Twenty-third Street at Madison Square:

> Fourteenth Street is always crowded with shoppers, and as they move by one seems to recognize factory girls, domestics, policemen's wives, janitors' daughters. . . . The older people are often dressed shabbily and look dingy in the face and hair; the younger ones are garbed flashily and cheaply. . . . The quickness of the Twenty-third Street people—people who look as though they never did any work and were in continual need of exercise—is absent.[13]

Such changes in the demographics of the area made its open spaces especially important. Childe Hassam's first New York studio was close to Union Square, and he interpreted the square in all seasons and all weathers, starting as early as 1890. His take on the square as a crossroads of great activity differed greatly from the measured elegance of his Washington Square pictures. The square appears rather calm through a veil of snow in *Winter in Union Square* (plate 49), probably painted in the winter of 1891–92. Snowstorms could, however, be quite perilous in the broad open space of the square, as Otto Stark had illustrated in 1888;[14] the hazards of blizzards appear to have been especially associated with Union Square, due in part to the death there of former Senator Roscoe Conkling after he lost his way during the great blizzard of 1888.

48. William Glackens (1870–1938). *Italo-American Celebration, Washington Square*, c. 1912. Oil on canvas, 26 x 32 in. (66 x 81.2 cm). Museum of Fine Arts, Boston; Emily L. Ainsley Fund.

Hassam painted this view from an elevated vantage point at Broadway and Seventeenth Street—perhaps an upper story of either the Decker Building (between Sixteenth and Seventeenth Streets) or the Hartford Building (at the corner of Seventeenth Street). This angle gave him both visual and psychological distance. Pedestrians, various kinds of horse-drawn cabs, and trolleys make their way through the snow along the diagonal crossing the northern part of the square.[15] In the left background, on Fourteenth Street, is Morton House, a hotel favored by a theatrical clientele. Across Broadway is Griffith Thomas's cast-iron Domestic Sewing Machine Building (1872), whose domed roof made it the most conspicuous building on the square; at the time of its completion, it was also New York's tallest commercial

49. Childe Hassam (1859–1935). *Winter in Union Square*, c. 1891–92. Oil on canvas, 18¼ x 18 in. (46.4 x 45.7 cm). The Metropolitan Museum of Art, New York; Gift of Miss Ethelyn McKinney, 1943, in memory of her brother, Glenn Ford McKinney.

building. Between them, shrouded in snow but still visible, is the spire of Grace Church, completed by James Renwick in 1847 at Broadway and Eleventh Street. Thus, Hassam identified several basic activities associated with life around the square: hostelry, commerce, and worship.

Both *Winter in Union Square* and *Union Square in Spring* (plate 50) were reproduced in Hassam's *Three Cities* (1899); by this time Hassam himself had left the area and moved to West Fifty-seventh Street. Prominently featured in *Union Square in Spring* is the cir-

50. Childe Hassam (1859–1935). *Union Square in Spring*, 1896. Oil on canvas, 21½ x 21 in. (54.6 x 53.3 cm). Smith College Museum of Art, Northampton, Massachusetts; Purchased 1905.

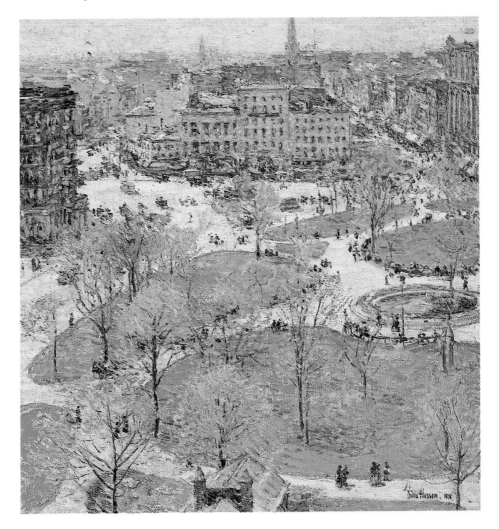

cular fountain, dedicated in 1842 and first operated as part of the Fourth of July opening of the Croton Reservoir, then located up at Forty-second Street and Fifth Avenue. The roof of a pretty cottage containing toilets for ladies and gentlemen is visible in the immediate foreground. Though the newly laid cable tracks are not clearly visible, several larger, brightly painted vehicles may signify the new cable cars that came into use during the summer of 1891.[16] The dangerous southwest corner of the square in front of Henry Kirke Brown's statue *Abraham Lincoln* (1868) was known as "Dead Man's Curve," due to the frequency of cable-car accidents.[17] But there is no sense of jeopardy suggested in Hassam's cheerful scene, just as he avoids any suggestion of the square as a gathering place for trade-union orators and firebrand reformers.

The park dominates the scene, and the largest building shown on the square, the Union Square Hotel at Fifteenth Street (at left), is in shadow. The vantage point is even higher than in *Winter in Union Square;* this time Hassam may have assumed a position high up in Everett House (1854), at Seventeenth Street and Fourth Avenue (the first hotel in the city to install electric lighting, in 1882); or even more likely, in the taller Century Building (1881), next to Everett House, and home to *Century Magazine,* which had employed Hassam to provide illustrations for its "Fifth Avenue" article in November 1893. (Hassam would have had easy access to the Century Building, for he was a good friend of both Richard Watson Gilder, editor of *Century Magazine,* and Alexander Drake, its art editor.)

Hassam obliterated with blooming trees the most imposing sculptural monument on the square, Henry Kirke Brown's equestrian statue of George Washington, dedicated in 1856—the city's first outdoor bronze. It had originally been placed just above the intersection of Fourth Avenue and Broadway (plate 51), to mark the spot where Washington met the people of New York when he reentered the city after the British evacuation on November 25, 1783; the sculpture was subsequently moved to the head of the square.

Hassam was not the only one of America's leading Impressionists to depict Union Square; Theodore Robinson painted *Union Square, New York* (1895; New Britain Museum of American Art, New Britain, Connecticut), which centers on Brown's statue. Though primarily a painter of rural figure subjects and landscapes, Robinson created at least three pictures of the square in the winters of 1894–96; another of the group is

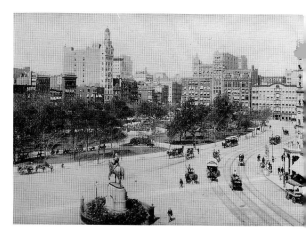

51. Union Square, from *Greater New York Illustrated,* 1898.

52. Theodore Robinson (1852–1896). *Union Square, Winter,* 1896. Oil on canvas, 18 x 22 in. (45.7 x 55.9 cm). Mr. and Mrs. Hugh Halff, Jr.

Union Square, Winter (plate 52). Unlike Hassam, Robinson moved into the square itself, looking out from ground level past empty park benches. A close-up of the lower portion of the Domestic Sewing Machine Building can be seen at the right, and again Grace Church rises in the distance. Robinson's picture is a more intimate and more personal view of Union Square than Hassam's, perhaps reflecting in its mood some nostalgia for the square's faded glory.

By the 1890s the carriage trade was moving from Union to Madison Square, later dubbed the city's "Place de la Concorde."[18] Artists such as Hassam and Robinson concentrated much of their artistic attention there. Indeed, while Hassam ostensibly covered all of Manhattan in the New York section of his *Three Cities,* most of his images were from Madison and Union Squares.

Madison was a relatively new square. The city did not acquire land for it until 1837; it took a few years to clear the squatters, and then the square was officially opened for promenading in 1844. The construction in 1853 of the Madison Square Presbyterian Church, at Madison Avenue and East Twenty-fourth Street, was the first sign that the district would become a magnet for fashionable residences, a process that

began three years later. Hotel development started at the same time on the west side of the square, with Amos Eno's Fifth Avenue Hotel (1859) constructed between Twenty-third and Twenty-fourth Streets; the hotel was then the most modern and luxurious in the city, with a fireplace in every room, private bathrooms, and the first passenger elevator in New York. It was followed by the Albemarle; Hoffman House (1864), famous for its art gallery; the Saint James Hotel; the Hotel Brunswick at Fifth Avenue and Twenty-sixth Street (opposite the north side of the square); the Bartholdi, built in the 1870s opposite the south side; and Madison House, on the east. Georges Sauvin, a French visitor to New York, noted in 1892 that Madison Square was the center of the city and that, while "the heart of the city is in Rome, a church, in London, a railway station, in Paris, the Opéra," it was "in New York, a group of hotels."[19]

For a while Madison Square was the center for the elite; one writer noted: "Fashion, Clubdom, Finance, Sport, Politics and Retail Trade all met here at high tide. It was said that one standing long enough on Fifth Avenue at 23rd Street might meet everybody in the world."[20] When the former Union Depot of the Vanderbilt family's New York and Harlem Railroad, an immense building occupying the block between Twenty-sixth and Twenty-seventh Streets and Madison and Fourth Avenues (opposite the northeast corner of the square), was abandoned in 1871, it was taken over by P. T. Barnum for his Roman Hippodrome. In 1879 the Vanderbilts reasserted control over the property and opened Madison Square Garden for boxing matches, athletic tournaments, and masked balls. A decade later it was replaced by Stanford White's great structure, the second Madison Square Garden, which opened in June 1890. This was the largest building devoted to amusements in the United States, housing a concert hall, an amphitheater, a theater, a roof garden, a restaurant, and shops; its three-hundred-foot (ninety-meter) tower, capped by Augustus Saint-Gaudens's weather-vane statue of a nude Diana, provided a panorama of the entire square.

The square also became a significant outdoor sculpture gallery, with Randolph Rogers's seated bronze of William H. Seward, installed at the southwest corner of the square in 1876; John Quincy Adams Ward's standing Roscoe Conkling in the southeast corner in 1893;[21] Augustus Saint-Gaudens's magnificent standing image of Admiral David Glasgow Farragut in the northwest corner in 1881; and George Bissell's 1898 standing bronze of President Chester Arthur, installed at the northeast entrance

[Madison Square] was much more a social centre than any like space in New York has ever been since or is likely ever to be again. . . . More dwellings of the highest respectability, and more clubs, on the east and north side of the square itself, and on the west side presently rose the most fashionable hotels in town, and on a northern corner there soon found shelter the most famous restaurant between Cape Horn and the north pole [Delmonico's].

E. S. Martin, "Moods of a City Square," *Harper's New Monthly Magazine* 115 (August 1907): 408.

53. *Madison Square*, from *King's Photographic Views of New York*, 1895.

at Twenty-sixth Street. In 1900 the Appellate Court Building, designed by James Brown Lord, was erected at Madison Avenue and Twenty-fifth Street; it was surmounted by statues of famous lawmakers by many leading American sculptors and decorated inside with the finest series of paintings by noted American muralists in New York City.

At the same time, the square was losing its residential status and succumbing to commerce. The first sign of this was the construction of Henry Janeway Hardenbergh's seven-story Western Union Building (1884) at the corner of Fifth Avenue and Twenty-third Street, across from the Fifth Avenue Hotel. In 1892 the Metropolitan Life Insurance Building went up opposite the southeast corner of the square, an eight-story structure designed by Napoleon LeBrun; it was joined in 1909 by a seven-hundred-foot (210-meter) tower—a replica of the Campanile of the Piazza San Marco in Venice and then the tallest building in the world. Meanwhile, the most pictorial of all of New York's edifices was constructed in 1902, opposite the southwest corner of the square: Daniel Burnham's Fuller Building, soon to become known as the Flatiron Building.

Some painters—such as Paul Cornoyer, a specialist in New York imagery—believed that Madison Square was the city's most beautiful spot.[22] Childe Hassam might well have agreed with Cornoyer, judging by the multiple images he painted of the square in nearly all seasons.[23] Hassam was painting Madison Square as early as 1892, when he gave A. E. Ives an extensive interview concerning the painting of street scenes. His comments centered on a springtime picture of the square, looking north along the park, which he painted from the second-story window at Dunlap's, about fifteen feet (4.5 meters) from the ground. He noted that he chose such elevated positions in order to sketch groups from a distance; when choosing to depict scenes at street level, he often painted from inside cabs.[24] One of Hassam's most frequent subjects, in fact, was the cab rank along Madison Square opposite the Fifth Avenue Hotel, which catered to the enormous hotel trade in the area.

In *Madison Square—Snowstorm* (plate 54), Hassam depicted the Seward statue at left, with the great soaring tower of Madison Square Garden behind; it reigns over the homes and the square as an almost spectral image. The square here assumes very human proportions, with its east side still dominated by private homes—the most

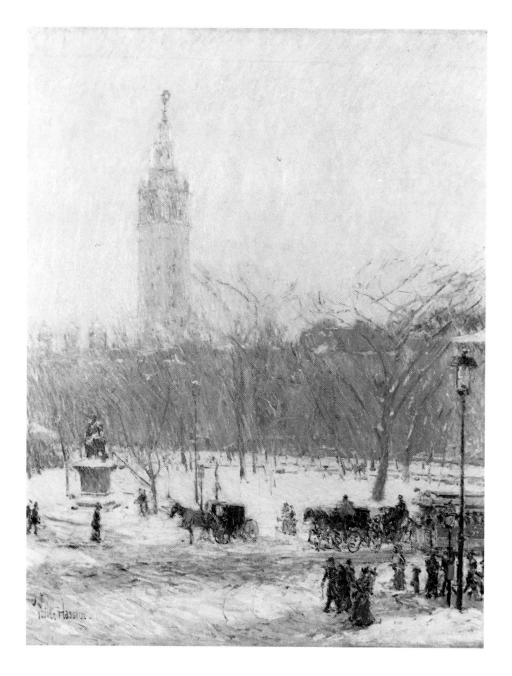

Here [Madison Square] you will be happiest in winter, for then a carpet of snow may give a key-note of color repeated in the white fronts of certain big shops, and again in the clouds. . . . This is not a beautiful view, but it is a picturesque one, and picturesque in a bold, careless, showy way quite characteristic of New York.

Mariana G. Van Rensselaer, "Picturesque New York," *Century Magazine* 45 (December 1892): 170.

LEFT
54. Childe Hassam (1859–1935). *Madison Square—Snowstorm*, 1893. Oil on canvas, 20¼ x 16⅛ in. (51.4 x 40.9 cm). Peabody Institute of the Johns Hopkins University, Baltimore.

OPPOSITE
55. Paul Cornoyer (1864–1923). *Rainy Day, Madison Square, New York*, c. 1907–8. Oil on canvas, 22¼ x 27¼ in. (56.5 x 69.2 cm). Private collection.

northern and grandest of which, across from Madison Square Garden, was the Leonard W. Jerome mansion, built in 1859 by John B. Snook. This was where Winston Churchill's mother spent several childhood years; at the time Hassam painted the square, the mansion was on lease to the University Club.[25] Hassam's viewpoint seems to be approximately from the site that would become the Flatiron Building and that had previously been occupied by the two-story Erie Railroad Office.

Theodore Robinson's one published illustration of New York was of Madison Square.[26] Whereas he and Hassam were depicting the square when it was still a fashionable district, Paul Cornoyer and Edmund W. Greacen continued to paint the area after it had become totally commercial. Both these painters preferred soft, hazy, romantic interpretations of the city, combining Tonalist and Impressionist strategies. In Cornoyer's *Rainy Day, Madison Square, New York* (plate 55) the gray light following a rainstorm introduces a poetic atmosphere but does not obscure the hotels on Broadway—the Albemarle at far left and Hoffman House, undergoing reconstruction, next door (this is the original, 1864 hotel; the eight-story Hoffman House addition at the corner of Twenty-fifth Street was built in 1887).

In 1914 Greacen, too, painted the square at various seasons; in *Madison Square* (plate 56) he used the Rogers statue of Seward as a touchstone.[27] His vantage point is rather directly to the west, probably in front of the former Fifth Avenue Hotel (destroyed 1908). The greensward of the park is only a minor note in Greacen's canvas, which focuses instead on the tall skyscrapers hemming in the square and on their counterpoint in the exaggeratedly tall lampposts, under which a throng of people circulate. In the left rear is featured the grandest of the great buildings, the Metropolitan Life Insurance Building, its summit cut off by the atypically square shape of the canvas.

Pictorially, the square's greatest moment came in 1899, with the celebration of Admiral George Dewey's triumphal return from the Philippines after having destroyed the Spanish fleet in Manila Bay on May 1, 1898, during the Spanish-American War. In Madison Square, at Fifth Avenue and Twenty-fourth Street, a great, though only temporary, triumphal arch was constructed of staff (plaster reinforced with hay or burlap filler); colonnades extended from it north and south for one block in each direction.[28] Using the Arch of Titus in Rome (and eventually the Arc de Triomphe in Paris) as a

56. Edmund W. Greacen (1877–1949). *Madison Square*, 1914. Oil on canvas, 30 x 30 in. (76.2 x 76.2 cm). Elizabeth Greacen Knudsen and Donald Knudsen.

model, the architect Charles R. Lamb designed Dewey Arch; its sculptural decoration, sponsored by the National Sculpture Society, was under the direction of Frederic Wellington Ruckstuhl. The arch was constructed between July 29 and late September, in time for the series of parades on Fifth Avenue, held from September 27 to 30. Ironically, on September 30 Dewey himself disembarked at the reviewing stand on the north side of the arch and thus never passed beneath it. Nevertheless, the positioning of the Dewey Arch at Madison Square made for a triumphal corridor between Washington and Madison Squares.[29]

The Dewey Arch, though temporary, was a gleaming symbol of America's might and of its imperialist conquests; the celebration and the monument brought forth the talent of artists both national and foreign. Childe Hassam and the French artist Jean-François Raffaëlli painted similar views of the arch—Raffaëlli in 1899 (plate 58) and Hassam in 1900 (plate 59). Both show the arch up front in all its splendor, with the triumphant parade alley marked by tall columns. The arch is capped by John Quincy Adams Ward's twenty-foot (six-meter) *Victory* aloft in her chariot, silhouetted against the sky and asserting her own triumph atop the Dewey Arch. On the southern face of the arch, Charles Niehaus's *Triumph* group is at left and Karl Bitter's *Battle* group at right. In the foreground are the sculptures on the south colonnade: Ruckstuhl's *Army* at right and George Bissell's *Navy* at left; the latter is cut off from view in Hassam's rendering. Beyond the arch at left in both plates 58 and 59 can be seen the Madison Square Bank Building at 202 Fifth Avenue (home to the New York Club until 1887, when the club moved up the avenue to Thirty-fifth Street).

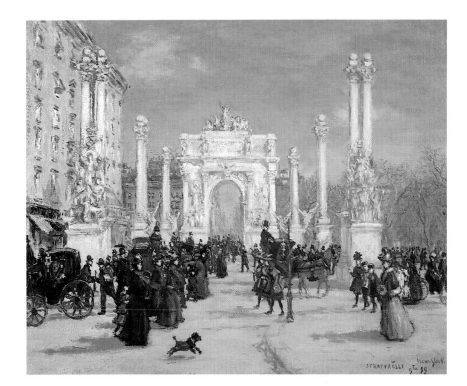

58. Jean-François Raffaëlli (1850–1924). *Dewey's Arch, New York*, 1899. Oil on canvas, 25½ x 32 in. (64.8 x 81.3 cm). Berry-Hill Galleries, New York.

59. Childe Hassam (1859–1935). *Dewey's Arch*, 1900. Gouache and watercolor on paper, 18 x 22 in. (45.7 x 55.9 cm). Private collection.

Raffaëlli's picture shows the facade of the Fifth Avenue Hotel at the left, with the darkly clad figures, carriages, and even a dog more prominent than in Hassam's view; this is consistent with Raffaëlli's reputation as a naturalist painter of modern mores. Raffaëlli associated with the French Impressionists and yet was admired for what appeared a more acceptable, more traditional approach to modern-life subjects. He enjoyed a great reputation in America as well as Europe and made several successful visits to America, the first in 1894.[30] On his second trip, in 1899, he served as a juror at the Carnegie International Exhibition in Pittsburgh; at the time, he discussed painting *Dewey's Arch, New York:* "When once more I reached the shores of America, I gazed about me, with the same intense interest with which I had been inspired on my first visit. Arriving in New York, I had the opportunity to behold your beautiful arch of triumph, and to perceive the great advance made in decorative effect throughout your big city."[31]

Everett Shinn, a younger artist, who was dubbed "an American Raffaëlli" in the New York press, was less impressed by the majesty and message of the celebration.[32] Taking a very different approach in his several known depictions of the Dewey Arch, he emphasized the diverse weather conditions of the square and their effect on those frequenting the park, with the arch only in the background. Shinn was a young Philadelphia newspaper artist who had moved to New York in 1897, working for the *New York World.* In his 1899 *Madison Square and Dewey Arch* (plate 60)—a pastel, gouache, and watercolor that was published in *Scribner's Magazine* the following year[33]—the arch is partially hidden by trees and seen only laterally. Attention is focused on a woman dragging a protesting child through the sunlit park in front of a group of men packed onto the park benches reading their newspapers. His pastel *Dewey Arch, Madison Square* (Christie's, December 6, 1991, no. 172) features the arch across the background, but here too it is the genre interests that come into primary play. The picture reflects the autumnal season of rain and high winds as men, women, and children attempt to make their way across Broadway at the square. In both works the glorious arch appears to be receding into the distance, as it was in the consciousness of contemporary New Yorkers.

The Impressionist painters paid less attention to the other major Manhattan crossroads. Colin Campbell Cooper painted a spectacular image of Columbus Circle (plate

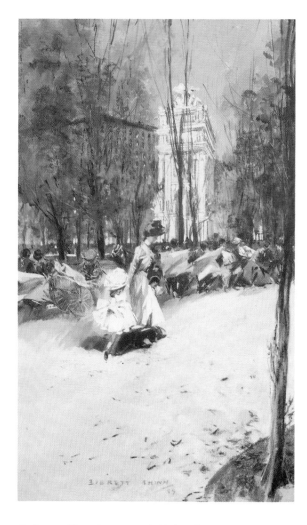

60. Everett Shinn (1873–1953). *Madison Square and Dewey Arch,* 1899. Pastel, gouache, and watercolor on board, 29¼ x 18¼ in. (74.2 x 46.3 cm). Courtesy Sotheby's, Inc., New York.

61) in 1909;[34] he had taken a space in the Gainsborough Studio Building on Central Park South just the year before, very near the circle. Nor was Cooper alone in his attraction to Columbus Circle; in 1911 his colleague Jules Guerin also found the circle one of his favorite sites in the city: "I call it the Place Pigalle of New York, because to me it bears a close resemblance to the beautiful square of that name in Paris."[35]

The intersection of Broadway and Eighth Avenue remained rural until well into the second half of the nineteenth century. In 1867 the Central Park Commission acquired control of it and planned a circle, originally called Grand Circle; it was not named Columbus Circle until 1892, when it was designed to match in magnificence the Grand Army Plaza, at the other end of Central Park South. Gradually Columbus Circle became a meeting point of eight elevated railroads and surface lines of public transportation. In the years just before Cooper painted his view, the circle had been the subject of extensive plans for improvement, particularly in the routing of the trolley lines. Cooper's view, taken from on high, looks down into the sun-filled well created by the varied buildings, with Fifty-ninth Street rising up through the center of the composition and Broadway trailing off to the right. Featured at the center of the circle is the monumental shaft surmounted by Gaetano Russo's statue of Christopher Columbus, a gift from America's Italian residents in 1892 to commemorate the four-hundredth anniversary of Columbus's discovery. It also celebrates the origins of American expansionism in a decade that would culminate with the Spanish-American War and the celebration for Admiral Dewey farther down Broadway.[36]

As in many of his other panoramic views painted throughout the city, Cooper delighted in the variety of sizes, shapes, and roof lines of the city's buildings, made more picturesque by his manipulation of shadow patterns among them. The diversity of visual images here seems to reflect the diversity of the district, described by one contemporary cultural historian as "the peculiar conflict of incompatible neighborhoods."[37] The most prominent building in the distance is the two-towered gray stone Church of Saint Paul the Apostle (known also as the Church of the Paulist Fathers), at Ninth Avenue and Fifty-ninth Street; built in 1876–85, it was second only to Saint Patrick's Cathedral in size and magnificence. In counterpoint, Cooper also focused on the famed Majestic Theatre (the building at the left with the corner dome), which was owned by William Randolph Hearst. It had opened in 1902 with the musical extrava-

ganza *The Wizard of Oz*; the following year Victor Herbert's *Babes in Toyland* premiered there.[38] Cooper's view toward the west, with the Hudson River and the New Jersey Palisades beyond, deliberately leaves out the corner of Central Park, which reaches the circle at its northeast intersection—the only border not visible here. Very likely this omission was partly due to Cooper's decision to concentrate on the urban compactness of the area and partly to what he could actually see from the convenient viewpoint of his studio building roof or one nearby.

61. Colin Campbell Cooper (1856–1937). *Columbus Circle*, 1909. Oil on canvas, 26 x 36 in. (66 x 91.4 cm). Allentown Art Museum, Allentown, Pennsylvania; Gift of J. I. and Anna Rodale, 1961.

62. David Milne (1882–1953). *Maine Monument,* 1914. Oil on canvas, 20¼ x 22¼ in. (51.4 x 56.5 cm). Thomson Works of Art Limited, Toronto.

The Majestic Theatre also appears at the rear, left, in *Maine Monument* (plate 62), a magnificent rendition of Columbus Circle by David Milne. Perhaps the most outstanding Canadian Post-Impressionist painter, Milne grew up in Paisley, Ontario, and in 1903 settled in New York City, where he reached artistic maturity by 1911. During the next five years Milne explored and recorded many facets of New York, from the waterfront to Fifth Avenue. In Manhattan his attention was drawn particularly to Columbus Circle.[39] In the bright colors, patterned forms, and flattened space of Milne's Post-Impressionist aesthetic, he captured the excitement of Columbus Circle from a point of view radically different from Cooper's. Typically avoiding the plunging

canyons of the city's streets, Milne's vantage point is at street level, in front of, and looking away from, the entrance to Central Park, with figures and automobiles interspersed before the theater and around the Columbus monument. Somewhat ironically, given Spain's sponsorship of Columbus's voyages, Milne concentrated on the other sculpture at the circle—Attilio Piccirilli and H. Van Buren Magonigle's Spanish-American War memorial, the Maine Monument Fountain, which was erected in 1911–12 to commemorate those who lost their lives in the explosion in Havana Harbor in 1898.

Artists occasionally investigated the city's other squares, those not along the course of the great avenues. One such depiction was Ernest Lawson's *Stuyvesant Square in Winter* (plate 63). Perhaps the most orthodox Impressionist among the Eight, Lawson is best known for his views made in the more northern reaches of Manhattan and on the shorelines across from the island in the Bronx and New Jersey, but he also investigated various districts in the lower part of Manhattan. Stuyvesant Square, on Second Avenue between Fifteenth and Seventeenth Streets, was designed by Peter Stuyvesant in 1836 as a private park, which he intended to establish as a center for the upper echelon of New York society. Ten years later the *Evening Post* named Second and Fifth Avenues "the two great avenues for elegant residence,"[40] but land prices became so prohibitive that Fifth Avenue developed alone as the fashionable residential district. Shortly before the Civil War the area around Stuyvesant Square began to fill up with the immigrant poor, and many of the fine homes in the area became boardinghouses. The square became a backwater. It remained that way, and that was its charm. Harrison Rhodes wrote in 1909, "In Stuyvesant Square, St. George's has already the air of antiquity, and the Quaker church and school—red brick and white, and dating only to the forties—have the serenity and peace of buildings in a cathedral close." And he told of an elderly lady of an old family—a friend of the novelist William Makepeace Thackeray when he visited New York in the 1850s—who still lived on the square and daily traveled in her "high-swung old barouche."[41]

In keeping with the cultural preferences of the Eight, Lawson has chosen here a neighborhood that was aristocratic in character but frequented by East Side tenement dwellers. He captured the square's spirit of nostalgia and antiquity, focusing on Saint George's Church at East Sixteenth Street, erected in 1845, and the Friends' Meeting

Grand old trees, some of them among the oldest triumphs of urban forestry, flourish here, and under their abundant shade swarms of children disport themselves. They are not the children of Gramercy Park, a few blocks away, surrounded by a high fence and open only to key-holders; but, though not so well dressed, more mothers come with them than nurses, and the babies are far more numerous and play just as heartily as if they were not locked in or had not locked some one else out.

"The Spectator," *Outlook* 9
(September 12, 1908): 65–66.

House and Seminary next to it, both on the west side of the square. It was an area that projected the harmony of the two very different sects, which had coexisted there for many years, influencing one another.[42]

Lawson chose to emphasize the old New York that was now frequented by the underclass; equally telling is his avoidance of the modern New-York Infirmary for Women and Children, a new structure on the square's east side. It is winter evening in his painting and no babies are playing in the park, but in a compositional format typical of Lawson, the two contrasting centers of worship spread out before the square, offering stability and peace to the pedestrians wending their way home through the snow.

63. Ernest Lawson (1873–1939). *Stuyvesant Square in Winter*, n.d. Oil on canvas, 25⅛ x 30⅛ in. (63.7 x 76.4 cm). Telfair Academy of Arts and Sciences, Savannah, Georgia; Museum Purchase, 1907.

LOWER MANHATTAN

Lower Manhattan has had its own history and dynamics, separate from the long stretch of the island north of Washington Square.[1] The area has been given various boundaries; "lower Manhattan" could mean the territory south of Eighth Street or even south of Madison Square. All would have agreed with John Gilmer Speed in 1892 that "the down-town of New York is that part of the city usually given up to business."[2] By the end of the nineteenth century what had been the financial and business center of New York City had become the financial capital of America. At the same time immigrants were being routed through this area, and parts of lower Manhattan, especially the Lower East Side, became home to crowds of the impoverished newcomers.

Impressionist artists shunned the latter subject, choosing instead to depict the distinctive skyline of lower Manhattan. This was pictured by painters, illustrators, and photographers both from the Battery shoreline at the tip of Manhattan and from the north. Colin Campbell Cooper, in his *Mountains of Manhattan* (plate 65), chose a vantage point above the low-lying smoking roofs on the east side of mid-Manhattan, looking south and allowing for the slightly spectral rise up to the heavens of the light-toned skyscraper "mountains." The loftiest peak is the Singer Building, at Broadway and Liberty Street.

The Singer Building is also featured in Edward Redfield's *Between Daylight and Darkness* (plate 14), one of a series of monumental canvases that this Pennsylvania Impressionist painted during a six-month stay in New York City in 1909. Fascinated by the city at night, with the glow of thousands of lights against the dark sky and

64. Detail of Edward Redfield, *Lower New York*, c. 1910. See plate 66.

shrouded buildings, Redfield created enormous Whistlerian nocturnes of great modernity. Not all of them featured the soaring vertical structures, however; in *Lower New York* (plate 66), Redfield revealed the immense urban sprawl across the lower part of the island, featuring electric signs as well as interior and street illumination.

Other painters, such as Everett Longley Warner, relished the picturesqueness of low, aging buildings presented in tandem with the new skyscrapers. In his *"Manhattan Contrasts," N.Y.C.* (plate 67) four old nineteenth-century houses on West Street near the Hudson River waterfront (the Glen Island Hotel is the corner building at Cortlandt Street) are contrasted with the great Neo-Gothic skyscraper, the Woolworth Building, rising to the northeast.[3]

In addition to the panoramic views of the lower Manhattan skyline, two areas especially appealed to Impressionist artists: the Battery and Wall Street. The Battery was the oldest section of the city, the site of the original Dutch settlement. It was named for the battery of cannon mounted along the waterfront during the 1680s. In the early nineteenth century the Battery was the location of New York's most fashionable residences, and the area was gradually extended by landfill and shaped into a

Down-town New York—it is a big place! Big and vastly varied, but with a certain homogeneity of its own.

Viola Roseboro, "Down-town New York," *Cosmopolitan* I (June 1886): 217.

65. Colin Campbell Cooper (1856–1937). *Mountains of Manhattan*, n.d. Oil on canvas, 42 x 68 in. (106.7 x 172.7 cm). The City of Santa Barbara; Gift of the Artist.

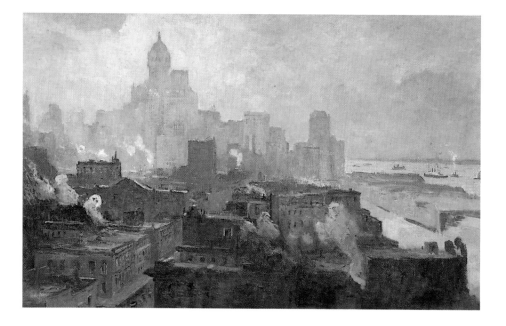

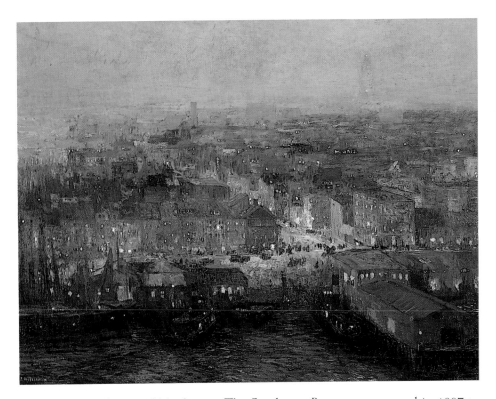

66. Edward Redfield (1869–1965). *Lower New York*, c. 1910. Oil on canvas, 38 x 51 in. (98.5 x 129.5 cm). CIGNA Museum and Art Collection, Philadelphia.

The Elevated is here not without redeeming features. The high-perched twin structures of the Battery station, for instance, are uncommonly picturesque, and seen from the station platforms in the summer the tracks curving from view amidst the trees have a pleasing sylvan suggestion.

Sylvester Baxter, "The New New York," *Outlook* 83 (June 23, 1906): 416.

curved park at the tip of Manhattan. The Southwest Battery was opened in 1807 to guard against potential enemy attack; eight years later it was renamed Castle Clinton in honor of Mayor DeWitt Clinton. The guns were dismantled in 1823 and the "castle" was leased the following year as Castle Garden for public entertainment; in 1855 the building became the immigrant landing station and remained so until the Ellis Island depot was opened in 1892.[4]

None of the unfashionable immigrants emerge in Willard Metcalf's *Battery Park, Spring* (plate 69). Metcalf chose to paint a park scene, though he acknowledged and even glorified the presence of modernity in the elevated train that crosses the composition at lower left. This is a rare excursion into urban subject matter by an artist who devoted most of his career to the rural, especially New England, landscape. Metcalf was scrupulous in detailing the situation of the moment: a great many passengers await the elevated train seen approaching in a westward direction, whereas only one passenger appears on the opposite platform, presumably because an eastbound train had recently departed. Both the station and the train are absorbed into the contemporary urban landscape and bathed in the rich spring sunlight.

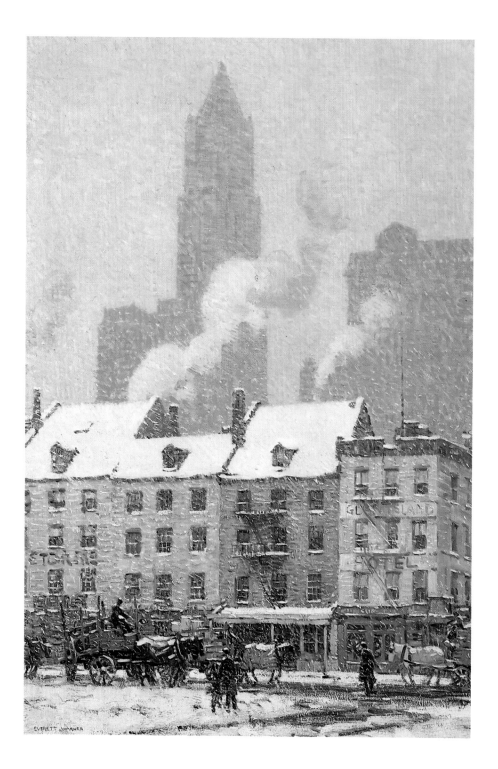

67. Everett Longley Warner (1877–1963).
"Manhattan Contrasts," N.Y.C., c. 1917. Oil on
canvas, 56 x 38 in. (142.2 x 96.5 cm). The New-
York Historical Society.

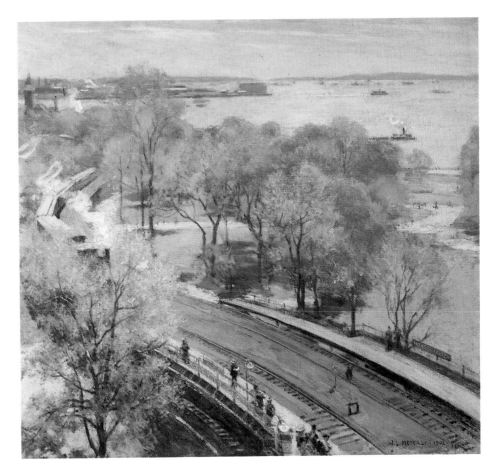

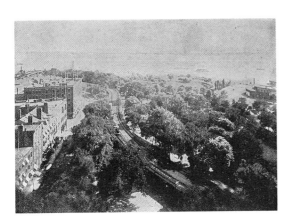

68. *Battery Park and Castle Garden,* from *King's Photographic Views of New York,* 1895.

69. Willard Metcalf (1858–1925). *Battery Park, Spring,* 1902. Oil on canvas, 25½ x 28½ in. (64.8 x 72.4 cm). Nancy Benson, Colorado.

Metcalf's painting appears to echo the sentiments of Richard Harding Davis: "The Battery . . . is the one place where the New Yorker can put the city behind him, can turn his back on its close hot streets, its blazing shop fronts, and his tenement or his second floor back."[5] In the middle distance of this placid scene is the circular Castle Williams on Governors Island, built by Lieutenant Colonel Jonathan Williams in 1811 to defend the harbor. Castle Garden, which became the New York Aquarium in 1896, would be just off to the right, beyond the edge of the painting. Metcalf's viewpoint quite deliberately excludes the tall commercial buildings in the area, though one is implied, of course, by his own position looking down on the station and the treetops, from the lofty Washington Building at 1 Broadway. A few years earlier a similar position had been taken on the Washington Building for the photograph *Battery Park and Castle Garden* (plate 68).[6] The most distinctive building in

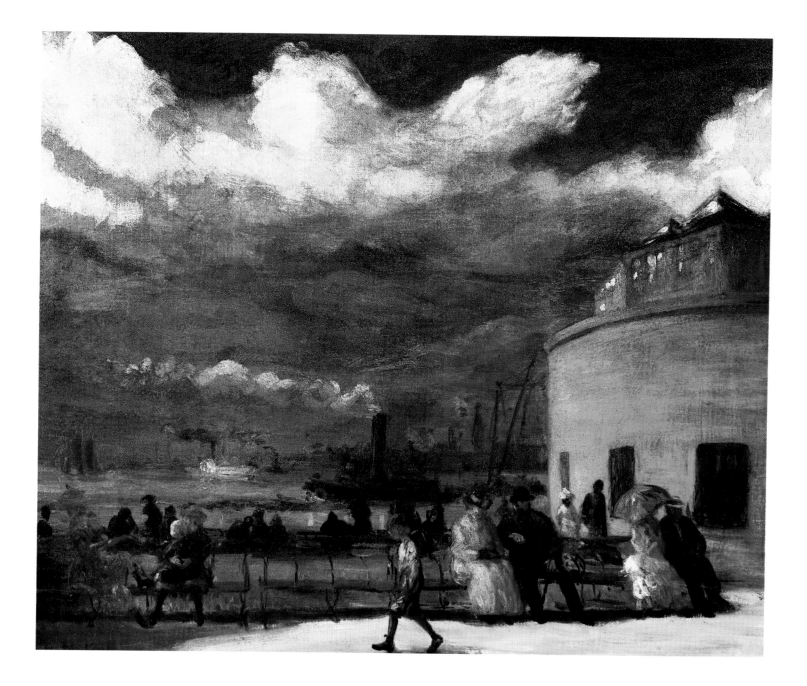

Metcalf's picture, the turreted United States Barge Office, with its customs inspectors and sailors' dispensary, is situated at the extreme left in the distance, almost disappearing from view.

At much the same time, c. 1902–4, William Glackens painted a very different view of the Battery (plate 70). As in the work of many of his future colleagues among the Eight, Glackens concentrated on the genre activity in the foreground—couples seated on park benches in front of the Aquarium and a schoolboy trudging along a park path—contrasting these with the vivid natural effects in the sky and with the active tugs, ferries, and even a ghostly sailing ship plying the harbor at left. As in the Metcalf painting, the city itself, with its tall buildings, has been eliminated.

Metcalf and Glackens presented the Battery as a pleasure zone, seemingly denying the almost totally commercial character of the tip of Manhattan. No such reinterpretation took place in the artistic assessment of Wall Street, the nation's financial capital. The view up Broad Street, looking toward Wall Street—a vista with a variety of architectural styles, accentuated by the new Stock Exchange—was probably the most replicated urban image in early twentieth-century America (plate 71). Painters such as Cooper and Hassam, printmakers such as Joseph Pennell, and photographers such as Alvin Langdon Coburn (see plate 72) were among the many who depicted this scene, which also appeared frequently in books and articles on the Stock Exchange and the New York financial world (plate 73).

Wall Street's name was derived from the city wall built by the Dutch in 1653 at the northern limit of New Amsterdam as protection against English invasion. Immediately after the American Revolution, Wall Street was the fashionable center of the city. The city's premier ecclesiastical structure, Trinity Church (on Broadway facing Wall Street), gave the dominant character to the area in its early days; the present Gothic Revival structure, the third to be erected on that site, was designed by Richard Upjohn and completed in 1846. An enduring icon of the region's past, the church remained a focus for many early twentieth-century artists, including Colin Campbell Cooper and, a bit later, John Marin, who depicted it many times.

By the end of the nineteenth century Wall Street represented the financial supremacy of America. Though it was often considered synonymous with the Stock

Many years ago . . . the Battery was the fashionable promenade. But as the town grew and fashion moved north with it, the Battery was left to the unfashionables, and to-day the Four Hundred know it only as the place where emigrants loiter before they become policemen, or begin cutting each other with poniards in Mulberry Street.

Richard Harding Davis, "A Summer Night on the Battery," *Harper's Weekly*, August 2, 1890, p. 594.

70. William Glackens (1870–1938). *Battery Park,* c. 1902–4. Oil on canvas, 26 x 32 in. (66 x 81.3 cm). Mr. and Mrs. Alan D. Levy, Los Angeles.

Exchange, as it is today, it also was a center for the banking industry. Trading had begun on Wall Street by 1792, when twenty-four brokers signed an agreement under a buttonwood tree fronting on 70 Wall Street; trading soon moved into the Tontine Coffee House at the corner of Wall and Water Streets, and in 1817 the New York Stock and Exchange Board was founded there. In 1842 Isaiah Rogers built a new Merchants' Exchange, with an Ionic colonnade and an eighty-foot (24.4 meter) dome, on the block bounded by Wall, Hanover, and William Streets and Exchange Place; in 1863 it became the Custom House and eventually was acquired by First National City Bank, in 1899. Also in 1863 the Stock and Exchange Board became known as the New York Stock Exchange, and two years later it acquired a permanent home and address

Breathing and embodying every development of the life of this rushing, whirling, electrical age, the new home of the New York Stock Exchange has a distinct personality. In outer contour it suggests monumental architecture of the ancient Greeks. But this exterior shelters the very essence of the strenuous energy of the twentieth century.

Ivy Lee, "The New Centre of American Finance," *World's Work* 5 (November 1902): 2772

73. Herman A. Webster (1878–after 1962). *Broad Street, Looking North to Wall Street*, from "Down Town in New York," *Century*, September 1913.

at 10 and 12 Broad Street, subsequently enlarged and altered. The present Stock Exchange there, which appears in the many images of the area, was designed by George B. Post, with pedimental sculpture designed by John Quincy Adams Ward; it was completed in 1903, with a sophisticated phone and paging system and a board-room connected with pneumatic tubes for message delivery. Constructed in traditional classical mode, with a colonnade of six Corinthian columns, fifty-two feet (sixteen meters) high, it was meant to project majesty, security, and permanence.

No artist was more enthralled by this site than Colin Campbell Cooper: "Broad Street above Beaver Street I consider one of the grandest things ever concocted by man. Nothing anywhere else approaches it. It has a very handsome skyline, a perfect

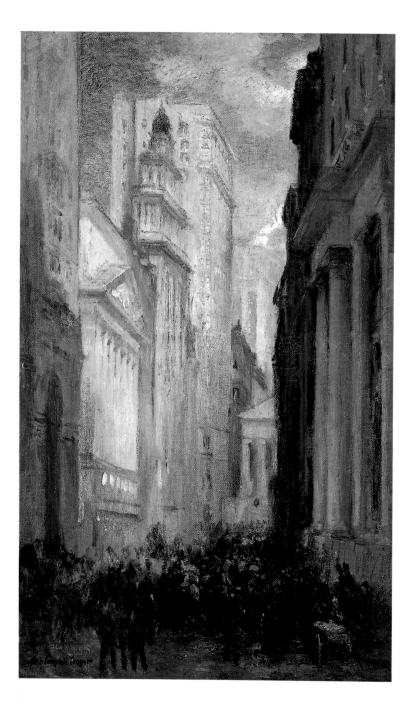

74. Colin Campbell Cooper (1856–1937). *Wall Street,* c. 1905. Oil on canvas, 29 x 18 in. (73.7 x 45.7 cm). The Colin Campbell Cooper Collection/S. Henderson.

75. Joseph Pennell (1857–1926). *The Stock Exchange,* 1904. Etching, 11¾ x 8⅜ in. (30.1 x 21.3 cm). Prints and Photographs Division, Library of Congress, Washington, D.C.

balance. It was one of the very first things I painted after arriving in New York." He went on to describe his course of action:

> I took a vacant room at 60 Broad Street, from the windows of which I could get an excellent view northward along Broad Street, and at once set to work to paint. And while I was in my upstairs room busily at work, another lover of the modern American skyscraper, Mr. Joseph Pennell, was seated on the stoop of the same building sketching the same view which had so strongly appealed to me. One of the points that most strikes me about this view up Broad Street is the dramatic contrast between the old, low type of buildings put up in the 50s—both the brick buildings and those of the type occupied by J. P. Morgan & Co. [the Drexel Building]—and the great skyscrapers. My pictures are built on these contrasts.[7]

A more likely candidate for Cooper's perch (60 Broad Street is so far south that he could not have seen the Subtreasury Building from it) is the eight-story Edison Building, which housed the General Electric Company of New York; it was at 44 Broad Street and just above the first building at the bend of Broad Street, thus allowing for a view down to the Subtreasury Building.

In Cooper's archetypical *Broad Street, New York* (1904; location unknown) the Stock Exchange itself is seen only laterally among the tall buildings. The view focuses on the Subtreasury Building (1842), constructed as the Custom House by Ithiel Town and Alexander Jackson Davis; it occupies the site of Federal Hall, the former seat of government, where George Washington was inaugurated. Thus, associations are abundant in the scene, offering the contrasts, both architectural and historical, to which Cooper referred. *Broad Street, New York* (also referred to as *Broad Street Cañon, New York*) is known today by many reproductions and also by *Wall Street* (plate 74), a lovely oil study for it. The now unlocated oil was one of Cooper's most acclaimed New York scenes; the watercolor version won the William T. Evans Prize at the 1903 annual of the American Water Color Society.[8] After much celebration the oil was acquired by the Cincinnati Art Museum in 1906 and was reproduced by A. W. Elson and Company in a facsimile edition of 250 impressions; it was deaccessioned by the museum in 1945.

Pennell's 1904 etching, *The Stock Exchange* (plate 75), is indeed taken from a vantage point similar to that in Cooper's painting, but from ground level. It is one of a

In these buildings, the face of America is concentrated. To erect donjons of 25 stories to superimpose business offices therein, to exalt above the city the omnipotence of money as the tower of the feudal castle was exalted of yore above the surrounding country—what exact and happy symbolism is this! Our ignorance has fondly maintained, hitherto, that the Yankee possesses no personal art. Here is the refutation.

Paul Adam, in "Pennell's Masterly Etchings of the American Scene," *Current Literature* 47 (September 1909): 287.

number of views created in the vicinity of Wall Street by this most famous of urban printmakers. *The Stock Exchange* is one of several views of New York that year in which Pennell amplified the canyon effect created by tall buildings lining both sides of narrow streets.[9] From his worm's-eye viewpoint, the city towers even more spectacularly in Pennell's prints than in the oils by Cooper and Hassam, embodying the city's energy and amplifying his celebration of the New New York.

In *Lower Manhattan* (plate 76, also known as *Broad and Wall Streets*) Hassam chose a viewpoint almost identical to those used by Cooper and Pennell three years earlier, though he moved closer to the Stock Exchange and Wall Street. This is a New York very different from the sedate, genteel images that Hassam had painted a decade and a half earlier at Washington Square or even those he had made in Union and Madison Squares during the 1890s. Here Hassam has taken a position on a level with the Stock Exchange colonnade, above the street but still below most of the tall buildings, and the sense of vertical rise is abetted by the extreme verticality of his canvas. In front of the Stock Exchange at the left is the narrow, twenty-one-story Commercial Cable Building (1897), designed by Harding and Gooch; beyond it is the ornate Gillender Building (1901) with a cupola and then the tall Hanover Bank Building (1904); and across Broad Street is the long facade of the eleven-story Mills Building, completed in 1883 by George B. Post. The skyscraper perspective suggests the modernity of the city, while the mass of traders on the street captures the frenzy of the negotiations of the Curb Market (brokers without a place on the Stock Exchange), a phenomenon that continued outdoors until 1921. The spirited activity calls to mind the comments made by Sir Philip Gibbs on a visit to the Curb Market in 1919, when the clamorous bidding of brokers in front of one narrow building reminded him of a madhouse: "It was a lively day in Wall Street, and I thanked God that my fate had not led me into such a life."[10]

When Hassam's picture was exhibited in the Eleventh Annual Exhibition of the Ten American Painters, held at the Montross Gallery in New York in March 1908, critics seized upon its identification with high finance. One identified the painting as "the cañon about which men pile up dollars or capitalize their conversation, as seen by the impressionist."[11] Another commented: "The painter has given an impression of the asphaltic Eldorado. A slight mist obscures the features of the amateur golden fleece hunters. We cannot recognize any of the magnates of our acquaintance, but we do feel

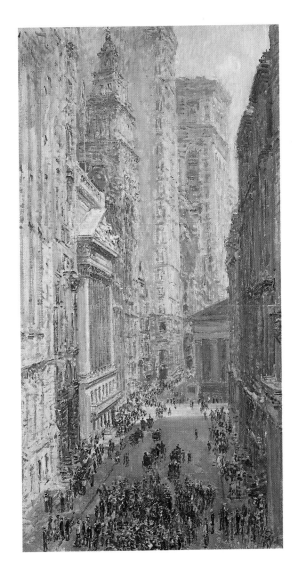

76. Childe Hassam (1859–1935). *Lower Manhattan (Broad and Wall Streets)*, 1907. Oil on canvas, 30⅛ x 16 in. (76.5 x 40.6 cm). Herbert F. Johnson Museum of Art, Cornell University, Ithaca, New York; Gift of Leonard K. Elmhirst, Collection of Willard Straight Hall.

the soul of the quarter."[12] The painter-critic Arthur Hoeber noted that Hassam had "wandered down with the bulls and the bears, to the domains of frenzied finance."[13]

Wall Street continued to offer inspiration even to more modern artists in the present century. John Marin's several 1924 watercolors entitled *New York Stock Exchange* (Mr. and Mrs. Herbert Hain; the Williams Companies, Tulsa, Oklahoma), with their strong diagonals and fragmented buildings towering over frenzied figures, are imbued with an energy and optimism not at all inappropriate to the financial center of the world.

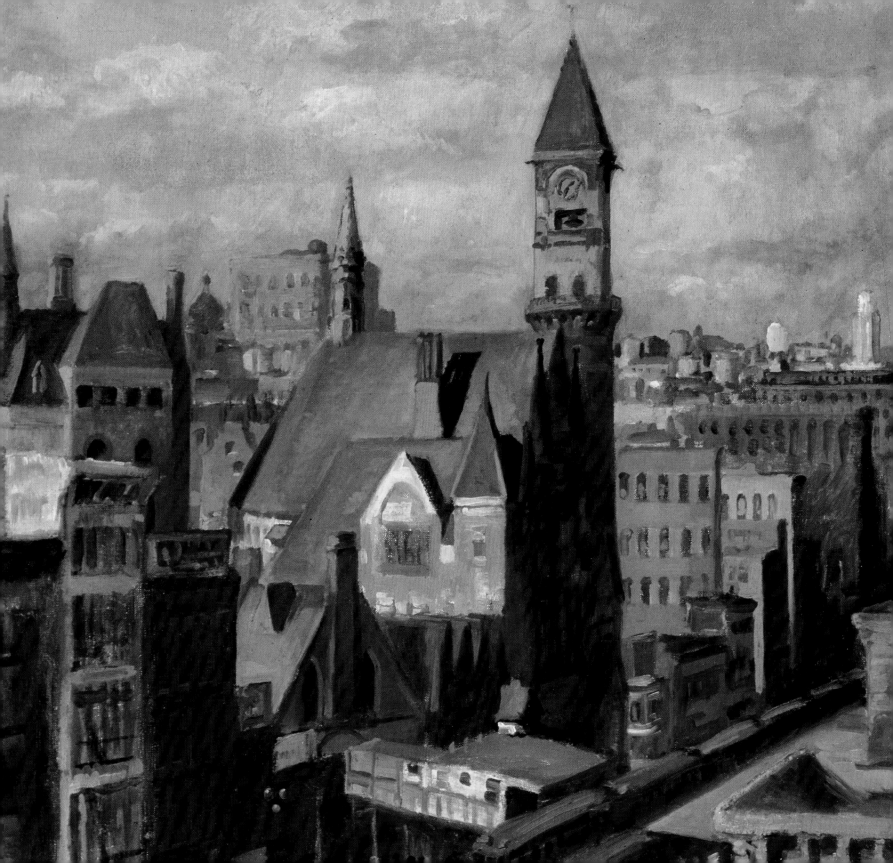

6

STATELY MANSIONS OF MAN, GOD, AND COMMERCE

In addition to panoramas of various sections of New York City, the urban painters of the period often concentrated on individual structures—sometimes older buildings, but more often new architectural triumphs celebrating both technological advances and the city's burgeoning economy. Of course, especially significant structures were often featured in such general urban prospects as Childe Hassam's *Madison Square— Snowstorm* (plate 54), where Madison Square Garden looms majestically in the background. And Colin Campbell Cooper's *Lower Broadway in Wartime* (plate 39) is as much a paean to the Woolworth Building as it is a patriotic tribute to the nation's armed forces.

Surprisingly, private dwellings, whether individual homes or the new monumental apartment complexes, figure seldom and often only incidentally in the work of the Impressionist painters. The apartment buildings bordering Central Park West appear in such pictures as Cooper's *Central Park in Winter* and Eliot Clark's *Central Park from the Landing* (both undated; The Pfeil Collection), but they are extremely generalized and form only a backdrop for what are essentially landscape views. The great mansions of the wealthiest families along Fifth Avenue, such as the Astors, Morgans, and Vanderbilts, seldom appear even tangentially in New York paintings.

Perhaps the best-known Impressionist image of a New York mansion is Hassam's *Manhattan Club* (plate 78), probably painted in 1891.[1] This was the former home of one of the greatest "Merchant Princes," the retail-store magnate Alexander T. Stewart, who died in 1876; after the death of his widow in 1886 the property was leased to the Manhattan Club.[2] Built in 1869 by John Kellum at the northwest corner of Thirty-

77. Detail of John Sloan, *Jefferson Market, Sixth Avenue*, 1917. See plate 92.

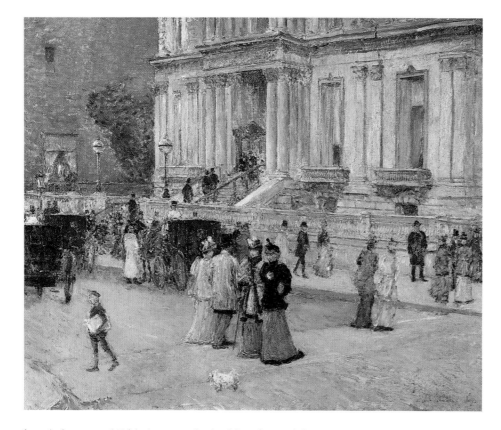

fourth Street and Fifth Avenue, the building housed Stewart's impressive art collection. Made of the finest Carrara marble, at a cost of two million dollars, the mansion was believed to be the most expensive private home then constructed in the city.[3] Hassam's attraction to the subject may have been due partly to its reputation; when it was built, it was viewed as a structure that "will stand as long as the city remains, and will ever be pointed to as a monument of individual enterprise, of far-seeing judgement, and of disinterested philanthropy."[4] Hassam's vantage is across Thirty-fourth Street, in front of Mrs. William Astor's house.[5] This is an area of New York that Hassam would surely have known well; just above the Manhattan Club was the auction house called the Fifth Avenue Art Galleries, and across the street were the Knoedler Art Galleries.

In *The Manhattan Club* Hassam painted the building in its role as a club, not a private mansion; this is emphasized by the all-male, top-hatted figures climbing the stairs

78. Childe Hassam (1859–1935). *The Manhattan Club*, c. 1891. Oil on canvas, 18¼ x 22⅛ in. (46.4 x 56.1 cm). Santa Barbara Museum of Art, Santa Barbara, California; Gift of Sterling Morton for the Preston Morton Collection.

to the building's entrance, perhaps for luncheon, for dinner, or for meetings. Hassam, himself a club man, rendered several of the period's imposing men's clubs, which were places of relaxation for some of his patrons; and clubs appear frequently in his Flag series: the Union League Club in *Allied Flags, April 1917* (Kennedy Galleries, New York), the University Club in *Allies Day, May 1917* (National Gallery of Art, Washington, D.C.), and the Friar's Club in *Flags on the Friar's Club* (1918; Mead Art Museum, Amherst College, Amherst, Massachusetts).

Churches and other ecclesiastical structures figure extensively in the work of the American Impressionists, especially in Hassam's paintings.[6] We have seen the spire of Grace Church among tall office buildings in the Union Square paintings by Hassam and Theodore Robinson; Saint Patrick's Cathedral rising in stately grandeur in Hassam's views of Fifth Avenue; and Saint Thomas and other churches highlighted in the Flag series. It would be ingenuous to suggest that they appear just because they were there. If Robinson had moved a few feet to the left or right while painting *Union Square, Winter* (plate 52), he would have avoided the distant image of Grace Church. Churches, with their picturesque spires and towers, offer pleasing architectural irregularity, breaking up a monotonous row of low houses or the soaring vertical lines of the new skyscrapers. But, in addition, churches were a significant affective element in the urban landscape, representing the city's antiquity; representing tradition and continuity; and representing spiritual faith.

In many of Hassam's paintings New York's churches are integrated into the urban landscape. In *Lower Fifth Avenue (with First Presbyterian Church)* (private collection) the Gothic tower of Joseph C. Wells's First Presbyterian Church (1845; between Eleventh and Twelfth Streets)—which was modeled after that of Magdalen College in Oxford, England—rises up almost spectrally at dusk, above the pedestrians, street traffic, and private redbrick and brownstone houses, providing spiritual guardianship while reaching to the heavens.

Hassam also created numerous images of individual churches with special significance to the city's history. These range from his *Saint Marks in the Bowery* (1910; Yale University Art Gallery, New Haven, Connecticut), commemorating the Colonial-style church (1799) in which Governor Peter Stuyvesant lay buried, to his massive *Calvary Church, New York, in the Snow* (plate 80). Both of these are Episcopal churches. The

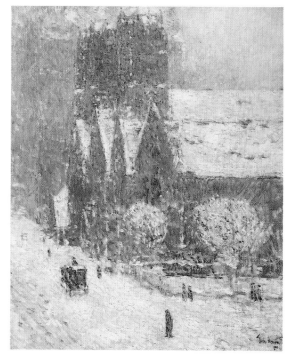

79. Childe Hassam (1859–1935). *Church of the Paulist Fathers,* 1907. Oil on canvas, 22 x 24 in. (55.9 x 61 cm). Private collection.

80. Childe Hassam (1859–1935). *Calvary Church, New York, in the Snow,* 1893. Oil on canvas, 22 x 18 in. (55.9 x 45.7 cm). Mr. and Mrs. Meredith J. Long.

Gothic Revival brownstone Calvary Church (1847) was built by James Renwick at Fourth Avenue and Twenty-first Street to serve a wealthy congregation that was expected to reside on the avenue; Peter Cooper, for example, lived at Fourth Avenue and Twenty-eighth Street during the mid-1840s. Hassam's studio at the time he painted this canvas, in 1893, was only a few blocks away, at Fifth Avenue and Seventeenth Street, and the National Academy of Design, where he often exhibited in the 1890s, was just two blocks up from Calvary Church. The wealthy congregation never really materialized, although there were private middle-class homes in the area. The avenue was instead devoted to trade early on, and most of it was built up in three- and four-story redbrick flats, with stores on the ground floor and with residential hotels on many corners.[7] In Hassam's canvas, Calvary Church, seen obliquely, fills the composition and dwarfs the pedestrians and single carriage on the snow-filled avenue below. The somber scene may reflect Hassam's cognizance that the church had fallen into financial difficulties through its decision to remain downtown.

Fourteen years later, in 1907, Hassam painted *Church of the Paulist Fathers* (plate 79), a view of the Roman Catholic church at Ninth Avenue between Fifty-ninth and Sixtieth Streets, built in 1876–85.[8] The rooftop vista looking south toward the church was probably taken from Hassam's studio building at 27 West Sixty-seventh Street. The round-towered building in the middle distance is the well-known Empire Hotel (between West Sixty-third and Sixty-fourth Streets and between Broadway and Columbus Avenue)—forerunner to the present structure of that name. The crenellated tower of the building in the foreground, topped with a furled American flag, is the First Battery National Guard Armory, built by Horgan and Slattery in 1901.[9] Here, as in many of Hassam's more sweeping compositions, the presence of religion is integrated with other phases of contemporary urban life, along with a panorama of contrasting architectural styles.

Hassam's concentration on church imagery surely reflects his traditional New England heritage and, more immediately, the crisis facing most urban churches in a city with an increasingly unaffiliated population. There was growing recognition that "Religion is today of very low vitality," and that "we are not bringing the full force of our religion to bear upon the hearts and lives of the people."[10] It is not too farfetched to suggest that Hassam was addressing this issue, among others, by introducing reli-

gious edifices into so many of his New York pictures. At the same time, the frequent appearance in both his paintings and his prints of Episcopal churches, a number of which had particularly affluent congregations, suggests his efforts to appeal to a wealthy patron class.

A younger artist who also devoted considerable effort to delineating New York churches was Ernest Lawson. We have already seen his presentation of two houses of worship at Stuyvesant Square (plate 63), and he also painted *The Little Church around the Corner* (I.B.M. Corporation, Armonk, New York), depicting the Protestant Episcopal Church of the Transfiguration on East Twenty-ninth Street. But his favored painting grounds were the upper reaches of Manhattan Island, so it is not surprising that the church that gained Lawson's greatest attention was the new Cathedral of Saint John the Divine, on Morningside Heights, between 110th and 113th Streets and Morningside Drive and Amsterdam Avenue. Designed by George L. Heins and Grant La Farge, it had been begun in 1892 and was still very much in the early course of construction when Lawson first painted it, around 1905; it remains unfinished today. Saint John the Divine was initiated by Bishop Henry C. Potter to serve not only as an American Westminster Abbey but also as the embodiment of the modern, democratic church with a bold missionary purpose, in reaction against the perception that religious institutions were becoming increasingly more social than godly. "The cathedral in its human inclusiveness, a grand charity of public worship, meets the situation more fully than any other remedy that has been proposed and is the direct outcome of the city's needs."[11] A major feature of the church from the beginning was its Chapel of Tongues, where sermons in seven different languages would be offered, to serve the needs of many sectors of the city's population.

Lawson painted numerous pictures of the church during its construction, including *Morningside Heights* (plate 82), featuring the first completed choir arch, which formed the eastern side of the crossing; the east buttress; and the central chapel behind the main altar, to the right of the arch. Even these few elements evoke the ambitious monumentality of a building that was expected to be the fourth largest cathedral in the world. At the far left of Lawson's painting is the eastern wing of the Leake and Watts Orphan Home (1843), acquired by the cathedral for use as its Synod House, and to the right of the cathedral are the mansard roofs of Saint Luke's Hospital

81. Charles A. Vanderhoof (1853–1918). *Cathedral of St. John the Divine,* from Roger Riordan, "The Building of a Cathedral," *Century,* February 1902.

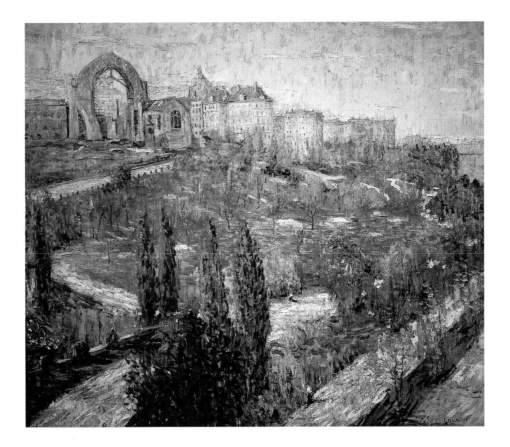

82. Ernest Lawson (1873–1939). *Morningside Heights*, c. 1902–3. Oil on canvas, 34⅝ x 40⅝ in. (87.9 x 103.1 cm). Dr. John J. McDonough, Youngstown, Ohio.

(1896) at 113th Street and Morningside Drive, designed by Ernest Flagg.[12] Lawson positioned himself beyond the southeast corner of Morningside Park, below the Heights, in order to contrast, in his usual manner, an empty foreground landscape with a majestic architectural construction. The paths that snake from the foreground up to the unfinished cathedral suggest pilgrimage roads, while the tall foreground trees echo the rising arch in the distance.

Since he included the eight great pillars of the choir, which were set up on November 25, 1904, Lawson's picture may have been painted around 1905; the building appears to have advanced to the same level pictured in photographs published that year.[13] In his various depictions of the cathedral, Lawson traced the progress of its construction over the years. *Cathedral Heights* (Columbus Museum of Art,

Columbus, Ohio) is a later picture, with the apse and choir of the church completed, and still other paintings reveal further progress. Lawson was, in fact, exalting New York's new Acropolis, as Morningside Heights was recognized at the time. Columbia University had only recently established its new location on the Heights in 1897, and the National Academy of Design, with which Lawson himself would exhibit regularly from 1905, had moved to 109th Street and Amsterdam Avenue in 1899.[14]

By the early twentieth century the buildings that the urban artists concentrated on were not mansions or churches but skyscrapers.[15] That these were commercial structures, rather than private residences or benevolent institutions, defines to some extent the cultural values of the day, though there seems no indication that such paintings were commissioned by or even offered to the builders, owners, or occupants of the edifices involved. The aesthetic problem presented by portraying the skyscrapers was their compactedness. Individual buildings could be identified in panoramic sweeps of the city skyline by their distinctive summits, but their street-level facades were almost indistinguishable, and the complete, towering mass was difficult to depict either from street level or from a high window or rooftop, so narrow are the adjoining streets and so packed together are the buildings. Still, if a building was tall enough, it could be shown towering over its neighbors, even from a ground-level view.

It was Daniel Burnham's Flatiron Building (1902) that was the most painted, printed, photographed, and illustrated of all American buildings.[16] One of the taller, but not the tallest, buildings in the city at the time, it was the subject of immense curiosity, celebrity, and praise on its completion, referred to as "the slenderest" and "the most aquiline" of structures.[17] Its unbroken, slablike shape, its rounded corner on the square, and its buff-colored brick and terra-cotta gave the building an almost impossible lightness. Its popularity was due not only to its unusual triangular shape, which gave the edifice its nickname, but also to its location. At the foot of Madison Square and at the intersection of the city's two most renowned thoroughfares—Fifth Avenue and Broadway—it was the most commanding building at one of the most active and diverse centers of New York life. A decade before the building's completion Mariana G. Van Rensselaer had pleaded for someone who "would build, on its sharp

Look at the Flatiron building! There it is, stuck in the common rock. But, see, it mounts into heaven itself, a thing of beauty its sordid builders never dreamed of realizing. The sky has taken it unto itself as part of its own pageantry. Let it be the symbol of your life. And look back at its magnificent perspective! It breathes hopes from every tower and turret.

Temple Scott, "Fifth Avenue and the Boulevard Saint-Michel," *Forum* 44 (December 1910): 684–85.

southern corner, another tall colored tower to challenge [Madison Square Garden] across the trees."[18]

The Flatiron Building had its triangle to itself, unobstructed by any other structure, offering artists a clear, uncluttered view. Photographers were the first to take on the pictorial challenge of depicting it, for photographic illustrations accompanied the various articles detailing the construction of the building.[19] A little more than a year after the building's completion, its aesthetics were addressed in a *Camera Work* article by Sadakichi Hartmann, a leading art critic and historian; it was illustrated with Alfred Stieglitz's photograph of the Flatiron Building in the snow, necessarily taken in the winter of 1902–3.[20] Stieglitz set the pattern for images of the building: obligatorily vertical in format (in Stieglitz's case, *extremely* vertical) and taken from Madison Square during late autumn, winter, or early spring, so that the building could be seen in counterpoint to the natural elements of the trees in the park, which at these seasons would allow an unimpeded view. Nature played a further role in softening the structure's sharp outlines by providing an atmospheric veil—of snow in Stieglitz's case, or of evening light and a rainy mist in the even more famous photograph *The Flatiron* (plate 83), taken by Stieglitz's colleague Edward Steichen and also published in *Camera Work*.[21] The Tonalist aesthetic here found perhaps its greatest photographic image. The skyscraper rises forward and up in the distance, almost dissolved in evening light; in the foreground the ubiquitous horse-drawn-cab rank plunges darkly along the Broadway side of the square, opposite the Fifth Avenue Hotel. By moving to the edge of the square, Steichen increased the sense of the Flatiron's narrowness, and unlike Stieglitz he cut off the tip of the building's cornice, adding an effective suggestion of limitless rise.

Graphic images soon followed, such as Joseph Pennell's etchings and lithographs executed during his first New York City campaign, in 1904. For his famous etching *The Flatiron Building* (plate 84), Pennell moved out of the square and onto the small plot formed at the crossing of Broadway and Fifth Avenue—a triangular parcel of land opposite the great triangular building—which offered a head-on view of the skyscraper. Pennell's decision to impose strict symmetry on the scene created a majestic icon, exaggerating its tremendous upward pitch and dwarfing all other structures down the two intersecting avenues. Pennell must have been aware of the effectiveness of this

83. Edward Steichen (1879–1973). *The Flatiron,* 1905 print from 1904 negative. Brown pigment gum-bichromate over gelatin silver. The Metropolitan Museum of Art, New York; Alfred Stieglitz Collection, 1933.

84. Joseph Pennell (1857–1926). *The Flatiron Building,* 1904. Etching, 10⅛ x 7⁹⁄₁₆ in. (25.7 x 19.2 cm). Jan McLaughlin and Bruce Weber.

85. Childe Hassam (1859–1935). *Washington's Birthday,* 1916. Etching, 12⁹⁄₁₆ x 7 in. (31.9 x 17.8 cm). Amon Carter Museum, Fort Worth.

Stop and peer through the mists where Broadway and Fifth Avenue join, and you will see a gigantic galleon sailing majestically into a shadowy harbor; the masts lost in the clouds and the orange lights through many portholes softly glimmering out as the night deepens—a ghostly ship that never reaches port and never changes course. In the daytime the strange ship is known as the Flatiron Building—the most famous skyscraper in the world.

Giles Edgerton [Mary Fanton Roberts], "How New York Has Redeemed Herself from Ugliness: An Artist's Revelation of the Beauty of the Skyscraper," *Craftsman* II (January 1907): 469.

composition, for he repeated it that year in his etching of the Times Building at Times Square, still under construction.[22]

Childe Hassam, in *Washington's Birthday* (plate 85), his much later, very vertical etching of 1916 (he had begun to work in earnest in the medium only the year before), chose essentially the same viewpoint. However, by moving a block farther north on Fifth Avenue, he was able to decorate the sides of his print with the panoply of flags hung from the tall buildings on the avenue, as well as to present the dynamics of automobile traffic, rushing almost insectlike below the soaring skyscraper. In a second state of his etching, presumably done the following year, Hassam introduced on the lower portion of the Flatiron Building the shadows cast by the tower of the Metropolitan Life Insurance Building, built in 1909, thus signaling the continuing ascent of New York's great towers.

Though it is firmly anchored to its triangular plot of land, the shape and height of the Flatiron Building create the illusion that it is sailing inexorably forward. The structure attracted such nautical similes early on, probably beginning with a November 21, 1902, article in the *Brooklyn Daily Eagle* entitled "Call It the Prow." There the Flatiron Building was described as "an enormous steamship, plowing its way up through seas of buildings and dashing aside a foam of traffic." In 1903 John Corbin recalled one observer who called the building "an ocean steamer with all Broadway in tow."[23] And in 1905 Rupert Hughes, in one of the first books on New York City published after the building's construction, commented, "The Flatiron is like a glorious white ship."[24]

The nautical simile seems appropriate also to Colin Campbell Cooper's *Flat Iron Building* (plate 86), one of the earliest and most spectacular paintings of the structure. Cooper has moved slightly to the west for his vantage point—an upper window or roof of a building on Broadway—so that the fifty-one-foot (fifteen-meter) Worth Monument at the small Twenty-fifth Street triangle appears in the lower left, providing a marvelous complement to the distant Flatiron Building. The monument had been erected in 1857 to Major General William Jenkins Worth, a hero of the Mexican War, who died in 1849. The artist slightly exaggerated the breadth of the streets and the square at the wide intersection between them, which he filled with wandering figures, horse-drawn carriages, and buses. Their seemingly haphazard movement reinforces the soaring stability of the great skyscraper, whose mass is softened by the steam clouds that float across its "prow."

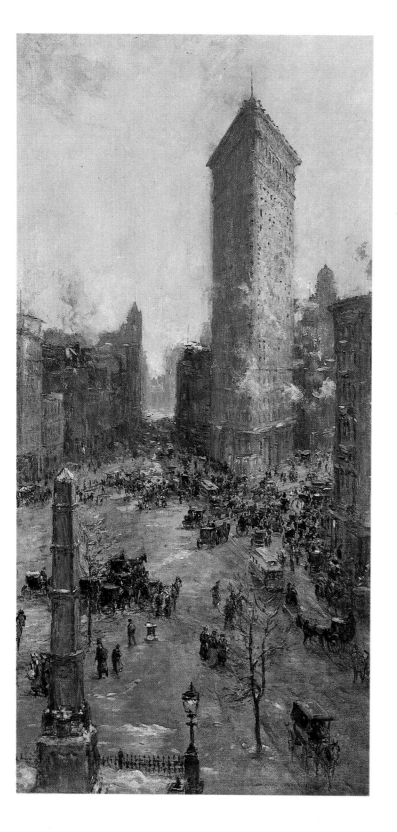

86. Colin Campbell Cooper (1856–1937). *Flat Iron Building*, c. 1908. Casein on canvas, 40 x 30 in. (101.6 x 76.2 cm). Dallas Museum of Art; Dallas Art Association Purchase.

87. Ernest Lawson (1873–1939). *Flat Iron Building,* c. 1906–7. Oil on canvas mounted on board, 30 x 25 in. (76.2 x 63.5 cm). Berry-Hill Galleries, New York.

Several painters executed multiple images of the Flatiron Building in the early twentieth century. At least three, all presently unlocated, are known to have been painted by Birge Harrison, who showed the building after a rainstorm, during a blizzard, and at twilight. All of these were Tonalist interpretations, very likely following in the path of the photographers Stieglitz and Steichen. Unlike them, however, Harrison chose to present the building head on, probably from in front of the Worth Monument, and he showed only a partial image of it, cutting off the shaft midway. Of *The Flatiron Building in Rain* (formerly Saint Louis Art Museum), one critic noted: "Harrison has given it a mellow charm in the drip of a soft spring storm. The outlines of the building and the cars and cabs are softened with the blur of rain, and as you face the picture the faint ineffable stirring of the heart that comes with the early April shower is yours."[25]

Ernest Lawson also painted the Flatiron at least three times, at much the same period as Harrison, probably c. 1906–7. Lawson moved to West Twenty-third Street from Washington Heights in 1905, and he promptly began to paint scenes in this section of New York. Lawson's images are more vigorously painted than Harrison's, and like Stieglitz he executed them in winter, at the Broadway edge of Madison Square, just inside the sidewalk bordering Fifth Avenue; the Fifth Avenue Hotel, with vehicles in front, fills the right side of each canvas (plate 87). The undulations of the snow-covered tree branches, a motif again borrowed from the photographers, partially screen the great skyscraper in each example.

Other members of the Eight varied in their reactions to the Flatiron Building. Robert Henri found it "a sheer work of art. It is beautiful in many senses, yet never so much as when typifying the New York spirit—the spirit of modernity and progress."[26] Everett Shinn, on the other hand, remarked: "The Flatiron Building is a signal atrocity. From Twenty-third Street the tremendous height and weight of it appears to be held up by two very slim panes of glass. That is ridiculous."[27] Ironically, Shinn did depict the Flatiron Building, in a pastel called *Fifth Avenue* (1910; Brooklyn Museum); Henri never did.

Though the aesthetic merits of the Flatiron Building could be debated, there was widespread recognition of the hazards caused by so formidable a structure at the meeting of the two great avenues. In 1903 falling terra-cotta injured one man, though

not seriously, and frightened several cab horses into bolting.[28] More grave, because irremediable, were the high winds that played havoc around the building, causing glass to fall and, in one instance, hurling a boy to his death in front of a passing automobile.[29] At the same time, those gusts lured crowds of males who came to ogle the windblown skirts of female passersby. The term *twenty-three skidoo* was coined by the policemen who were stationed at the building to send loitering men on their way. John Sloan noted this situation in his diary on April 17, 1907: "A high wind this morning and the pranks of the gusts about the Flatiron Building at Fifth Avenue and 23rd Street was interesting to watch. Women's skirts flapped over their heads and ankles were to be seen. And a funny thing, a policeman to keep men from loitering about the corner. His position is much sought, I suppose."[30]

Sloan had participated in a similar experience on June 8 the year before: "In the afternoon, walking on Fifth Avenue, we were on the edge of a beautiful wind storm, the air full of dust and a sort of panicky terror in all the living things in sight. A broad grassy curtain of cloud pushing over the zenith, the streets in wicked dusty murk."[31] Two days later he began to capture the ferocity of this "new form of hurricane," in *Dust Storm, Fifth Avenue* (plate 88). Typically, he centered his attention on the human activity of women, children, and vehicle passengers, while the great skyscraper looms ominously in the rear, serving almost as a pedestal for the dark spreading storm cloud. The picture was first shown in the Winter Exhibition at the National Academy of Design in December 1906, where it received a positive review from James Gibbons Huneker: "The Flatiron Building, its prow cleaving the dust that eddies about it top and side, comes swimming toward you; its head is threatened by a stormy blackness; sharply outlined white clouds are driven eastward by the gale. All living and inanimate things are bending or running."[32]

The forty-seven-story Singer Building (1908) had a picturesque silhouette and crown, and as the tallest structure in the world it attracted the attention of painters, printmakers, and photographers. It was generally most effective seen from afar, either from Brooklyn, as in Joseph Pennell's 1908 etching *New York, from Brooklyn Bridge*, or in river views such as Alfred Stieglitz's *City of Ambition* (plate 89). The popular observatory at the top of the Singer Building could itself be used as a perch for making dramatic views of the city below, as in Pennell's 1908 etching *The West Street Building, from*

One vast horror, facing Madison Square, is distinctly responsible for a new form of hurricane. . . . When its effects first became noticeable, a little rude crowd of loafers and street arabs used to congregate upon the curb to jeer at and gloat over the distress of ladies whose skirts were blown into their eyes as they rounded the treacherous corner.

Sir Philip Burne-Jones, *Dollars and Democracy* (New York: D. Appleton and Co., 1904), pp. 58–59.

88. John Sloan (1871–1951). *Dust Storm, Fifth Avenue*, 1906. Oil on canvas, 22 x 27 in. (55.9 x 68.6 cm). The Metropolitan Museum of Art, New York; George A. Hearn Fund, 1921.

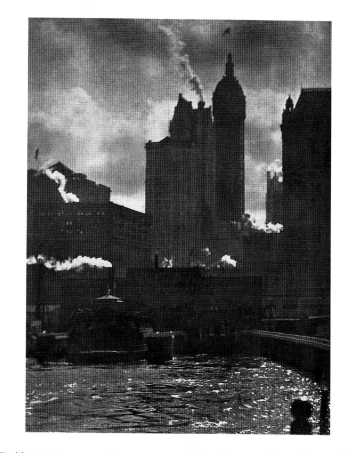

89. Alfred Stieglitz (1864–1946). *The City of Ambition*, 1910. Photogravure, 13⅜ x 10¼ in. (34 x 26 cm). National Gallery of Art, Washington, D.C.; Alfred Stieglitz Collection.

the Singer Building.[33] Among painters, it was John Marin who celebrated the Singer Building most often, beginning with one watercolor in 1909 and executing at least fifteen others during the next three years; Marin returned to this subject in his 1921 *Singer Building* (Philadelphia Museum of Art).

When Cass Gilbert's Woolworth Building, occupying the entire block between Park Place and Barclay Street, was completed in 1913, it was the tallest edifice in the world—reaching a height of 792 feet (241 meters)—and it too attracted artistic attention, as much for its Gothic styling as for its height. The great architectural critic Montgomery Schuyler considered the Woolworth Building the culminating triumph of commercial architecture.[34] With its vertical lines and peaked towers, it so resembled a modern skyscraper-cathedral that it was aptly dubbed "The Cathedral of

OPPOSITE, TOP

90. Joseph Pennell (1857–1926). *The Woolworth Building*, 1915. Etching, 11¾ x 7⅜ in. (29.8 x 18.8 cm). Picker Art Gallery, Colgate University, Hamilton, New York; Gift of the Judd family.

OPPOSITE, BOTTOM

91. John Marin (1870–1953). *Woolworth Building, No. 31*, 1912. Watercolor over graphite on paper, 18½ x 15¹¹⁄₁₆ in. (47 x 39.8 cm). National Gallery of Art, Washington, D.C.; Gift of Eugene and Agnes E. Meyer.

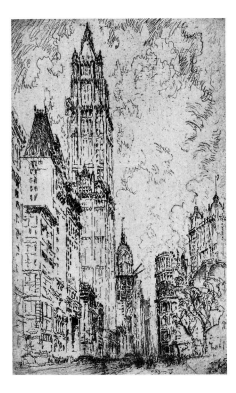

Commerce"—"the chosen habitation of that spirit in man which, through means of change and barter, binds alien people into unity and peace, and reduces the hazards of war and bloodshed."[35]

The building's position across Broadway from City Hall Park allowed for agreeably long vistas. For any of the tall buildings, and the Woolworth Building especially, the trick was to capture its entire length on a single canvas—a problem not unlike that faced by Albert Bierstadt and other western artists in the nineteenth century when they were painting the giant sequoias of California. This problem could be solved, as in Pennell's *Woolworth Building* (plate 90) and Cooper's rendition of the building in his *Lower Broadway in Wartime* (plate 39), by using an extremely vertical canvas and by stepping back far enough north so that the building is in the middle distance. The Woolworth Building is the focus of both these depictions, but the artists have carefully included other famous structures of once-landmark height. (The same structures are to be found in both Cooper's painting and Pennell's print, but the latter vista is actually falsified because it is printed in reverse, so that left is right and vice versa.) Cooper's vantage point seems to have been an upper story in a building at Broadway and Chambers Street, the site in 1848 of Alexander T. Stewart's dry-goods store, whereas Pennell worked at ground level, so that the Woolworth Building appears to loom even nearer and higher.

Today, the best-known images of the Woolworth Building are those not by Impressionist painters but by John Marin, who "had fallen in love with it at first sight."[36] Between 1911 and 1915 he executed numerous watercolors and etchings of it, both under construction and completed. Marin's depictions, such as *Woolworth Building, No. 31* (plate 91), have been compared with the Eiffel Tower paintings by the French Orphist painter Robert Delaunay; both artists fractured their images to express the buildings' surging vitality.[37] It has also been proposed that Marin's tilting and bending of the straight surfaces of the Woolworth Building were his humorous response to the question of the building's height. Engineers measured it at forty-two feet (thirteen meters) taller than it was designed to be, and the architect, Cass Gilbert, claimed that if the calculators were correct, the structure must be lopsided and the builders should be made to straighten it up.[38]

Although the great skyscrapers attracted the principal attention in the early twentieth century, some writers and artists expressed their preference for some of the city's

121

older monuments. This was particularly true regarding houses of worship, especially Trinity Church and Saint Paul's Chapel; Colin Campbell Cooper had painted both monuments (unlocated) by 1906, and John Marin was to feature the two structures in watercolors numerous times during the next decade. Such early buildings appealed not only because of their spiritual significance and their historic associations; their intimate scale and irregular forms and outlines provided welcome relief from the grandiose, slablike modern high-rise structures. As such, they added to the concept of the picturesque, and writers of the period, both those who looked favorably on the new skyscrapers and those who did not, were seeking out the remnants of the picturesque in the city as a counterweight to the new construction.

Mariana G. Van Rensselaer defined the appeal of the picturesque in fairly traditional terms as grounded in the charm of variety; in this context, she singled out among New York buildings as "pictorially, if not architecturally, very valuable," Grace Church, the Friends' Meeting House on Stuyvesant Square, and the Jefferson Market.[39] The Jefferson Market Courthouse, completed in 1877 by Frederick Withers and Calvert Vaux on the site of the old marketplace at Sixth and Greenwich Avenues and West Tenth Street, was the dominant structure in Greenwich Village, due to its height, its function, and its central location. It is the epitome of American Victorian Gothic, with its gables, turrets, balconies, and belfry; its banded brick-and-stone work; its polychromy and its carvings.

John Sloan chose the Jefferson Market area as a subject several times, first in 1911 in *Jefferson Market Jail, Night* (Tokyo Central Museum) and then in 1917 in *Jefferson Market, Sixth Avenue* (plate 92). In the latter he concentrated more on the building's picturesque form and its situation within the urban panorama and less on the genre elements that he had featured in the earlier canvas. Sloan obviously delighted in the irregular rooftop patterns and the spires of several other structures beyond, contrasting the soaring tower and gables of the courthouse with the swift rush of the Sixth Avenue elevated railroad below. Sloan had moved to a top-floor apartment at 88 Washington Place in the Village in October 1915, from which he had a view of this scene.[40] It is characteristic of an artist of the Eight that he chose to commemorate a functioning community courthouse and jail rather than a commercial structure or an elegant hotel. Nor was the courthouse simply an architectural curiosity to him; Sloan frequented the

92. John Sloan (1871–1951). *Jefferson Market, Sixth Avenue*, 1917. Oil on canvas, 32 x 26⅛ in. (81.3 x 66.3 cm). Pennsylvania Academy of the Fine Arts, Philadelphia; Henry D. Gilpin Fund.

night court there as early as 1909, at one point commenting: "This is much more stirring to me in every way than the great majority of plays. Tragedy-comedy."[41] Sloan was obviously drawn to the building's picturesque mass as well as to its physical and symbolic situation within Greenwich Village, and no other New York structure, not even the Flatiron Building, enjoyed such distinctive, monumental rendering by him.

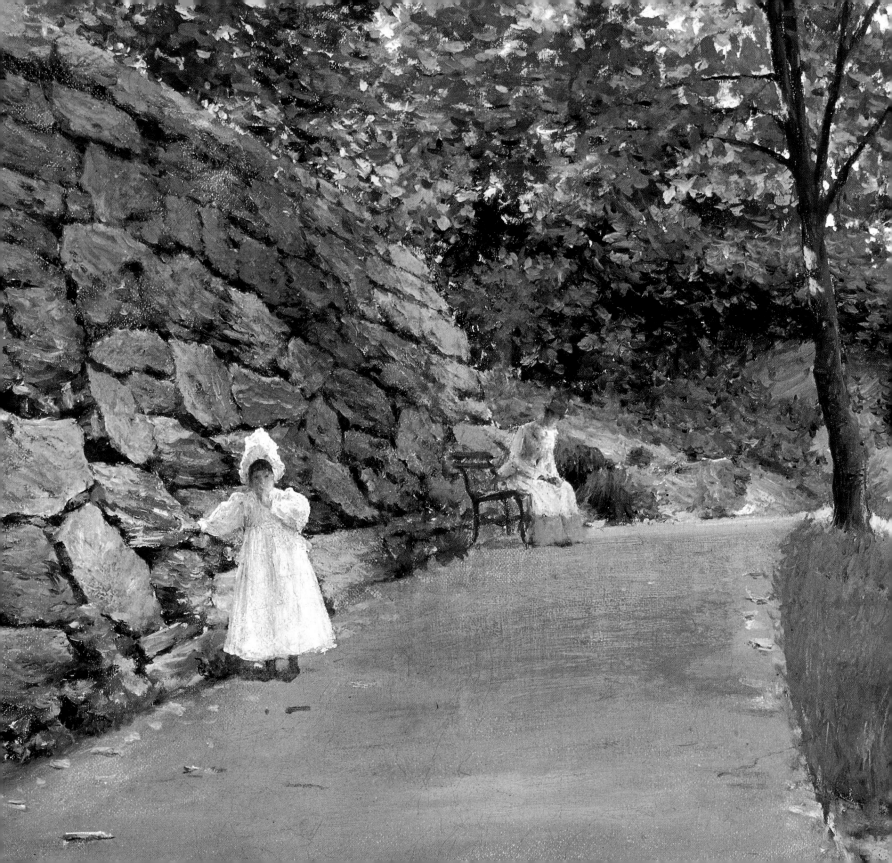

7

<div align="center">❦</div>

CENTRAL PARK

93. Detail of William Merritt Chase, *In the Park: A By-Path,* 1890–91. See plate 99.

With the vast increase in the urban population during the nineteenth century, a need was growing for a haven within the city where people could relax in an airy, green setting. As early as 1844 William Cullen Bryant had called for the establishment of an urban green space, and after considerable controversy, in 1853 approval was given to construct a park between Fifth and Eighth Avenues, running from Fifty-ninth to 106th Street (extended six years later to 110th Street); work began in 1857, under Egbert Viele, a civil engineer. The Central Park Board of Commissioners then decided to hold an open design competition, and on April 1, 1858, Frederick Law Olmsted and Calvert Vaux presented their "Greensward" plan to the board.[1]

Certain innovative features of Olmsted and Vaux's prize-winning design bear directly on the artistic images subsequently produced—most notably, the creation of four sunken and camouflaged transverse roads, which kept crosstown traffic out of the park, allowing the designers to create the impression of a rural landscape. Their ideal was an informal, pastoral setting, all green, and picturesque in its curvilinear bypaths, except the straight line of the Mall. There were to be no formal gardens, and buildings were to be concealed.

Olmsted provided for two disparate forms of social assembly: the formal axis lent itself to promenades, carriage concourses, and concert areas, while the Ramble and the pastoral meadow were suited for informal gatherings, picnics, and play areas. The pathways—pedestrian, bridle, and carriage roads—were almost totally curvilinear, discouraging high-speed travel and immersing the visitor in the scenery. Olmsted

believed in "unconscious or indirect recreation, and the restorative influences of the natural landscape on city-bound people."[2]

Almost from the start of construction, the public began to use and enjoy the park. One of the requirements of the competition had been the inclusion of a winter skating ground, and ice skating began as soon as the lake was filled in December 1858. Calcium flares on the shores of the lake allowed for night skating as well, and tens of thousands of people came to skate or to watch the skating in the 1860s. This activity, in fact, accounts for some of the earliest painted scenes in the park, including *Skating on the Central Park* (Saint Louis Art Museum), Winslow Homer's earliest exhibited work, shown in the 1860 annual at the National Academy of Design. In his 1865 *Skating in Central Park* (plate 94), Johann Culverhouse transformed the seventeenth-century skating imagery of his native Holland into a nineteenth-century New York City scene. The view is north and west from the Terrace; Bow Bridge can be seen off in the distance at left.[3] Though a few of the myriad skaters have fallen flat on the ice, this is a sedate scene of nicely dressed couples and well-behaved children enjoying themselves in a landscape setting; only the fashionable garb suggests an urban milieu.

Though the park was designed to serve the people, it was not truly a park for all New Yorkers in its early decades, when the "carriage trade" paraded on the drives, and

The primary purpose of the Park is to provide the best practicable means of healthful recreation for the inhabitants of the city, of all classes. It should present an aspect of spaciousness and tranquillity with variety and intricacy of arrangement, thereby affording the most agreeable contrast to the confinement, bustle, and monotonous street-division of the city.

Frederick Law Olmsted, *Creating Central Park, 1857–1861*, vol. 3 of *The Papers of Frederick Law Olmsted*, ed. Charles E. Beveridge and David Schuyler (Baltimore: Johns Hopkins University Press, 1983), pp. 212–13.

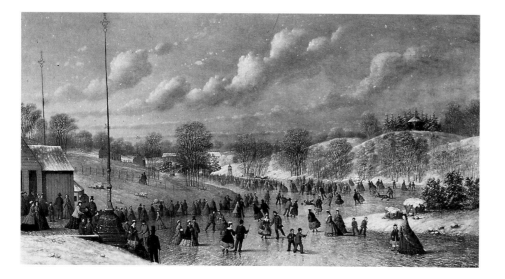

94. Johann Culverhouse (1820–1891). *Skating in Central Park*, 1865. Oil on canvas, 19⅛ x 35⅜ in. (48.5 x 90 cm). Museum of the City of New York; The J. Clarence Davies Collection.

95. William Merritt Chase (1849–1916). *An Early Stroll Through the Park*, 1890. Oil on canvas, 20⅜ x 24¼ in. (51.6 x 61.6 cm). Montgomery Museum of Fine Arts, Montgomery, Alabama; The Blount Collection.

96. Photographer unknown. *The Esplanade at Bethesda Fountain, Central Park*, n.d.

the middle classes enjoyed skating, strolling, boating, picnicking, and listening to the Saturday afternoon band concerts. It was costly for the poorer classes to reach the park, and when they arrived—usually on Sundays, their one day off—activities were limited by Sabbatarian rules, though these gradually abated.

It was not until 1889, when William Merritt Chase shifted the focus of his urban landscape painting from Brooklyn to Central Park, that an artist became specifically identified with the park and that a specific pictorial image of the park emerged.[4] Contemporaries acknowledged that Chase had "hit upon a discovery which is yet to be made by a very great proportion of the inhabitants of New York. He has discovered Central Park. Not that most New York people do not know there is such a place, and are not more or less proud of it, but comparatively few of them ever go into it, and when they go they rarely see anything."[5] Actually, it may have been Chase's close friend the painter J. Carroll Beckwith who "discovered" Central Park. In the 1886 Autumn Exhibition of the National Academy of Design, which opened in November, Beckwith exhibited *Scene in Central Park* (location unknown). He had probably been inspired to undertake such a subject by Chase, who had just that summer begun painting in Brooklyn's Prospect Park. Beckwith's *Old Boathouse in Central Park* (formerly, Mr. and Mrs. George Arden) recalls Chase's Prospect Park pictures, being executed in a similar manner though somewhat more tightly rendered and in an unusual vertical format.[6]

When Chase undertook his Central Park images, made directly out of doors, the park was finally becoming very much an all-city park. But in Chase's paintings, such as *An Early Stroll Through the Park* (plate 95), the common man, woman, and child are nowhere to be seen. Chase underscored the urban setting of the park by situating his scene on the Terrace, with Emma Stebbins's gigantic Bethesda Fountain, or *Angel of the Waters* (1873), filling almost the entire middle distance; at the left is Bethesda Terrace (1873), the one formal structure in the park (plate 96). This nearly empty space, pairing verdant landscape with architectural and glyptic grandeur, conjures up an American Tuileries, an informal and modern incarnation of the European royal park. The rich colorism and bright sunlight not only embody Chase's unique Impressionist aesthetic but also offer a natural restorative that parallels the biblical message of healing implicit in Stebbins's fountain.[7]

If you are a yachtsman, young or old, and you love the white sail, you will hurry along . . . to the model yacht course known as Conservatory Water. On bright afternoons when the wind is astir the young yachtsmen of the city, in blue and white sailor uniforms, with gold anchors on their shoulders, and golden curls falling from under their sailor hats, hurry down here with their yachts under their arms. Cruises, races, and runs of all sort are arranged on the spot, sails hoisted, ships trimmed, and the little boats put off this way and that in fleets across the inland sea. Hither and thither they scud, with pennants flying, careening to port or dipping their rails to starboard, while their owners, shouting with enthusiasm, chase after them along the plank lined coasts. It is a stirring scene, full of young, joyous life.

Arthur Wakeley, "The Playground of the Metropolis," *Munsey's Magazine* 13 (September 1895): 568–70.

OPPOSITE

97. William Merritt Chase (1849–1916). *Lake for Miniature Sailboats, Central Park*, c. 1890. Oil on canvas, 16 x 24 in. (40.6 x 61 cm). Peter G. Terian.

ABOVE

98. T. W. Ingersoll, *Saturday Afternoon in Central Park, New York*, c. 1900. Stereograph (one side). Prints and Photographs Division, Library of Congress, Washington, D.C.

Most of Chase's Central Park images are not quite as depopulated as *An Early Stroll Through the Park*. *Lake for Miniature Sailboats, Central Park* (plate 97) features a group of well-dressed little girls and boys enjoying the sunshine and sailing their boats on the small artificial lake, while the adults tending them sit discreetly in the background and others stroll along the far shore. There is a great sense of decorum here, in this upper-middle-class world set in a pleasantly informal but well-kept greensward. The setting is the model-boat pond, Conservatory Water, looking north, with Fifth Avenue at the right.[8] Sailing model boats was a popular pastime here for many decades, with a Model-Boat House at one side of the pond (plate 98).

Most of Chase's Central Park pictures, like this one, are painted in a high color key, with a strong sense of sunlight adding to the cheerful tenor of his urban interpretation. To underscore both the urban setting and the fashionableness of the park's clientele, Chase included the peaked roofs of several large buildings in the center distance over the trees. One of the towered buildings in the distance at the left belonged to the clothing manufacturer and real-estate investor Isaac Vail Brokaw. Constructed in 1887

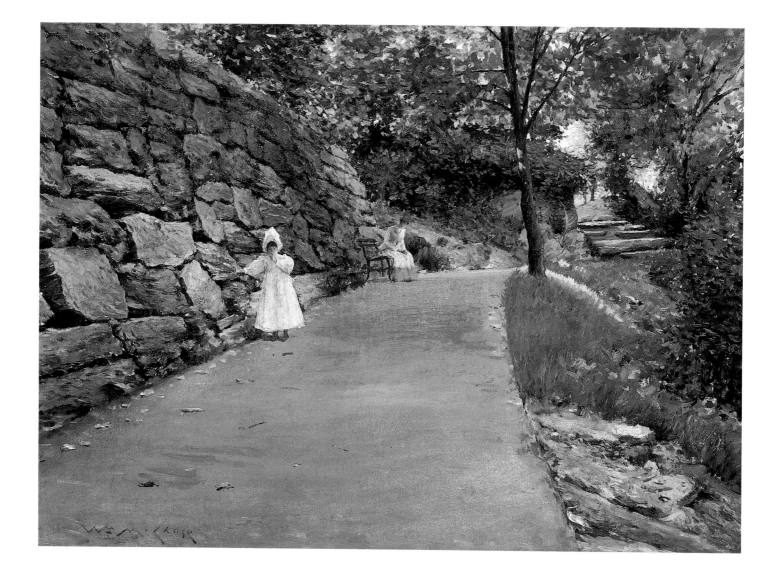

99. William Merritt Chase (1849–1916). *In the Park: A By-Path*, 1890–91. Oil on canvas, 14 x 19⅜ in. (35.5 x 49 cm). Thyssen-Bornemisza Collection, Lugano, Switzerland.

100. Foundation wall of Mount Saint Vincent's.

by Rose and Stone at the northeast corner of Seventy-ninth Street, it was modeled on a French Renaissance Loire Valley château, complete with a moat.[9] The building at the right is very likely the two-spired house of William Van Duzer Lawrence at Seventy-eighth Street, designed three years later in a similar Loire Valley style by one of the most renowned architects of the time, Richard Morris Hunt.[10] Both houses were recent celebrated additions to Millionaires' Row at the time Chase painted them. Diminutive though these architectural references may be, these fashionable and much-discussed structures would have been very recognizable to Chase's urban audience.

A number of Chase's Central Park pictures were painted in the relatively remote northern section of the park, which attracted fewer general visitors or artists; *In the Park: A By-Path* (plate 99) is one of these. At the left is the foundation wall of Mount Saint Vincent's (plate 100), which Chase has uncharacteristically depicted with almost photographic accuracy. This was the former site of a convent, which had housed a chapel, school, and boarding academy. The Sisters of Charity of Saint Vincent de Paul, primarily Irish, had to move from their convent in 1859 when the park came into existence, though they returned temporarily to run a military hospital there during the Civil War. The hospital was replaced by a restaurant, while the chapel became an art gallery housing the sculptures of Thomas Crawford, who had died in Rome in 1857; both structures burned to the ground in 1881. The restaurant was rebuilt in 1883 and became a gathering place for wealthy men-about-town, horse fanciers, and the sporting crowd, but this was demolished in 1917; only the foundation wall remains.[11]

In the Park: A By-Path was described by one critic as representing "one of those sections of rough rock-work which gave character to many nooks and corners of the Park at the same time that they serve a useful end. Here, again, the ever-present nurse and child recall the purposes for which Central Park and many another park of New York have been established."[12] The subjects may well be Mrs. Chase and Alice (known as Cosy), the first of their eight surviving children.[13] One could read the scene as a metaphor of the child's path of life toward adulthood, but this seems improbable for Chase, given his proclivity for naturalism. However, the towering rock wall, which obviously fascinated the artist and offers superb contrast with the soft green grass and foliage at the right, seems emphasized as a supportive rather than a threatening element for the young child.

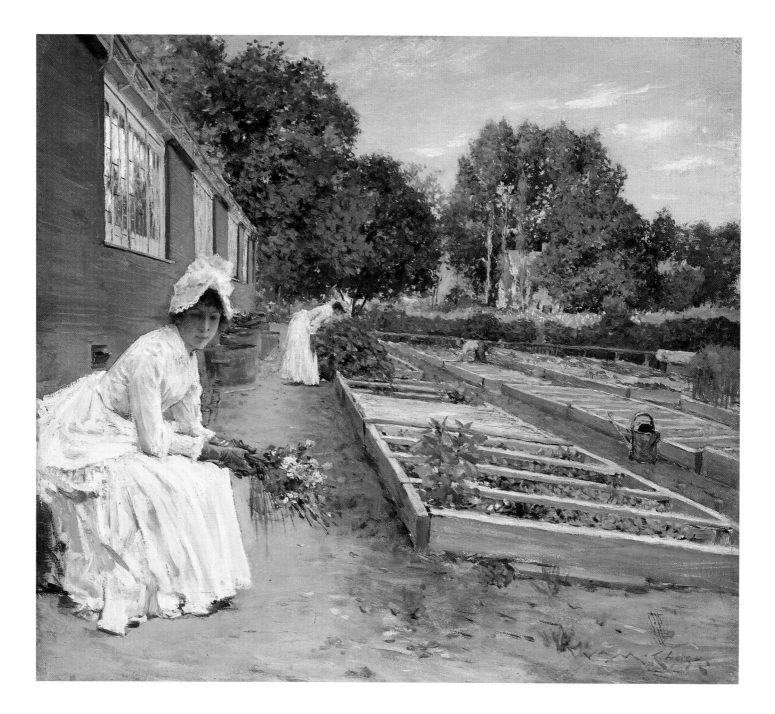

Probably the best-known today of Chase's Central park pictures is *The Nursery* (plate 101), also painted in the upper reaches of the park and one of his few pictures that does not feature its lawns, pathways, or lakes. The nursery was situated between Harlem Lake and the Upper Reservoir, on the site of the present Conservatory Gardens at Fifth Avenue and 105th Street; at the left is probably the Propagating House. The land had originally been designed for an arboretum but this proved impractical. Chase painted this scene in June, when the seedlings cultivated in the cold frames had developed, and most had been transplanted to beds and urns throughout the park.[14] Almost indistinguishable among the cold frames is a gardener, a rare inclusion by Chase of a working-class figure. Chase's views of a manicured, orderly park with well-groomed visitors seem to belie the charges made by the East Harlem Improvement Association this same year, 1890, that the neglect of the northern end of the park made their nearby lots unmarketable.[15]

On numerous occasions Chase was recognized not only as the artistic discoverer of the park but also its only delineator. This did not last long, however, and it may well be that the positive critical reception of Chase's paintings led other painters to investigate Central Park. Childe Hassam painted the park numerous times in the 1890s and the early 1900s. Like Chase, he often focused on children with their nurses or mothers on paths among the trees or along the lakes and ponds. *Central Park* (plate 102) is again a scene at Conservatory Water, although only one boy is playing with a model boat, and the artist concentrated instead on the promenading figures. This area of the park, in the lower Seventies near Fifth Avenue, was clearly one preferred by painters in the 1890s, and it is probably not coincidental that it adjoined Millionaires' Row.

In *Model Sailboat Pond, Central Park, New York* (plate 103), painted early in the twentieth century, Ernest Lawson chose the same subject of model boat sailing in Conservatory Water.[16] Unusual for Lawson, though not for the Eight generally, the figures are prominent. They are no longer the decorous children of Chase's picture (plate 97) but a group of primarily young men, vigorously urging on their sailboats. A prominent feature in the background is the dome of the Byzantine-Moorish Temple Beth-El, covered with a tracery of gilded copper. It had been built in 1891 by Arnold Brunner, a leading architect of the city's synagogues, at Fifth Avenue and Seventy-fifth Street. This flamboyant structure received conflicting reviews; typical is that by

101. William Merritt Chase (1849–1916). *The Nursery*, 1890. Oil on panel, 14⅜ x 16 in. (36.6 x 40.6 cm). Manoogian Collection.

Mariana G. Van Rensselaer, who called it "the gorgeous synagogue which looks over Central Park, with its ugly but showy big gilded dome."[17] Beth-El, the city's leading Reform synagogue, was one of the first religious structures built among the elegant houses on Millionaires' Row; some of those homes may be indicated beyond the synagogue in Lawson's canvas, but like many of his colleagues, he generally shunned depicting the private dwellings of the wealthy.

Though the park was becoming more democratic in both its rules and its constituency in the 1890s, artists and writers still portrayed it as a middle- and upper-class playground. Aside from the very occasional park employee, such as Chase's gardener, almost the only working-class folk who appear in Chase's and Hassam's park scenes are nurses accompanying children. But if working-class people are seldom present in these pictures, the painters nevertheless depicted the park on work days, not Sundays or holidays. Not only is the laboring class absent because they *are* laboring, but the inhabitants of the park are solely women and children—almost no adult males are present. Husbands, fathers, and young men-about-town are *in* town, at the counting house, on Wall Street, and in the new high-rise commercial buildings, not in the park. Such pictures therefore reflect the gender segregation of the time.

In the early twentieth century almost all the members of the Eight painted scenes in Central Park—Henri, Lawson, Luks, Shinn, and Sloan occasionally, and William Glackens and especially Maurice Prendergast very often—and their images depict a broad spectrum of society. Prendergast's *Mall, Central Park* (plate 104) depicts the same area of the park as Chase's *Early Stroll Through the Park* (plate 95), but in contrast to the stark elegance of that scene, Prendergast's picture pulsates with life. Figures, mostly women and children but some men as well, move up and down the Terrace steps, while others are ranged along the upper Terrace at the left. This is a summer picture, with the trees in full leaf, and the urns at the top of the Terrace balustrades are overflowing with flowers; many of the women and children wear white summer frocks and carry brightly colored parasols. The aesthetic and even the composition here reflect Prendergast's recent trip to Italy, in 1898–99, especially his vistas on the stepped bridges of Venice and on the Spanish Steps and steep church approaches of Rome. In these works he invented a new form of "popular pageantry," which he transferred to America in 1901 and situated in Central Park.[18]

The case was, unmistakably, universally, of the common, the very common man, the very common woman and the very common child; but all enjoying what I have called their promotion, their rise in the social scale. . . . The children at play, more particularly the little girls, formed the characters, as it were, in which the story was written largest; frisking about over the greenswards, grouping together in the vistas, with an effect of the exquisite in attire, of delicacies of dress and personal "keep-up," as through the shimmer of silk, the gloss of beribboned hair, the gleam of cared-for teeth, the pride of varnished shoe, that might well have created a doubt as to their "popular" affiliation.

Henry James on Central Park, *The American Scene*, ed. Leon Edel, from the 1907 London and American editions (Bloomington and London: Indiana University Press, 1968), pp. 177, 179.

OPPOSITE, TOP
102. Childe Hassam (1859–1935). *Central Park*, c. 1892. Oil on canvas, 18 x 22⅛ in. (45.7 x 56.1 cm). Anonymous.

OPPOSITE, BOTTOM
103. Ernest Lawson (1873–1939). *Model Sailboat Pond, Central Park, New York*, 1904–7. Oil on canvas, 20 x 24 in. (50.8 x 61 cm). Courtesy Hirschl and Adler Galleries, New York.

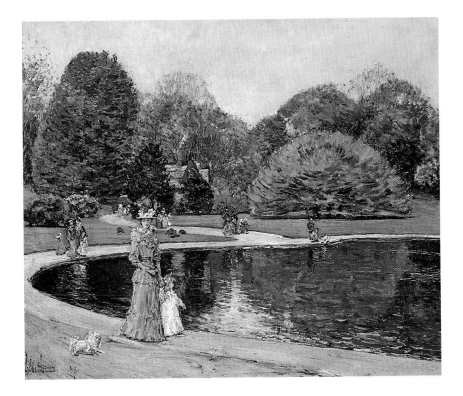

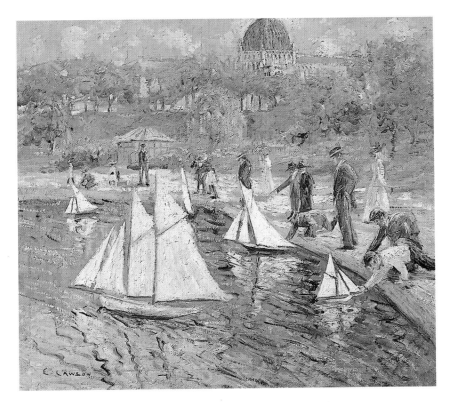

Prendergast was living in Winchester, Massachusetts, at the time he painted *The Mall, Central Park,* but the year after his successful one-artist show at the Macbeth Gallery in March 1900, he began to visit New York City regularly. His painting activity was centered in the park, though he also depicted other typical subjects, as in *Madison Square* (1901; Whitney Museum of American Art, New York). In the park Prendergast concentrated his activity in and around the Terrace, though he also

104. Maurice Prendergast (1861–1924). *The Mall, Central Park,* 1901. Watercolor on paper, 15⅜ x 22⅜ in. (38.8 x 56.9 cm). The Art Institute of Chicago; Olivia Shaler Swan Memorial Collection.

105. Maurice Prendergast (1861–1924). *May Day, Central Park,* 1901. Watercolor on paper, 13⅞ x 19¾ in. (35.3 x 50.2 cm). The Cleveland Museum of Art; Gift from J. H. Wade.

painted other familiar themes, such as *Sailboat Pond, Central Park* (c. 1900–1903, Whitney Museum of American Art).

The May Day festivities in the park attracted a good deal of artistic attention at this time; this ancient ritual celebrating the advent of spring was recorded by both Glackens and Prendergast (plate 105). At these celebrations more than twenty thousand children from many walks of life, though usually not of the well-to-do, would flock to the park with their maypoles, wearing their very best clothes. They danced around the poles, crowned a series of May Queens (twenty-four in 1904 alone), and played games before enjoying an outdoor meal. These were also political gatherings, arranged by the political machines of various election districts, and allegiance and parental votes were requested in return for cake, fruit, ice cream, and lemonade. Still, whatever the motivation, thousands of children were "transported from the streets . . . to one day of perfect happiness in the free out-of-doors."[19]

It was at this time that Prendergast developed a close friendship with William Glackens, which led Prendergast into an association with the other members of the

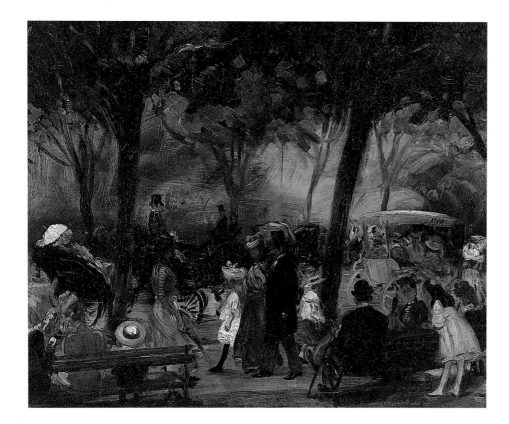

future Eight; in turn, it may be that Glackens began to investigate Central Park sub-
jects through Prendergast's example. Glackens seems to have first painted in the park
around 1905, depicting a much more raucous and more irrefutably working-class
crowd of children than those depicted by Prendergast. Even when Glackens painted a
more upper-class subject, such as *The Drive, Central Park* (plate 106), with its fashionable
folk being driven in carriages, he included members of diverse classes on the paths and
benches. Due to the increasingly polyglot nature of the park, the wealthy—who had
earlier followed a route that began at the Fifth Avenue entrance at Central Park West
and passed by the Mall over to West Seventy-second Street—now were confining
their carriage parade to the late afternoon along the East Drive, near Fifth Avenue,
where Glackens very likely recorded this scene. Henry Beekman, the East Drive com-
missioner, commented, "I do not know why the East Drive should be so crowded,

106. William Glackens (1870–1938). *The Drive,
Central Park,* c. 1905. Oil on canvas, 25¾ x 32
in. (65.4 x 81.3 cm). The Cleveland Museum of
Art; Purchase from the J. H. Wade Fund.

while the West Drive is comparatively free, except that the former happens at present to be more fashionable."[20]

Carriage driving is certainly confined to the distant East Drive in *The Mall in Central Park* (plate 107), painted by the much underestimated Gifford Beal, a contemporary of the Eight on familiar terms with them.[21] The view here is across the north end of the Mall, with the buildings around Seventy-first Street on Fifth Avenue visible in the distance. Beal had been a longtime student of William Merritt Chase, so that his inclination to paint the park had diverse sources; the area of the park painted here by Beal is contiguous with the sections particularly favored by Chase—the Terrace, the Lake, and Conservatory Water. Prendergast's conception of pageantry is exceedingly strong in Beal's colorful, light-filled canvas, but the latter's emphasis is unquestionably on the park, or at least the Mall, as a recreation center for the upper classes; the costumes of both women and men, including the top-hatted old gentleman accompanying a young girl in white at the far right, seem anachronistically old-fashioned, alluding to an earlier aristocratic New York.

In addition to subjects intrinsic to the park itself, Central Park provided the Impressionist painters with effective vistas of the surrounding city. We have already

107. Gifford Beal (1879–1956). *The Mall in Central Park*, 1913. Oil on canvas, 30 x 40 in. (76.2 x 101.6 cm). National Academy of Design, New York.

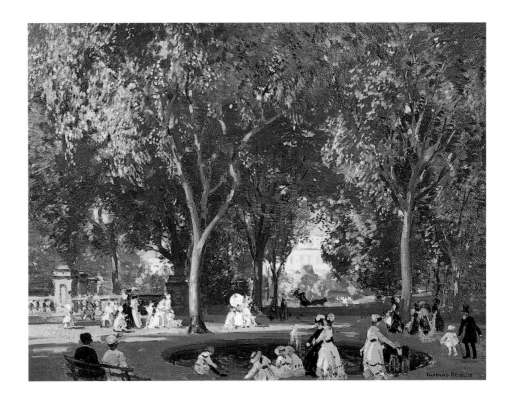

seen one such image in Hassam's *Hovel and the Skyscraper* (plate 6), in which he portrayed the view down into the park from high above, near Central Park West. Five years later Elmer Livingston MacRae adopted a similar but more panoramic stance in his *View of Central Park West from Carnegie Hall* (plate 108), with the park intervening between new construction in the immediate foreground and the distant line of highrise buildings along Central Park West. Seen from on high, the low park "blanket" thus became a softening element between the near and far bands of sharply defined buildings.

Carnegie Hall had opened in 1891 at Fifty-seventh Street and Seventh Avenue, with a tower added three years later; in addition to concert halls and music rooms it offered studios to artists, and MacRae was a tenant there beginning about 1908. The building under construction in his painting is probably the heavily decorated Alwyn Court apartment house at Seventh Avenue and Fifty-eighth Street. It was completed in 1908, which suggests that MacRae began this work that year and finished it early in 1909. At the left rises the eleven-story Osborn apartment building, erected in 1885—at that time the tallest dwelling in the city.

MacRae's painting recorded a swath of the city that was vital to artistic life in New York and, in addition, celebrated the city's cultural and residential growth. Farther west on Fifty-seventh Street was Henry Janeway Hardenbergh's American Fine Arts Society (1892), where major art exhibitions, including those of the National Academy of Design, took place. Fifty-seventh Street was also becoming renowned for its studio accommodations for artists. The earliest had been the Sherwood, constructed in 1879 at Sixth Avenue and Fifty-seventh Street, followed by the Rembrandt, built in 1881 at 152 West Fifty-seventh Street. Subsequently, in addition to Carnegie Hall itself, the Gainsborough Studio Building was erected nearby at 222 Central Park South. In 1908 the painter Robert Vonnoh arranged for the construction of cooperative studios at 130 West Fifty-seventh Street; Childe Hassam moved in immediately.[22]

One of the best-known vistas across the park from a high building is Willard Metcalf's *Early Spring Afternoon, Central Park* (plate 109), taken from the vicinity of his studio at 33 West Sixty-seventh Street. Richard Boyle pinpoints its location in "the Pimlico" (actually the Pamlico Apartments), at 69 Central Park West.[23] Metcalf was primarily a landscape painter, and executed very few urban views; even here he obvi-

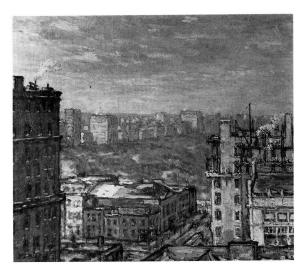

ously delighted in such landscape features as the feathery spring foliage of the park, just coming into bloom. And he inserted the blue of the lake at the left (crossed by the Bow Bridge) to contrast with the hazy lavenders and soft greens of the lawns. Beyond the vast expanse of natural grandeur rise the distant buildings of the great modern city: the panorama of Fifth Avenue, centered on the green dome of Temple Beth-El.

Metcalf also appears to have relished the sinuous configurations of the wide roadways within the park, contrasting pedestrian and motor traffic with the male and female riders on the bridle path in the foreground—a somewhat controversial upper-class recreation.[24] The presence of motor vehicles in the park was also con-

ABOVE
108. Elmer Livingston MacRae (1875–1955). *View of Central Park West from Carnegie Hall*, 1909. Oil on canvas, 25 x 30 in. (64 x 76 cm). Courtesy William Doyle Galleries, Inc., New York.

RIGHT
109. Willard Metcalf (1858–1925). *Early Spring Afternoon, Central Park*, 1911. Oil on canvas, 36⅛ x 36 in. (91.7 x 91.4 cm). The Brooklyn Museum; Frank L. Babbott Fund.

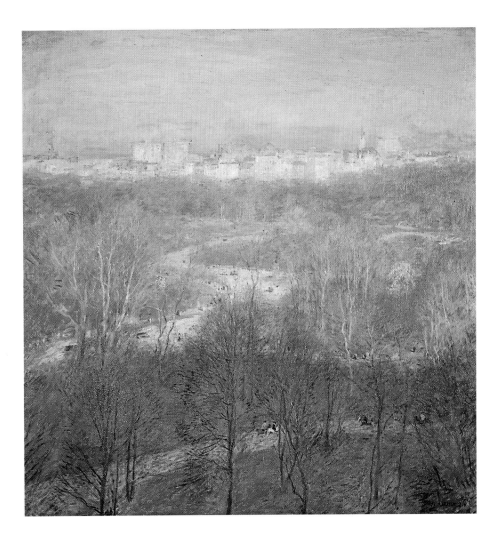

tentious; the first ones had been allowed in 1899, and during the first decade of the twentieth century, chauffeur-driven motorcars skirmished with coachman-driven carriages, which resulted in frightened horses and torn-up pavement. The motorized vehicles won, and in 1912 (the year after Metcalf painted *Early Spring Afternoon, Central Park*) the carriage drives were asphalted to make them more suitable for high-speed automobiles.[25]

Long before Metcalf painted his view, artists had positioned themselves inside the park and juxtaposed the natural environment with the soaring skyline. Chase introduced this motif into a number of his park scenes around 1890; we have seen, for example, the tiny images of the Brokaw and Lawrence homes in *Lake for Miniature Sailboats, Central Park* (plate 97). A range of buildings appears much more prominently, though still in the distance, in his unpopulated *View from Central Park* (Mr. and Mrs. Ralph Aryeh). Here Chase recorded the twenty-five-acre (ten-hectare) Sheep Meadow, between Sixty-sixth and Seventy-first Streets, the broadest plane of uninterrupted lawn remaining in the park (though without the sheep that had first been allowed to graze there in 1864). The meadow's almost limitless spread contrasted with the large turreted redbrick Navarro, or Spanish, Flats—an eight-building apartment complex, located at Seventh Avenue and completed in 1882, that initiated the development of Central Park South.

Multiple-unit dwellings for a middle- and upper-class clientele were a controversial innovation in New York. When these enormous buildings were first erected in areas of the city either uninhabited or occupied by extremely modest dwellings—sometimes literally shanties—they appeared grotesquely isolated. Setting them against a lovely segment of the park, therefore, considerably enhanced their image, as in Chase's rendition of the Navarro Flats and Charles F. W. Mielatz's inclusion of the Dakota in his etching *In Central Park* (plate 110). The Dakota, a communal palace in French château style, was built by Henry Janeway Hardenbergh at Seventy-second Street and Central Park West in 1884. The next year mammoth apartment buildings were restricted by a new law that was passed because private townhouse owners had complained about the loss of light and air caused by the erection of tall apartment houses.[26] Nevertheless, the Dakota was the linchpin for the development of the Upper West Side, and though the area appears only peripherally in paintings, prints, and illus-

110. Charles F. W. Mielatz (1864–1919). *In Central Park*, etching from Mariana G. Van Rensselaer, "Picturesque New York," *Century*, December 1892.

142

111. Colin Campbell Cooper (1856–1937). *Central Park*, c. 1927–31. Oil on canvas, 36 x 36 in. (91.4 x 91.4 cm). David Findlay, Jr.

trations of the period, the incorporation of this region into the fabric of the city was yet another aspect of the New New York.

Meanwhile the Dakota appeared strangely detached from the rest of the city in Mielatz's lovely etching, but the artist solved the problem by situating it centrally in the distance, behind a very pastoral park view seen from the edge of the lake. In the bright sunshine, figures walk and sit on benches on the path bordering the water, while swans swim in the distance. The largest tree, an evergreen, rises high in the middle distance, dwarfing the Dakota's peaked roofs while echoing their vertical rise. Mielatz incorporated the Dakota into the essence of the urban picturesque, quite correctly for an illus-

tration for an article entitled "Picturesque New York."[27] Mielatz was probably second only to Joseph Pennell as a printmaker of New York scenes, and preceded Pennell by a good number of years, having undertaken his earliest New York prints by 1888.[28]

Many painters in the early twentieth century positioned themselves inside the park and looked out at the New York skyline. Colin Campbell Cooper chose such a viewpoint in *Central Park* (plate 111), with the Gapstow Bridge in the foreground. This stone bridge, which crosses the northern end of the pond situated in the southeast corner of the park, was built in 1896 to replace an earlier wood-and-cast-iron structure.[29] In the middle distance is the park carousel, operating since 1870, beyond which rise the tall buildings on and just off Central Park West, beginning at Seventieth Street. The low, temple-fronted Shearith Israel synagogue (1897) appears at the left, while the Majestic Apartment Hotel is in the center of the skyline, at Seventy-second Street (it was replaced by the present Majestic in 1931). The tall structure that is the focus of Cooper's picture is the Oliver Cromwell, an apartment house just beyond the Majestic on West Seventy-second Street, designed by Emery Roth in 1926–27. Thus, though undated, the picture must have been executed between 1926 and 1931. It may be that the soaring tower of the Oliver Cromwell inspired Cooper to create this picture—a late reflection of his thirty-year celebration of the New New York. Cooper carries the viewer from the rustic bridge, through the children's amusement center, to monumental structures of material and spiritual existence, culminating in the most recent and the most towering.

Arthur Clifton Goodwin also chose to depict the park in the snow in his *View of the Plaza from Central Park in Winter* (plate 112), picking a position very close to that selected by Cooper but turning instead toward the southeast and focusing on Central Park South. Both the old Plaza Apartment Hotel (1891), built by Carl Pfeiffer at Fifth Avenue and Fifty-ninth Street, and Henry Janeway Hardenbergh's new Plaza Hotel, which replaced it in 1907, were popular subjects for painters, but these were usually street views. Goodwin featured the great hotel rising above the snowy paths of the park, with what may be the New York Athletic Club (1897) off to the right. Having been Boston's leading painter of urban scenes, Goodwin took a studio in New York City in 1919, and much of his work in the next decade was centered there, with Central Park a frequent base.

112. Arthur Clifton Goodwin (1864–1929). *View of the Plaza from Central Park in Winter*, c. 1920. Oil on canvas, 26 x 30 in. (66 x 76.2 cm). Herbert F. Johnson Museum of Art, Cornell University, Ithaca, New York; Gift of Dwight H. Emanuelson.

Edward Potthast was a neighbor of Cooper's in the Gainsborough Studio Building at 222 Central Park South, so that the park was extremely convenient to both of them. In 1896 Potthast had moved from Cincinnati to New York, where he remained for the rest of his career; in recent decades Potthast's reputation has been based to such a great degree on his numerous beach scenes that his other themes have been overlooked. In Manhattan scenes such as *In Central Park* (plate 113), as in his beach pictures, he focused mostly on genre activities, displaying a full range of modern city inhabitants—infants, small children, and adults in various combinations. This is a warm, late spring or early summer day, perhaps a weekend when the wealthy were out of town and only the hoi polloi remained to enjoy the park. For Potthast the park served as a safe and pleasant outdoor environment for the urban everyman, and the buildings, too,

are "typical" rather than monumental—as varied in size, shape, and color as the cast of characters below. His composition appears similar to those chosen by Cooper, Goodwin, and even Metcalf and Chase, with the city skyline rising up over the park, but Potthast aligned the path, lawn, and figures parallel to the avenue of buildings rather than leading the viewer through the park up to the towering buildings. The city therefore is seen more as backdrop than focus, more a factual presence than a glorification of the New New York.

As J. Horace McFarland wrote in 1904: "Beauty came even before food in Eden. And while we cannot restore man to the garden, we can . . . make the city garden-like."[30] Central Park as portrayed by the artists reflects the City Beautiful movement of the period, which attempted to merge order and beauty to provide a better way of life to the urban people of all classes. The painters working at the end of the nineteenth century projected this ideal in terms of the middle and upper classes, some of whom lived alongside the eastern sections of the park upon which these artists concentrated. The somewhat later painters included working-class figures, reflecting an awareness of the community needs that had motivated Olmsted's design of the park in the first place and that those in the City Beautiful movement recognized through their emphasis on recreational facilities.

113. Edward Potthast (1857–1927). *In Central Park*, c. 1915. Oil on canvas, 24 x 30 in. (61 x 76.2 cm). Jordan-Volpe Gallery, Inc.

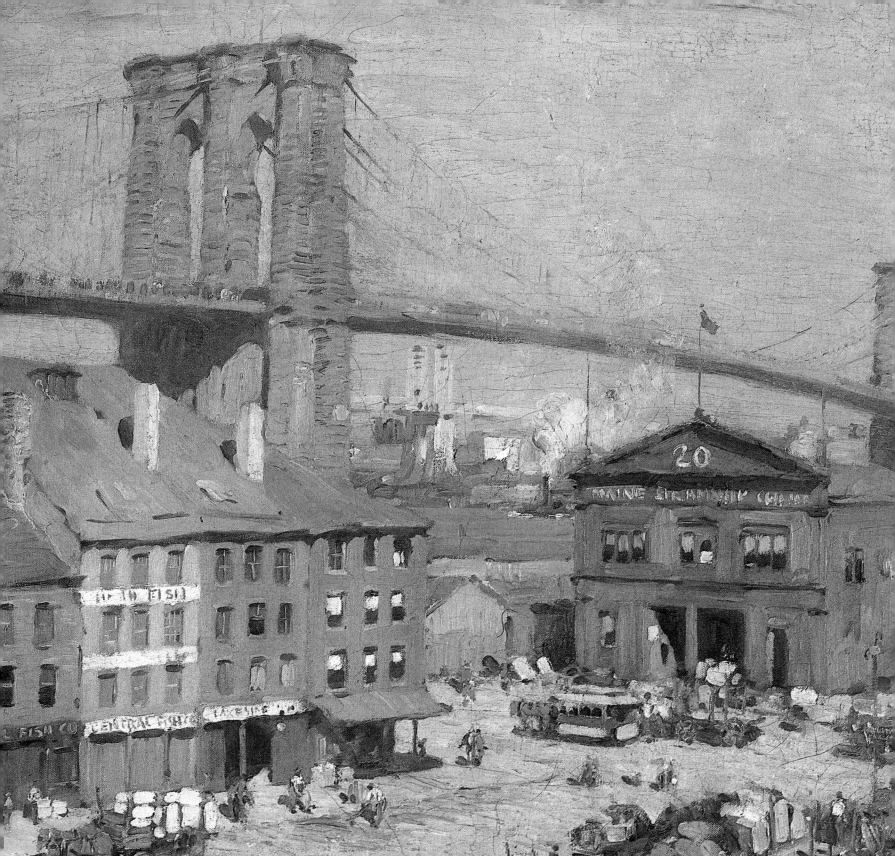

8

THE WATERFRONT AND THE BRIDGES

Manhattan's waterfront gained new prominence both as symbol and as enterprise in the late nineteenth and early twentieth centuries.[1] Nonetheless, the mainstream Impressionist painters usually avoided it, as one of the grittier aspects of contemporary urban life.

New York Harbor and Battery (plate 115), painted by the Scottish émigré painter Andrew Melrose in 1885, is one of the finest of traditional renderings of the city's harbor prior to the more innovative interpretations of the New New York. Here he presents an airy, sunlit scene on the Battery, juxtaposing the Castle Garden Immigration Station at the right with a tall-masted sailing vessel and a large steamship at left, while several immigrant families gather in the foreground; in the background is the Jersey shoreline and the Palisades. (Melrose lived in New Jersey along the Hudson, in Guttenberg.) The narrative is clear—the ships had brought the foreigners who had passed through Castle Garden and were now to make their way in America, as Melrose himself had done back in 1856. The busy activity in the harbor and the variety of other vessels—tugs and ferries, steam and sail—reflect the diversity of American society and provide an optimistic context for the new immigrants. Nevertheless, Melrose has avoided any sense of the developing metropolis, and his picture is as much a park landscape as it is an urban commentary.

Much greater vitality, in a more modern idiom, can be found in John Twachtman's *New York Harbor* (plate 116), painted around 1878–79, soon after Twachtman had returned from his sojourn in Munich. These are the "wretched, half-decayed and dirty"

114. Detail of Everett Longley Warner, *Along the River Front, New York,* 1912. See plate 134.

149

There are many harbors intrinsically more
beautiful than that of New York, but few
more interesting and none more busy.

Walter Prichard Eaton, "The
Harbor," *Scribner's Magazine* 49
(February 1911): 129.

piers described by James McCabe in 1872.[2] Just back from Venice, where he had been
involved with harbor depictions, Twachtman deliberately chose to paint such disrep-
utable subjects. The slashing brushwork and strong chiaroscuro, allied to the radical
manner he had earlier learned in Munich, are particularly appropriate to portraying
these functional, unbeautiful tugs and other small harbor vessels. Twachtman was to
adopt the formal strategies of the Impressionist aesthetic a decade later, but here he is
Impressionist only in his concern for the immediacy of a modern subject. Eliot Clark,
the most perceptive and devoted of Twachtman's early biographers, noted, "In New
York . . . he at once seized upon the pictorial possibilities of the harbor with its ship-
ping, docks and bridges."[3] The subject here may be the oyster boats docked at the
Oyster Market at Charles Street on the Hudson River, one block north of Tenth
Street.

It is characteristic that Twachtman avoided the great piers where the transatlantic
ships docked, farther up the Hudson River, and chose instead the more dynamic if less
glamorous section of the harbor, where the docks were "a tattered, dirty fringe to the
city."[4] Twachtman painted along the East River as well as the Hudson. His *Dredging in
the East River* (plate 117), probably painted around 1879,[5] is again a Munich-influenced

115. Andrew Melrose (1836–1901). *New York
Harbor and Battery,* 1885. Oil on canvas, 22 x 36
in. (55.9 x 91.4 cm). The New-York Historical
Society.

canvas of a New York harbor scene. The specific nature of the dredging procedure is not clear, but the dynamism of the scene, together with the considerable harbor activity in the background, suggests an agenda of municipal clearance and expansion; a national note is injected, too—the name of the dredging scow is clearly delineated as "America." It was almost surely a work somewhat similar to this that led W. Mackay Laffan to credit Twachtman for expanding the parameters of the American landscape. Laffan described the experience of sitting with an unnamed "extremist" artist near

> a long row of piling that projected far beyond the wharves and bulkheads out into the current of the [unnamed] river. . . . To the left there rose up a mass of great beams and stout weather-boarding, surmounted by a tall crane, that swung and creaked with its tackle, and projected its gaunt awkward arm against the morning sky. Ropes and chains hung from it, and an iron scoop at intervals ran swiftly up and down, in obedience to some hidden engine, dipping into noisy coal-barges below, and showering at each ascent a load of coal among the confusion of black timbers and iron rods and fixtures that crowned the mass itself. This was the scene of which the artist was seeking to make an impression.[6]

The modern waterfront appeared first in photographic and print illustrations, some of which documented the developing skyline that fronted on the harbor.[7] More significant for integrating the waterfront into the design of the New New York were those illustrations that emphasized port activity. The appropriately titled *New New York* (plate 118), published in Jesse Lynch Williams's article "The Water-Front of New York," features a maze of square-rigged ships—"symbols of the world's commerce"—located in the East River between South Ferry and the Brooklyn Bridge. Through and beyond these ascend the crests of the skyscraper skyline—among the best known are the familiar towers of the Manhattan Life Insurance Building (1893) at the left, the dome of the recent Commercial Cable Building (1897) right of center, and behind it, Bruce Price's American Surety Building (1895). The illustration appears to be taken from out in the river near Coenties Slip and South Street, just northeast of the Battery. The counterpoint of the two forms of commercial activity, one traditional and one very recent, is brilliantly established, with a national note inserted in the small American flag positioned almost precisely at the center of the composition.[8]

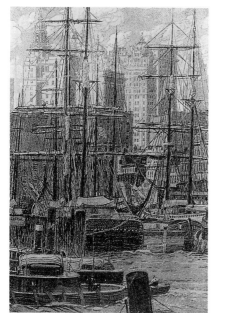

Henry McCarter's *Down along the Battery Sea-Wall* . . . (plate 119), another illustration for the same article, offers a different approach.[9] His vista, probably taken from a Jersey ferry, at the west end of the Battery, emphasizes the blocky forms of the urban mass, with the only conspicuous tower being that of the Manhattan Life Insurance Building at left. The tallest building at the right, with a crane still perched atop it, appears to be the Bowling Green Building (1898). McCarter's view of the city is juxtaposed with the riverfront and a boat terminal (perhaps the Fireboat Station), as well as a variety of river and ocean vessels, most of them out on the water. There is the bowsprit of a sailing ship in the foreground, a side-wheel ferry, several tugs, and a barge, with a large docked steamship. The emphasis here is less on the symbolic significance of the waterfront and more on the panoply of river and harbor traffic. We have already seen Alfred Stieglitz's 1910 photograph *The City of Ambition* (plate 89), where he played the soaring skyscrapers against the squat ferry and terminal in the shadowy foreground. Stieglitz's ferry is berthed at the terminal of the Central Railroad of New Jersey, having delivered commuter-rail passengers to Liberty Street, some of whom were surely employed in those same tall towers. Even the lowly ferry boat played its role in aggrandizing New York.

120. Henry Deville. *Fishing Boats—East River Docks*, from Mildred Stapley, "The City of Towers," *Harper's New Monthly Magazine,* October 1911.

Jesse Lynch Williams discussed the superiority of the East River waterfront, with the markets exuding their smells of the world, the ship stores, the sail lofts and sailors' lodging houses, and the overall charm of the sea, as opposed to the more prosaic railway ferry-houses and ocean steamship docks along the Hudson.[10] The East River, too, was more picturesquely chaotic, whereas shipping in the lower Hudson was more ordered, with distinct areas relegated to particular river and ocean crafts and functions. For turn-of-the-century artists and writers, the East River was certainly the more attractive and picturesque subject of the two.

There is an effective juxtaposition of tall-masted ships at dock with the pyramid of rising towers in *Fishing Boats—East River Docks* (plate 120), an etching by the French-born Henry Deville, who began specializing in views of the city's tall buildings around 1910. During his short career as an American etcher—Deville returned to France at the start of World War I—he ranked with Joseph Pennell and Charles F. W. Mielatz among the urban print-making specialists of the day. Deville, who was noted for choosing unusual urban vantage points, took pains here to illustrate the fascinating incongruity of old and new: "the dimensive extremes of the shipping, incessant, restless, wonderfully expressive foreground to the motionless cliff of buildings back of them. Vessels of every size and build move the surface of the water, or lie for a brief spell, tied to the very street-ends, discharging their cargoes animate or inanimate."[11] The scene is possibly from the vicinity of the Fulton Fish Market on South Street or farther south, near the foot of Wall Street; the tallest building in the painting bears some resemblance to the Mutual Life Insurance Company at Cedar, Nassau, and Liberty Streets.

In contrast to Deville's juxtaposition of the old and the new, the illustrations from James B. Connolly's 1905 article "New York Harbor," such as *The East River, Brooklyn Bridge in Background* (plate 121), emphasize the vigorous dredging activity: "the clanking dredges, raising mud ceaselessly, and their scows moored alongside"; the ubiquitous tugs: "The East River . . . seems to belong to towboats"; and the large ocean-going steamers passing under the Brooklyn Bridge, that great symbol of modern engineering.[12] Here the author and his illustrator intended to associate the tremendous volume of traffic crossing the bridge with that taking place beneath it. Whereas the Hudson River docks sheltered most of the North Atlantic liners, the great vessels on

the East River were from foreign fleets and often carried exotic cargo—still another attraction among the pictorial and literary associations of the East River.

One of the first Impressionist painters to investigate East River subjects was William Merritt Chase, who may have been inspired in part by the New York harbor paintings of his Munich colleague, Twachtman. In the later 1880s Chase painted many small oils at the Navy Yard, on Gowanus and Gravesend Bays, and elsewhere along the Brooklyn waterfront. Henry Ward Ranger's somewhat later *East River Idyll* (plate 122) is a relatively rare Tonalist scene of the river. His view is believed to have been taken from a street on Manhattan's Lower East Side, looking across to the Williamsburg district of Brooklyn, but it may instead depict a view toward Greenpoint, just north of Williamsburg, and the church in the distance may be Saint Anthony's Roman Catholic Church (1873) at the head of Morton Street on Manhattan Avenue. In either case, what is significant is that the distant view focuses on a church, rising above the warehouses and sailing vessels and adding a spiritual component to the scene.[13] The dreary darkness of the street and the wharfside activity in the foreground belie the title and

The most casual eye may find delight in noting how softly building fades into building in the heart of the town, and with what rich variety of tone the smoke of steamers and factories on the water-front merge into the surrounding gray. There are dull days in summer that take a tinge of color from green trees and vines, and there are dull days in winter that catch up a sheen of white from a mantle of snow. Most beautiful of all are the flurries of snow-flakes, in which the commonest city sights loom vague and mysterious.

John Corbin, "The Twentieth Century City," *Scribner's Magazine* 33 (March 1903): 259.

anticipate Robert Henri's city paintings of a few years later, though Ranger has organized his composition according to traditional classical norms.

Perhaps the first painter to interpret New York Harbor in a fully Impressionist mode was Theodore Earl Butler. Butler had become the American mainstay of the art colony in Giverny, France, by dint of marrying Claude Monet's stepdaughter Suzanne Hoschedé-Monet. After Suzanne died in 1899 Butler maintained his position in the Monet household by marrying Suzanne's sister, Marthe, on October 31, 1900. In between, Butler took his children back to America, and his joyous response to New York was evident in the paintings he created during about six months in 1899–1900, which constitute some of his finest work. The East River figures significantly in many of these canvases, such as *East River* (plate 123), in which the harbor is filled with tugs and ferries, while the smoke billowing from their funnels carries the eye to the distant

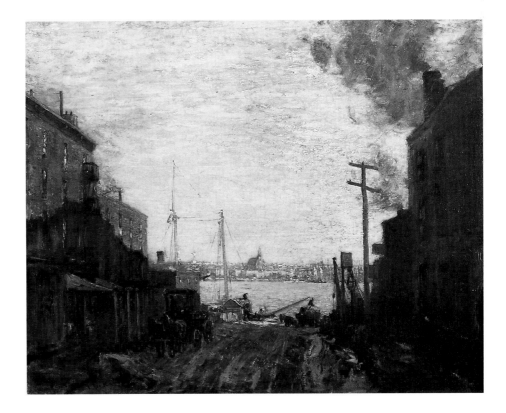

skyline of tall buildings. Butler generalized his forms so that certain identification is tricky, but the tallest building at the center is likely the American Surety Company. The artist seems to have positioned himself on the Brooklyn Bridge, the subject of a number of his other New York canvases, with the Fulton Street Ferry in front of him. (This facility continued its busy operation until 1924, although ferry traffic to Brooklyn declined after the opening of the Brooklyn Bridge in 1883.) Butler's vigorous brushwork lends excitement and exhilaration to the dynamic scene, as does the bright Impressionist palette.

A number of Butler's New York canvases appeared in his one-artist show at the Durand-Ruel Galleries in New York City in March 1900, including three versions of *The East River*.[14] In other New York canvases Butler often included three-masted sailing vessels; one of these appears along with a ferry in his *Statue of Liberty* (plate 124), one of two canvases on that subject that he painted and showed with Durand-Ruel in 1900. Though often reproduced in prints, photographs, illustrations, and posters, the statue had not been a favorite subject of earlier American painters, with the exception of Edward Moran, who depicted it a number of times. One difficulty may have been locating an advantageous vantage point; Butler's is quite peculiar, both fairly close up and yet from on high. One critic stated that it was taken from the top of a downtown skyscraper, but it is difficult to determine what building might be close enough; the Washington Building or the taller Bowling Green Building are the most likely candidates.[15] In Butler's several canvases of the gigantic sculpture it appears almost spectral, nearly dissolved in the mist that enshrouds the scene.

A gift from the people of France to the United States, Frédéric-Auguste Bartholdi's Statue of Liberty, dedicated in 1886, was a bridge between the two nations. It was not only an agent of welcome to the expatriated Butler and to his children, arriving for the first time in their father's native land, but also a beacon of deliverance. Butler's representation seems a symbol of release from personal sorrow, in contrast to Harry Fenn's illustration of *Liberty Enlightening the World* (1886), which shows Liberty's lofty torch breaking the top edge of the sheet and uniting with the beneficent rays pouring down on New York from the heavens, and Joseph Pennell's *Hail America*, a mezzotint of 1908; in both of these illustrations the colossal sculpture in New York Harbor seems to embody the national image of liberation and embrace.[16]

ABOVE
123. Theodore Butler (1876–1937). *East River*, 1899. Oil on canvas, 30 x 40 in. (76.2 x 101.6 cm). Private collection.

OPPOSITE
124. Theodore Butler (1876–1937). *Statue of Liberty*, 1899. Oil on canvas, 40 x 30 in. (101.6 x 76.2 cm). Private collection.

Probably just a few weeks after Butler left for France, Henri came back to America from Paris and settled in Manhattan. With the help of his Philadelphia colleague William Glackens, in August 1900 Henri took a place overlooking the East River on East Fifty-eighth Street; a year later he moved to a studio in the Sherwood Studio Building on West Fifty-seventh Street at Sixth Avenue. Urged on by his dealer, William Macbeth, Henri resolved to devote the next year to depicting New York City. He painted in various sections of Manhattan, such as Central Park, but concentrated on the river and the harbor. These are somber, dusky canvases, embodying a "dark impressionism," allied with the earlier work of his idol, Edouard Manet; they also recall his own previous work in Philadelphia and Paris. But in those cities he concentrated on street scenes; in New York he devoted himself to the city's river traffic and its shore.

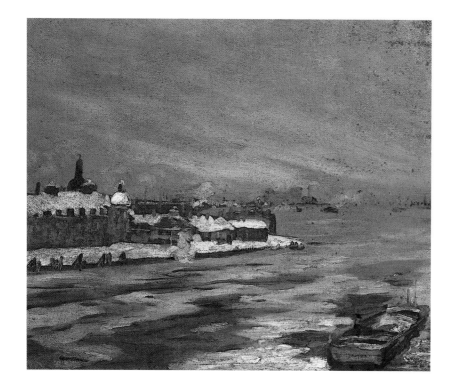

Typical of these pictures is his *Blackwell's Island, East River* (plate 125), which records the river traffic during his first winter in New York. This is almost surely a view from Henri's own windows; soon after he moved to East Fifty-eighth Street, he boasted to Macbeth that he had "a view of the river from both ends of the house."[17] Henri's wife, Linda, described their location as "right on the banks of the East River—and out of both the front and back windows that river is fine—busy little boats hurrying by—and big white river steamers."[18] This was a gritty part of New York, not at all the elegant Sutton Place neighborhood of today; right across from it, on Blackwell's Island (now Roosevelt Island), were city buildings of public health, welfare, and correction. One of these was the Charity Hospital, the building visible in this painting. It was built of gray stone quarried on the island by prisoners from the penitentiary, which was situated just north of the hospital and directly opposite Henri's home. The seasonal harshness of the painting mirrors the grim subject matter.

Henri's Philadelphia colleague Everett Shinn had depicted a similar scene even earlier in the pastel *Barges in the East River* (1898; private collection). Henri's new acquaintance Maurice Prendergast produced several watercolors, including *The East

125. Robert Henri (1865–1929). *Blackwell's Island, East River,* 1900–1901. Oil on canvas, 20 x 24¼ in. (50.8 x 61.6 cm). Whitney Museum of American Art, New York; Lawrence H. Bloedel Bequest.

River (Museum of Modern Art, New York) and *East River Park* (private collection), in 1901. These are warmer weather pictures, executed father upriver at East River Park (now Carl Schurz Park), around Eighty-sixth Street; Astoria, Queens, can be seen across the river. Some of the smoking chimneys visible in Astoria are those of the Edison Power Plant on Hallett's Point, hardly a fashionable setting for genteel urban imagery.

The barges in Henri's *Blackwell's Island, East River* are probably those of the Burns Brothers' coal company, which had its loading piers a block south on the East River. Industrial activity is underway also in *Derricks on the North River* (plate 126), one of the most dramatic of Henri's New York pictures. The derricks are probably supporting a pile-driving operation, with steam or air hammers driving piles into the Hudson River, in preparation for building piers. The wharfs and docks of both the Hudson and the East Rivers were for the most part raised on wooden pile foundations, unlike the massive stone quays of Europe. At the time Henri painted *Derricks on the North River*, criticism of the piers was rampant not only concerning their disheveled appearance but, more dramatically, the danger they posed to life and property. Just before Henri turned to painting the docks and river,[19] a conflagration on June 30, 1900, totally destroyed the North German Line premises across the river in Hoboken, with the loss of millions of dollars and many lives. With the company's terminal facilities seriously crippled, new pile-driving technology and the shift to concrete construction were issues frequently discussed.[20] Henri would surely have been aware of these issues and the substantial literature they generated.

The operation is clearly demonstrated in George Herbert Macrum's *Pile Driver* (plate 127), a scene on the Hudson, with the New Jersey Palisades easily distinguishable across the river. Macrum, little remembered today, was an urban specialist working in a somewhat Tonal Impressionist manner; like Lawson, he often painted in the northern reaches of Manhattan, where this picture may have been executed.[21]

For *Derricks on the North River*, Henri too had moved over to the North, or Hudson, River, as documented in an inscription on the back of the canvas: "Summer Evening/North River." Although the precise location is not identified, it was probably painted at the foot of West Twenty-third Street. This was a section of the city that many of the working class, as well as Henri, knew well, for the Erie Railroad pier and

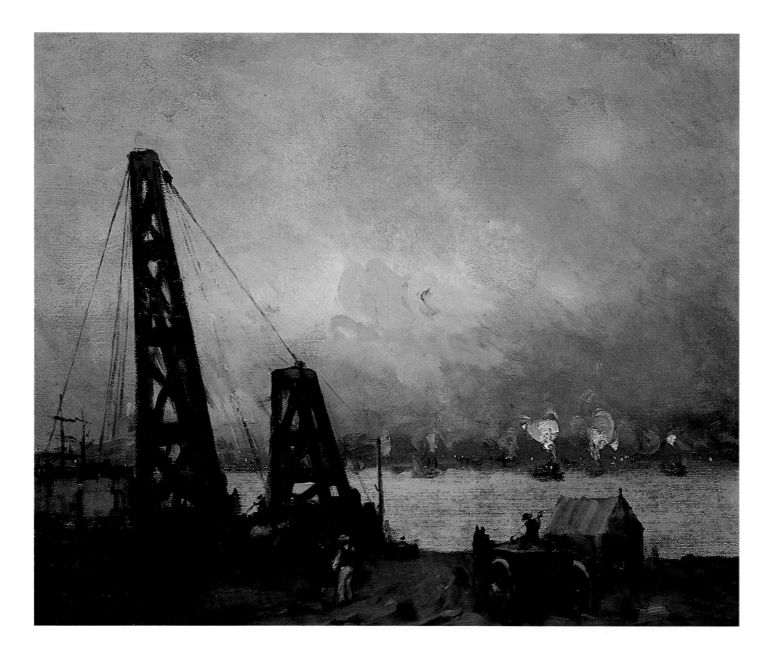

one of the docks for ferries to New Jersey were located there; it was also, characteristically, an industrialized area, with railroad-car barns and lumberyards.[22] In the distance, puffs of smoke identify the small ships, tugs, barges, and ferries to and from New Jersey. This seems to be one of Henri's last New York pictures, for it is listed in his record book as "Derricks on the North River. Dec. 1902."[23] Presumably, then, the scene was actually painted months after Henri first witnessed it, based on an oil sketch done on the spot and also recorded in the record book but now unlocated.

William Glackens painted a number of scenes of New York Harbor and the East River at the same time Henri was depicting similar themes; the Statue of Liberty makes a rare appearance off in the distance in his *Breezy Day, Tugboats, New York Harbor* (before 1908; Milwaukee Art Museum). Glackens's Manet-influenced *East River from Brooklyn* (plate 128) was executed from a position across the mouth of the river. A group of

OPPOSITE

126. Robert Henri (1865–1929). *Derricks on the North River*, 1902. Oil on canvas, 26 x 32 in. (66 x 81.3 cm). Santa Barbara Museum of Art, Santa Barbara, California; Museum Purchase for the Preston Morton Collection, Chalifoux fund.

BELOW

127. George Herbert Macrum (1888–?). *The Pile Driver*, 1912. Oil on canvas, 20¼ x 24⅛ in. (51.4 x 61.2 cm). Pennsylvania Academy of the Fine Arts, Philadelphia; John Lambert Fund.

In New York Harbor the tide is so small that it can practically be neglected in so far as the construction of piers is concerned. . . . In most parts of New York Harbor there is a bottom of mud or sand which permits the driving of piles, giving about the cheapest pier foundation which could be imagined. . . . All that is necessary is to start a pile-driver to driving pile foundations, and a dredge to scooping out some of the sand or mud between the piers.

Williard C. Brinton, "Contrasts of New York and Foreign Harbors," *American Review of Reviews* 49 (May 1914): 579.

"river rats," naked young male swimmers, are entering the river in the left foreground, and in the middle distance the artist included a variety of vessels—a sailing ship, a side-wheeler, and a tug, with numerous other docked ships vaguely visible. The Brooklyn Bridge stretches across the far distance; the view seems to be from Red Hook, with perhaps the edge of Governors Island seen at far left. This may be the painting referred to as *East River* shown in the ground-breaking show of work by six of the future Eight in January 1904 at the National Arts Club; in reviews of that show all six artists, including Glackens, were referred to as "Impressionists."[24]

The picturesqueness of the East River was in sharp contrast to the more structured setting documented by Edmund W. Greacen in his *Docks, Hudson River* (plate 129). This is almost surely the *West Street Docks* that was included in the 1912 Winter Exhibition

128. William Glackens (1870–1938). *East River from Brooklyn,* 1902. Oil on canvas, 25⅛ x 30 in. (63.8 x 76.2 cm). Santa Barbara Museum of Art, Santa Barbara, California; Gift of Mrs. Sterling Morton for the Preston Morton Collection.

129. Edmund W. Greacen (1877–1949). *Docks, Hudson River,* 1912. Oil on canvas, 26 x 32 in. (66 x 81.3 cm). Private collection.

of the National Academy of Design, the same show in which Macrum displayed *The Pile Driver*; this was one of Greacen's first New York scenes to be exhibited. In his soft, Tonal Impressionism, Greacen presents a panoply of small ships and other vessels, with some river traffic seen through the misty atmosphere. West Street, on Manhattan's Lower West Side, was home to about fifty piers, and it is difficult to determine more specifically where Greacen's scene is located. However, the intrusion of terminals out into West Street, as can be seen in the foreground building, occurred only along the harbor from Murray Street south; this may be the section of the docks just beyond Battery Place or those at the foot of Park Place. Pedestrian walkways can be seen straddling West Street to take passengers to and from the ferries and liners.

By and large we have seen little acknowledgment in these paintings of the city's prominence as the major shipping center for the nation's foreign commerce; nor are

warships or naval pageantry featured in such paintings.[25] Most of the mainstream urban Impressionists, painters such as Hassam and Cooper, were not drawn to the rivers and the harbor; that became much more the domain of artists such as Henri, Glackens, Lawson, Shinn, Prendergast, and Luks. This was consistent with the attraction for these painters of working-class neighborhoods rather than the white-collar and upper-class districts along Broadway and Fifth Avenue. These river and harbor scenes usually involved places like Red Hook, Astoria, and the Blackwell's Island Charity Hospital—plebeian subjects hardly characteristic of Impressionist painting. As such, these often dark Impressionists enlarged the vision of the New New York.

Impressionist painters paid much attention to the bridges that straddled the East and Harlem Rivers, linking Manhattan with its eastern boroughs. Bridges, of course, are dramatic structures, in forms utterly unlike the buildings and landscapes that they link or the ships that pass below them; they therefore add immeasurably to the variety that is the essence of the picturesque. They are familiar to all the classes that pass along them, some almost daily. And they richly support all forms of human endeavor—governmental, commercial, and social. But for the period under consideration, they also offered two additional pictorial and psychological enticements. First, they were often marvels of engineering, symbols in their own way of progress and modernity, and celebrated, like the skyscraper, as national achievements. And second, since they linked Manhattan with Brooklyn, Queens, and the Bronx, they reflected the expansion of the city—physical embodiments of the Consolidation Act of May 5, 1897, which approved a charter for an enlarged New York that went into effect on January 1, 1898. As of that date, New York consisted of 326 square miles (844 square kilometers), with a population of 3.4 million. Indeed, unification exacerbated the need for additional spans across the rivers surrounding Manhattan, in order to solve the problem of increased traffic.

The greatest and most pictured bridge was the Brooklyn Bridge, which was opened on May 24, 1883.[26] Proposals for a bridge connecting Brooklyn and Manhattan stretched back to 1800, but it was not until 1867 that Albany authorized a private bridge company to build and operate an East River bridge. German-born and -trained John Roebling, who had come to America in 1831, was appointed chief engineer in charge of the project. Roebling had initially conceived of a bridge across the

It will be our own fault if our imperial city is not made for all time the City of Beautiful Bridges.

John De Witt Warner, "The City of Bridges," *Municipal Affairs* 3 (December 1899): 663.

It so happens that the work which is likely to be our most durable monument, and to convey some knowledge of us to the most remote posterity, is a work of bare utility; not a shrine, not a fortress, not a palace, but a bridge.

Montgomery Schuyler, "Brooklyn Bridge as a Monument," *Harper's Weekly*, May 26, 1883, p. 326.

river in 1852, and in 1857 he proposed the present site for the structure, which would link the City Halls of Brooklyn and Manhattan. A decade later, after the Civil War, Roebling's conception became practicable. His death in 1869 from an accident connected with the building of the bridge kept him from seeing his dream to completion, but his son, Washington Roebling, carried on with the project.

With a length measuring over sixteen hundred feet (480 meters), the Brooklyn Bridge was the globe's largest span, with two decks carrying both carriages and trains (and later automobiles). Within a decade, about 100,000 people were passing over the span daily, and fifteen years later that figure had doubled, even after two other bridges were built between Manhattan and Brooklyn; in 1907 it had a single-day high of 423,000 people.[27] Celebrated as a symbol of "the will, the intelligence and the progress"[28] of the American government, the Brooklyn Bridge became a symbol of national innovation and technological world dominance, while at the same time its outstanding historical architectural feature, the great Gothic arches, were borrowed from the age of faith.[29]

An important factor in the aesthetic appreciation of the Brooklyn Bridge as well as the other spans in lower Manhattan was their scale. As John C. Van Dyke wrote in 1909:

Their approaches now reach down into streets where stand buildings of four and five stories, looking singularly mean and small by comparison; but the small buildings are coming down one by one, and will eventually be replaced by newer and higher ones which the size of the bridges anticipates. The Brooklyn Bridge in the lower city, brought into close contact with the down-town sky-scrapers, demonstrates the rightness of its proportions. The Singer, the Terminal, the Metropolitan Life, the Flatiron, the Times buildings, all belong in scale with the East River structures.[30]

A more negative sentiment was voiced by Henry James during his 1904–5 New York visit:

One has the sense that the monster grows and grows, flinging abroad its loose limbs even as some unmannered young giant at his larks, and that the binding

stitches must forever fly further and faster and draw harder; the future complexity of the web, all under sky and over the sea, becoming thus that of some colossal set of clockworks, some steel-souled machine room of brandished arms and hammering fists and opening and closing jaws. The immeasurable bridges are but as the horizontal sheaths of pistons working at high pressure, day and night, and subject, one apprehends with perhaps inconsistent gloom, to certain, to fantastic, to merciless multiplication.[31]

The reaction of H. G. Wells in 1906 provides perhaps the best analogue to the vision of many painters:

> More impressive than the sky-scrapers to my mind is the large Brooklyn suspension-bridge. . . . One sees parts of Cyclopean stone arches, one gets suggestive glimpses through the jungle of business now of the back, now of the flanks, of the monster; then, as one comes out on the river, one discovers far up in one's sky the long sweep of the bridge itself, foreshortened and with a maximum of perspective effect; the streams of pedestrians and the long line of carts and vans, quaintly microscopic against the blue, the creeping progress of the little cars on the lower edge of the long chain of netting; all these things dwindling indistinguishably before Brooklyn is reached.[32]

The bridge was memorialized in words, paint, and graphic design, though these tributes were not immediately forthcoming. Chromolithographs by Currier and Ives and Charles Parson promptly documented the appearance of the bridge, but professional painters appear to have ignored it at first, except for scenes of its inauguration, as in John Mackie Falconer's *Fireworks at the Opening of the Brooklyn Bridge* (1883; Long Island Historical Society, Brooklyn). In general, artists appear to have had difficulty in coming to terms with the pictorial possibilities of the bridge, perhaps because it was out of sync with the old, low-lying, horizontal New York. Only as the skyscraper city developed were painters able to relate the bridge, both architecturally and philosophically, to its urban association. Even then, one of the earliest professional paintings, *Brooklyn Bridge* (plate 130), was by William Louis Sonntag, Jr., better known today as an illustrator of New York urban life. Sonntag here presents the bridge from below, from

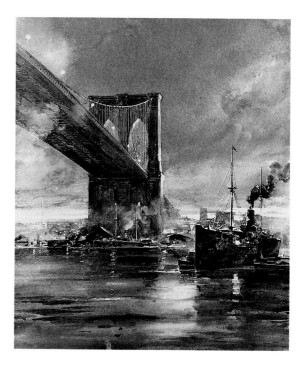

130. William Louis Sonntag, Jr. (1869–1898). *Brooklyn Bridge*, c. 1895. Watercolor with tempera on paper, 18 x 15 in. (45.7 x 38.1 cm). Museum of the City of New York; Gift of Mrs. Frederick A. Moore.

This massive and giant work [the Brooklyn Bridge], with its majestic towers and simple Gothic arches, with its tons of iron stretched from shore to shore, and over an immense span, is, to the eye and fancy, full of lightness and grace. The curves of the span are exquisitely perfect. The whole structure, which might have been an ugly and awkward mass, is like a delicate gossamer network poised ethereally above the river and its cities.

"New York Topics," *Boston Daily Evening Transcript*, May 26, 1883, p. 23.

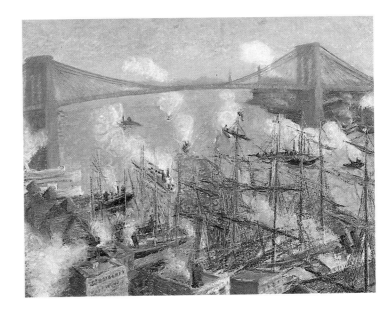

131. Theodore Butler (1876–1937). *Brooklyn Bridge*, 1900. Oil on canvas, 30 x 40 in. (76.2 x 101.6 cm). Courtesy Maxwell Galleries, San Francisco.

either the river or the edge of the shore, looking up against the span and tower of the bridge, silhouetted against the deep blue of the night sky. The city itself—Brooklyn or probably Manhattan—is minimalized, and the bridge is played off against the large steam vessels passing below it; like the bridge, these are modern icons of movement and passage. The view is most likely to the west—this is presumably a sunset—and the bridge seems to thrust into immeasurable space.[33] Likewise, the ships are moving out of the East River and into the harbor, on their way to distant destinations. The scene thus becomes a metaphor for the vastness of both the nation and its destiny.

John Twachtman may have been the earliest Impressionist painter to tackle the bridge, probably about 1887–88. In *Brooklyn Bridge* (private collection, Cincinnati) he assumed a vantage point similar to Sonntag's, but at the edge of a pier below the bridge, perhaps on Peck Slip at the end of Ferry Street, with tugs, barges, and sailing vessels below.[34] Theodore Butler, in his several renditions of the Brooklyn Bridge (plate 131), moved farther south and away from the East River;[35] more significantly, he also moved to an upper story or the rooftop of a tall building, so as to present a complete panorama of city and shore, with ferries crossing over to Brooklyn and both steamers and tall-masted ships berthed along South Street. The long axis of the bridge is balanced by

the strong diagonal of the commercial buildings in the foreground, receding north, and although no skyscrapers are in view, their presence is insinuated by the fact that the viewpoint is high above the adjacent buildings, with six-story structures appearing far below. Smoke from both vessels and buildings activates the view even more; in one of Butler's renditions of this scene an American flag rises up at the left, celebrating his return to his native land as well as adding to the Impressionist color display.

Childe Hassam painted the bridge a number of times—always in winter, it seems. The earliest is a grisaille watercolor and gouache, *Winter Day on Brooklyn Bridge* (1892; Berry-Hill Galleries, New York), which focuses on the traffic, pedestrian and vehicular, across the bridge. More panoramic is his *Brooklyn Bridge in Winter* (plate 132), taken from a position not dissimilar from Butler's but a bit closer to the Manhattan tower of the bridge. This is Hassam at his most Tonalist, with a predominantly blue-and-white color range. He integrated the bridge into the urban panorama through the snowy veil, with the rooftops in the foreground transformed into an even pattern by their covering of snow. The bridge appears less monumental here, and it is the aerial rather than the technological aspect of the structure that Hassam has emphasized.

This more Tonalist approach to the bridge was also taken by Edmund W. Greacen in 1916, in *Brooklyn Bridge, East River* (plate 133), though this is a stronger, more robustly

ABOVE
132. Childe Hassam (1859–1935). *Brooklyn Bridge in Winter*, 1904. Oil on canvas, 30 x 34¹/₁₆ in. (76.2 x 86.5 cm). Telfair Academy of Arts and Sciences, Savannah, Georgia; Museum Purchase, 1917.

OPPOSITE
133. Edmund W. Greacen (1877–1949). *Brooklyn Bridge, East River*, 1916. Oil on canvas, 29¹/₂ x 29¹/₂ in. (74.9 x 74.9 cm). Cummer Gallery of Art, Jacksonville, Florida.

colored picture than many of that artist's urban scenes. Greacen chose to paint the bridge from the north, perhaps from somewhere along James Street, contrasting the low-lying factory buildings in the foreground—Van Dyke's buildings "four and five storied . . . mean and small"—with the blue-toned bridge, which merges with the water and sky. The structures here are pretty anonymous—it is even possible that Greacen is painting the subject from the Brooklyn side of the East River, south of the bridge— but the large commercial buildings and the piers in front of them in the left distance suggest the area around Water Street in Brooklyn, with its warehouses such as the Grand Union Tea Company and the Tobacco Inspection Warehouse.

The juxtaposition and commingling of older, utilitarian commercial structures with the soaring bridge was a motif favored by Everett Longley Warner. His favorite subject, one he painted numerous times, was a view taken a few blocks south of the bridge from Peck Slip, as in *Along the River Front, New York* (plate 134). Warner positioned himself at the upper-story window of a building on the slip between Water and Front Streets. This is a sunny, animated scene in a busy, working-class neighborhood; fish is being brought from the docks, and several of the buildings on the slip are identified as the Mutual Fish Company, the Central Fish Company, and the Lakeside Fish Company—the Fulton Fish Market was only two blocks south. The building at the far left housed the Winona Fish Company on the ground floor, and above, the Globe and Sons Boat firm. This is a thriving commercial section of old New York, with the ramp of the great bridge sweeping above it, also alive with moving traffic.

Warner started painting in this part of New York about 1906, soon after having returned from study in Europe. He went back to the Peck Slip area in the early 1920s and took a room on the attic floor of a primitive old hotel on the corner of Fulton and South Streets, looking out at the Brooklyn Bridge. This was Jimmy Lake's hotel, and Sweet's restaurant there had been at one time the fashionable place for epicures to go for the finest seafood. Warner was intrigued by the commercial activity in the area and also enjoyed the old buildings with sloping roofs, which had "not entirely succumbed to the march of progress."[36] He recognized, too, that the bridge was essential to his concept of reconciling the old and the new, the human and the technological. Few painters have immortalized one section of the city as consistently as Warner did this region in the shadow of the Brooklyn Bridge.[37]

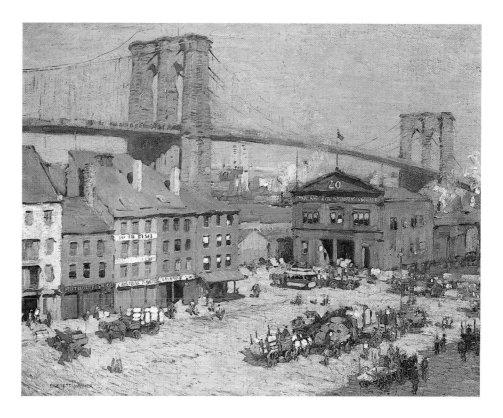

134. Everett Longley Warner (1877–1963). *Along the River Front, New York,* 1912. Oil on canvas, 32 x 40 in. (81.3 x 101.6 cm). The Toledo Museum of Art, Toledo, Ohio; Museum Purchase Fund.

One of the most romantic visions of the span is Edward Redfield's *Brooklyn Bridge at Night* (plate 135). As in the other large paintings of nocturnal New York that Redfield executed at this time, he provided a Whistlerian interpretation of the city, with the cables of the bridge appearing almost like a net or veil that further shrouds the great Gothic tower already enveloped in the darkness of night. Redfield's greatest interest in the scene is the play of lights on the bridge, the tall towers and waterfront buildings on shore, and the ferry- and tugboats on the East River, all reflected in the rippling water. His vantage point appears to be south of the bridge on the Brooklyn side, for the mass of tall buildings at the left seems inconsistent with the architectural development north of Brooklyn Heights in 1909.

Few painters of the Impressionist era stressed a modernist agenda of technological progress when interpreting the Brooklyn Bridge. Nor usually did those members of the Eight who painted it; it was not a favorite theme of these artists, though several did render it: George Luks from near Peck Slip in 1916 (Mr. and Mrs. Meyer P. Potamkin,

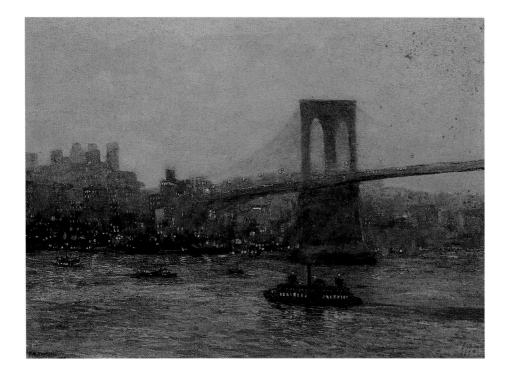

Philadelphia) and Ernest Lawson from deep inside lower Manhattan (Leslie Katz, New York City). Like the older Impressionists such as Hassam, these artists generally ignored the dynamism implicit in the Brooklyn Bridge and its relationship to the great metropolis, choosing instead to depict it bathed in snow or nocturnal atmosphere. Perhaps they were intimidated by both its majesty and its significance. It was the artists of a more advanced aesthetic, such as Leon Kroll, John Marin, Joseph Stella, and Max Weber, who exploited the bridge as an icon of modern technology.

As the nineteenth century ended, the city was all too aware of the traffic congestion on the one ramp over the East River and planned to remedy this with additional bridges; a call for a span over the Hudson also went forth, though this was a wider river and thus a more challenging proposition.[38] The building of the Williamsburg Bridge was inaugurated even before the borough consolidation of 1898, though it was not fully opened until 1903. Both the Manhattan Bridge—originally referred to as the Pike Street Bridge—and the Queensborough Bridge were opened in 1909, but of all these new bridges, only the last received much artistic attention, and no bridge ever rivaled the Brooklyn Bridge for pictorial enshrinement.

135. Edward Redfield (1869–1965). *Brooklyn Bridge at Night,* 1909. Oil on canvas, 36 x 50 in. (91.4 x 127 cm). CIGNA Museum and Art Collection, Philadelphia.

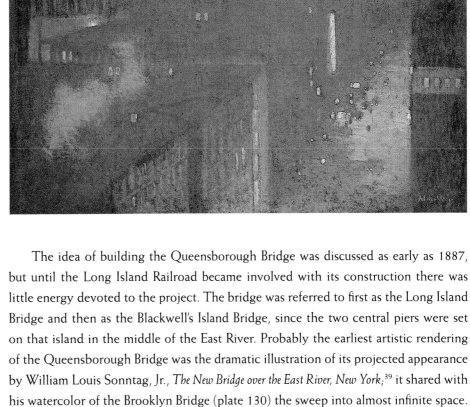

Weir has given us a supreme representation of the palpitating mystery of night, the suggestion of city lights and life, and the fascinating allure of a great human habitat. With a delicacy of tonal relations which is almost ethereal, he has rendered in material pigment the immensity and the mystery of night.

Eliot Clark, "J. Alden Weir," *Art in America* 8 (August 1920): 242.

136. Julian Alden Weir (1852–1919). *The Bridge: Nocturne*, 1910. Oil on canvas mounted on wood, 29 x 39½ in. (73.6 x 100.4 cm). Hirshhorn Museum and Sculpture Garden, Smithsonian Institution, Washington, D.C.; Gift of Joseph H. Hirshhorn, 1966.

The idea of building the Queensborough Bridge was discussed as early as 1887, but until the Long Island Railroad became involved with its construction there was little energy devoted to the project. The bridge was referred to first as the Long Island Bridge and then as the Blackwell's Island Bridge, since the two central piers were set on that island in the middle of the East River. Probably the earliest artistic rendering of the Queensborough Bridge was the dramatic illustration of its projected appearance by William Louis Sonntag, Jr., *The New Bridge over the East River, New York;*[39] it shared with his watercolor of the Brooklyn Bridge (plate 130) the sweep into almost infinite space. Artists may have been attracted to the span because of the attention it received in the press. That attention, in turn, was due partly to the impact of the increased flow of traffic and goods between the new areas of Queens and Long Island and Manhattan, and partly to the bridge's unusual cantilevered construction—the Queensborough is the only cantilevered bridge connected to Manhattan.[40]

Perhaps the best-known and certainly the most distinctive representation of the Queensborough Bridge is Julian Alden Weir's *The Bridge: Nocturne* (plate 136). This is a Whistlerian nocturne of the bridge almost fading into the night sky, seen from on high

above a dark Manhattan street and distinguished only by its electric illumination. This is one of two nocturnes that Weir painted at this time, and mystery, not majesty, is the essence of his interpretation. Given the obscurity of the scene, it is difficult to comprehend Weir's exact vantage point, but he seems to have been looking east from his apartment at Park Avenue and Fifty-eighth Street.[41]

It was not only the newer bridges in the lower regions of Manhattan that attracted artists; several of the spans across the Harlem River connecting the island to the Bronx, which are among the oldest of the city's bridges, also received considerable attention in the early twentieth century. They may have appealed in part because they differed so in scale and style from the bridges farther south, since the Harlem River was significantly smaller than the East River. As John C. Van Dyke wrote of these older spans, "They seem to belong to another city, an earlier age, and are grade-crossings, so to speak—little bridges twenty or forty feet above the water, with neither form, weight, nor color to distinguish them or dignify them."[42] This identification with the past was especially true of High Bridge (the city's oldest), which opened in 1848 at 175th Street, and of the Washington Bridge, at 181st Street, which opened in 1888.

Certainly the age of these bridges was partly responsible for their popularity with artists, and their distance from the usual painting sites probably also made them popular. In addition, the bridges were the sites of many recreational activities at the turn of the century. Boathouses offered rowboats for hire, and rowing clubs were active along the Harlem River. Horse racing was fashionable on the Speedway along the Harlem River below the two bridges; this was a four-mile drive, blasted from the rocks north of 155th Street, which took six years to construct. Visitors could stay at the Grand View Hotel at the top of the slope, just south of the Washington Bridge, which had a pier and a boathouse with ready access to the river. In 1893 the Washington Bridge was deemed "one of the most popular places of public resort in the city"; three years later it was called "the most beautiful link of our island with the mainland" and "a notable work of art."[43]

Of the two, it was High Bridge that was especially favored by artists and illustrators. Its series of closely spaced masonry arches resting on fourteen solid-granite piers allied the form of High Bridge to the aqueduct across the Roman Campagna, which had been a triumph of engineering in ancient times and was still standing as a heroic

137. William Henry Jackson. *Manhattan above 182nd Street (Washington and High Bridges)*, 1895. Photograph. Museum of the City of New York; Gift of Miss Bartlett Cowdrey.

RIGHT

138. George Schulz. *High Bridge*, c. 1895.

FAR RIGHT

139. Henry Ward Ranger (1859–1916). *High Bridge, New York*, 1905. Oil on canvas, 40¼ x 50⅛ in. (102.2 x 127.3 cm). The Metropolitan Museum of Art, New York; Gift of William T. Evans, 1907.

140. Charles Hinton. *This Is the Tired City's Playground*, from Jesse Lynch Williams, "The Water-Front of New York," *Scribner's Magazine*, October 1899.

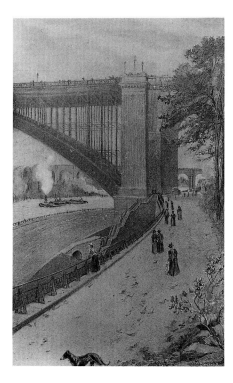

ruin, thus offering tremendous associative meaning for High Bridge.[44] High Bridge (originally called Aqueduct Bridge) was built primarily to carry water to Manhattan from the Croton Reservoir in Westchester. A pedestrian walkway was added in the 1850s, and it was extremely attractive in summertime, when visitors could enjoy the views as well as the park and picnic grounds at each terminus.

The Harlem River at the turn of the century also offered a more casual and rural atmosphere for the city's inhabitants. As Jesse Lynch Williams wrote: "There is a different feeling in the air up along this best-known end of the city's water-front. The small, unimportant looking winding river, long distance views, wooded hills, green terraces, and even the great solid masonry of High Bridge, and the asphalt and stone resting-places on Washington Bridge somehow help to make you feel the spirit of freedom and outdoors and relaxation. This is the tired city's playground."[45] Williams's depiction is mirrored in Henry Ward Ranger's *High Bridge, New York* (plate 139), with the sloping terrace of High Bridge Park at the right, contrasted with the towered city far to the south. The two worlds, one rural, one urban, are separated by High Bridge in the center, mirrored in the glistening waters. The soft, Tonalist atmosphere imparts an idyllic cast to the scene, and the medieval-style Highbridge Water Tower at the Manhattan end of the span, built in 1872 to equalize pressure in the Croton Aqueduct, adds a romantic note.

To paint this picture Ranger may have stationed himself at the entrance to the Washington Bridge, six city blocks north. This bridge is the subject of Childe Hassam's rare excursion into the upper reaches of Manhattan, the misidentified *High Bridge* (plate

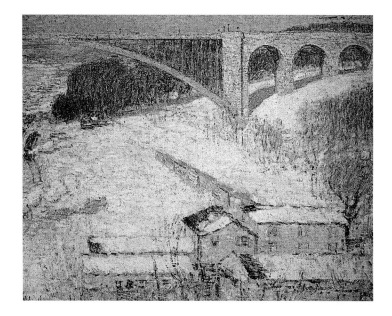

141). (The Washington Bridge has often been confused with the older and more famous High Bridge; the confusion was exacerbated when some of the masonry arches of High Bridge were replaced in 1923 with a single wide cast-iron arch, in order to accommodate boating and shipping interests. This caused that section of High Bridge to closely resemble its northern neighbor.) Painting on a sunny winter day, Hassam effectively used a bright color scheme of whites mingled with blue and purple shadows. The broad curve of the Washington Bridge's arch suggests both speed and space. Though the Harlem River may be partially frozen, traffic moves both on the bridge and below it; a train passes along the tracks of the Harlem River Railroad, making its way into the city. Hassam utilized a modern idiom to record icons of modern technology both above and below. His position was on the Bronx side of the river looking north, probably standing on High Bridge. When the picture, under the title *Washington Bridge*, was shown at the end of March 1902 at the Durand-Ruel Galleries, in the Fifth Annual Exhibition of the Ten American Painters, one critic found it "uncommonly successful in its use as a factor in composition of the arches of the fine structure over the Harlem River."[46]

Unquestionably, the artist most associated with these two bridges was Ernest Lawson.[47] He was uniquely drawn to the painting of bridges, viaducts, and aqueducts

ABOVE
141. Childe Hassam (1859–1935). *High Bridge*, 1902. Oil on canvas, 24 x 30 in. (61 x 76.2 cm). Private collection, Santa Barbara.

OPPOSITE
142. Ernest Lawson (1873–1939). *The Bridge*, c. 1912. Oil on canvas, 25 x 30¼ in. (63.5 x 76.8 cm). Art Gallery of Nova Scotia, Halifax, Canada.

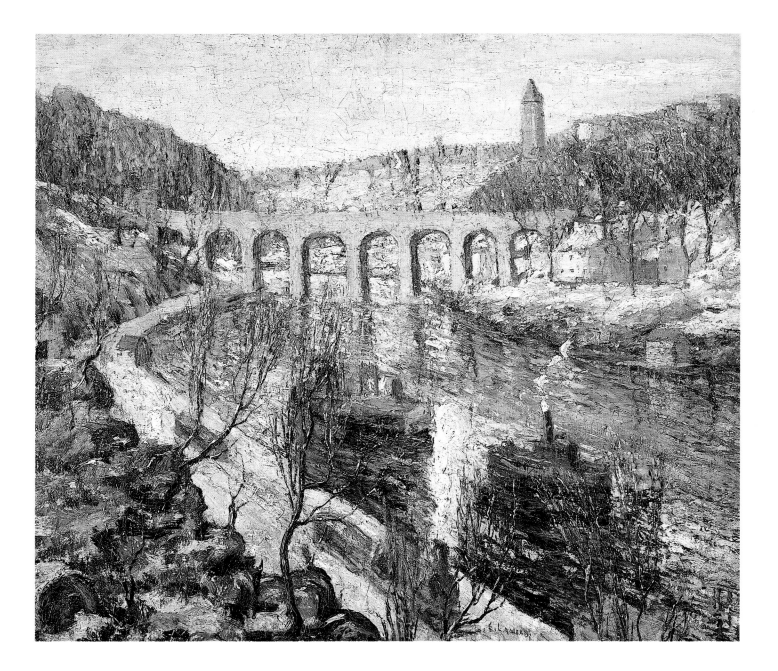

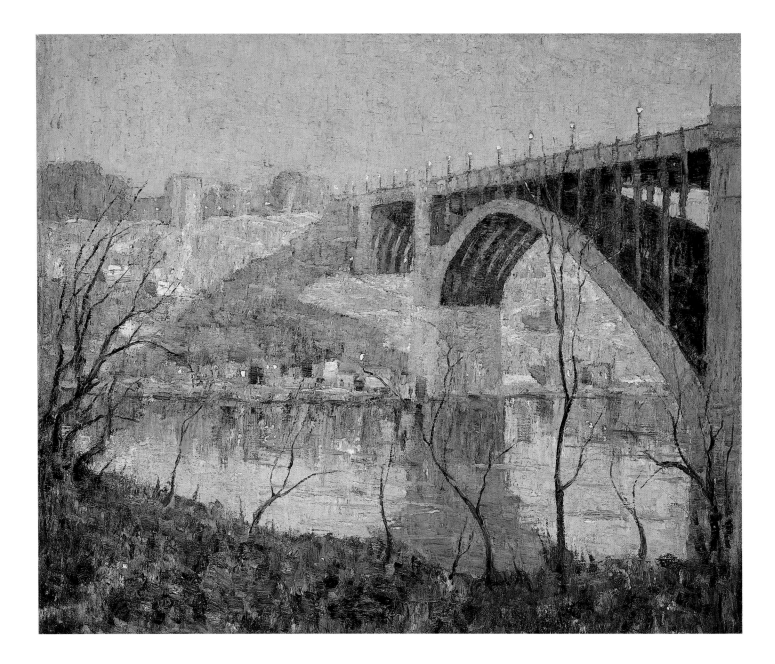

throughout his career, both in this country and abroad, from Little Falls, New Jersey, to Toledo and Segovia in Spain. Lawson resided in Washington Heights for several years, but after 1902 or 1903 he was far to the west, on 155th Street at the edge of Trinity Church Cemetery, and quite a distance from these two bridges. Yet they became his favorite site in which to paint, even after he moved downtown in 1905. The earliest records I have located documenting his pictures of the bridges date to 1903, about the same time he moved to upper Manhattan;[48] he thereafter recorded them in all seasons and from both the Manhattan and Bronx sides of the river. Determining the precise dates of his images can be difficult, though the gradual industrialization of the area and the fundamental change in the appearance of High Bridge in 1923 offer some chronological clues.

The Bridge (plate 142) depicts High Bridge, with its tower, from the Bronx—very likely from the Washington Bridge. It seems a relatively early foray into High Bridge imagery by Lawson, for the two sides of the river still look quite rural and undeveloped. In a sense it could be considered a companion to Hassam's image (plate 141), as the view is to the south, with trains now speeding north, away from the city. In keeping with the predilections of the artists of the Eight, this is a more industrial landscape, with the train an emphatic element in the composition, as are the tugs puffing along the East River.

Probably Lawson's best-known rendering of this region is *Spring Night, Harlem River* (plate 143), a lyrical image of the Washington Bridge specifically dated to 1913. The bridge, seen from the Bronx and looking toward the Manhattan side, is a strikingly solid, majestic image, set against the glowing lamps on the bridge, the lights of the shacks along the river, and those of the more substantial buildings on the heights above, all reflected in the water. The thick paint and rich colors, against the nocturnal blue, earned Lawson's palette the designation of "crushed jewels,"[49] and this rare nocturnal view does convey the poetry of the commonplace. This balancing of the modern structure with the scrubby landscape of this outlying region of the city constitutes Lawson's most singular contribution to the interpretation of the New New York.

143. Ernest Lawson (1873–1939). *Spring Night, Harlem River*, 1913. Oil on canvas mounted on panel, 25⅛ x 30⅛ in. (63.8 x 76.5 cm). The Phillips Collection, Washington, D.C.

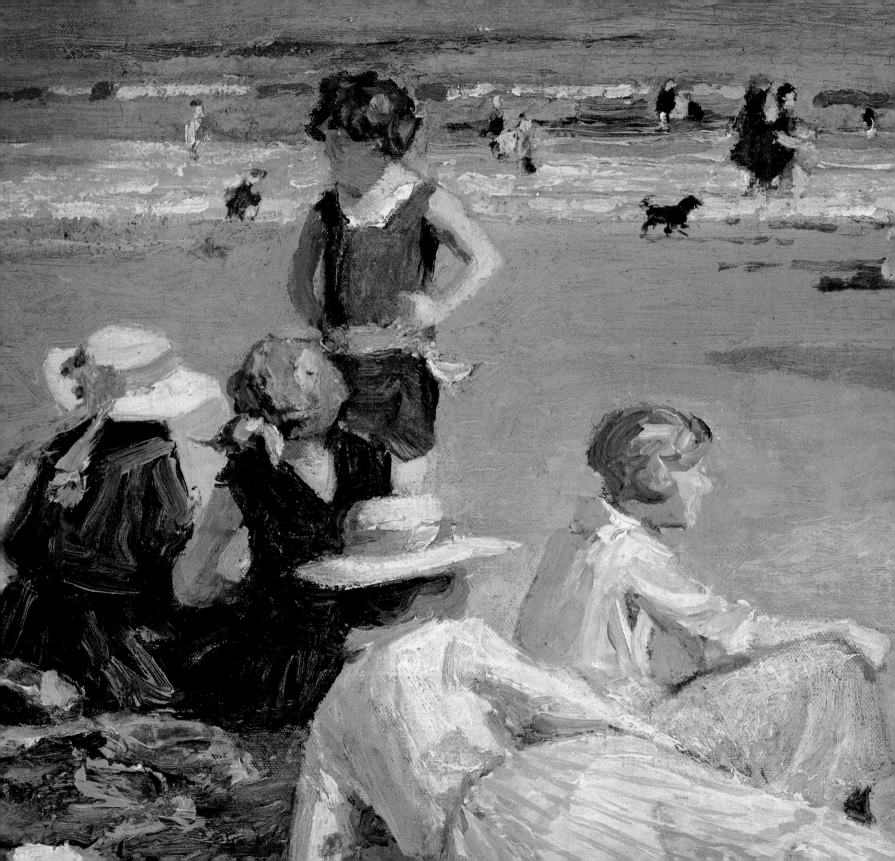

9

BEYOND MANHATTAN

Most of the Impressionist painters appear to have ventured beyond Manhattan for their subjects only rarely, with the exception of crossing a bridge to depict the island from the opposite shore. One of the few, and probably the most distinguished, Staten Island scenes is John Sloan's *South Beach Bathers* (Walker Art Center, Minneapolis), begun on June 24, 1907, after a visit to South Beach the day before, though not completed until over a year later. Likewise, Queens seems to figure almost exclusively as a background for East River pictures by artists such as William Glackens and Maurice Prendergast, although some painters did occasionally venture to Rockaway Beach.

The situation is different for the Bronx and especially Brooklyn. The more idyllic rural areas of the latter were memorialized particularly by William Merritt Chase for a relatively brief period in the later 1880s. Chase's Brooklyn pictures are not only among the most beautiful of all paintings of the borough, but they are also milestones in the history of American Impressionism; they can fairly be termed the earliest Impressionist pictures painted in this country. Though trained in academic strategies at the Munich Royal Academy and influenced by the Realist approach to art associated with the radical painting of Wilhelm Leibl and his circle in Munich, Chase subsequently became receptive to the art of Edouard Manet. He slowly came around to plein-air painting, and the color and light innovations of French Impressionism first appear in his pastels in about 1883–85. Chase therefore had already been involved with the methodology of Impressionism when the great Impressionist show sent over by the Parisian dealer Paul Durand-Ruel appeared at the American Art Association in New York City in April

144. Detail of Edward Potthast, *Manhattan Beach*, c. 1919. See plate 154.

1886. This exhibition, along with its critical notoriety, must have reinforced Chase in the direction he was taking his art, which first came to fruition in his paintings of Prospect and other Brooklyn parks.[1]

Though a number of painters depicted Central Park soon after its inception, these were essentially rural landscape views transplanted to the city. Urban park imagery was a new motif, essentially derived from French Impressionism. Both Manet and Monet painted Parisian parks, and Chase may have had an opportunity to see some of these pictures, but what is certain is that in April and May of 1886, just a month before he began to paint in Prospect Park, he saw at least one study for the most celebrated of all urban scenes: Georges Seurat's *Sunday Afternoon on the Island of La Grande Jatte* (possibly the 1884 version now in the Metropolitan Museum of Art, New York) was displayed in Durand-Ruel's Impressionist show at the American Art Association. Chase's pictures are very different, of course, far more genteel and lacking Seurat's enormous range of urban characterization, but Chase would certainly have paid close attention, especially since Seurat's paintings—his great *Bathers at Asnières* (1884; National Gallery, London) was also included—represented the most avant-garde aesthetic on view in that exhibition.

Prospect Park was the second of the great urban parks designed by Frederick Law Olmsted and Calvert Vaux.[2] Plans for the park were begun in 1859, as a competitive move to make Brooklyn comparable in grandeur to Manhattan. Like Central Park, it was intended to be an arcadian landscape within the urban confines, and one that would cater to the recreational needs of all classes. Culturally and financially, however, the park had a different agenda from its counterpart across the East River. Unlike the range from the very rich to the very poor that characterized Manhattan, Brooklyn was known as a bedroom community of clerks and "the married middle people."[3] But as James T. Stranahan, the president of the Board of Park Commissioners, stated, "Prospect Park will hold out strong inducements to the affluent to remain in our city, who are now too often induced to change their residences by the seductive influences of the New York Central Park."[4] The park was expected to gain higher tax revenues for the city from the influx of the wealthy, and property values in the vicinity of the park would dramatically increase. Meanwhile, property owners whose land was within the area designated for the park were paid to move, while the shanties, with their lower-class tenants, were quietly torn down.

Our artists cannot paint foreign themes with the sincerity which is within the reach of men who have felt them all their lives. . . . Mr. Chase shows us how many a happy refuge art may find along the busy wharves of a great city, or in the flowered and terraced avenues of a park. He studies a boathouse embowered in green, its pink roof reflected in the limpid water, and canopied pleasure-boats moored near by, and straightway we have a joyous little masterpiece.

"Mr. Chase's Pictures," *Chicago Tribune*, September 15, 1889.

The 525-acre (210-hectare) park was created on a tripartite scheme of meadows, woods, and water, with thatched-roof shelters and impressive stone bridges and arches placed strategically throughout. As in Central Park's Sheep Meadow, sheep were installed in Prospect Park's Long Meadow, the most open area, which ends in a heavily wooded section that includes Lookout Hill, the park's highest point. Below the hill is the artificial, fifty-seven-acre (twenty-three-hectare) Prospect Lake, dotted with islands; on its eastern shore were four log shelters for visitors. Above the lake is Concert Grove, where visitors could listen to music played on an island facing the grove. On both sides of the grove was a carriage concourse, and terraces fanned out from the grove, flanked by stone antepodia. The park was first opened to the public in October 1867 and was considered completed in 1874.

Though park statistics document annual visitors of around ten million in the late 1880s, there is no sign in Chase's pictures of such crowds of common folk.[5] He depicted only the middle class strolling through the urban landscape, relaxing on benches, playing croquet, or boating on Prospect Lake (see plate 145). The rustic

145. William Merritt Chase (1849–1916). *Boat House, Prospect Park*, c. 1897. Oil on canvas, 10¼ x 16 in. (26 x 40.6 cm). Margaret Newhouse, New York.

boathouse was situated on the Lullwater, an appendage of Prospect Lake linked to it by the park's most important span, Terrace Bridge. In addition to the boathouse itself, Chase recorded the rowboats and the canopied party boats, both of which were rented out in summer, though their high prices made them accessible only to more affluent visitors.

Chase's Prospect Park pictures appear to be quite self-contained; that is, the artist appears not to have been concerned with establishing the relationship of the park to the surrounding urban area, as he was later to do in some of his Central Park pictures. Chase painted specific sites within Prospect Park less often than he did later when investigating Central Park, though some documented examples—such as the oil *Bouquet Garden, Prospect Park* and the pastel *Shelter House, Prospect Park*, both shown in the Chicago Inter-State Exposition in September 1888—are now unlocated. Several of his pictures record the appearance of Concert Grove, including the pastel *Prospect Park, Brooklyn (South Terrace, Concert Grove)* (plate 147), filled with bright patches of sunlight passing through the heavily leafed trees. In the foreground is a walkway that ran along the base of the terrace, following the lake; in the background is John G. Draddy's 1879 bust of Thomas Moore, one of only two of Concert Grove's sculptures in place at the time. In Chase's pastel of the South Terrace and in another of the East Terrace (private collection), the artist was obviously fascinated with the architectural elements, whereas people and their activities are totally eliminated.

Chase's Brooklyn park pictures are undated, and it is difficult to determine an order in their execution; they were usually completed in a half-day's time, mainly in the month of June. He first showed a number of them in his one-artist show held at the Boston Art Club in November 1886, but the generic titles he assigned them then, such as *On the Lake—Prospect Park, In the Park, In Prospect Park, By the Side of the Lake, Pulling for Shore, Prospect Park—Brooklyn*, preclude easy identification with located pictures today, most of which also have only generic titles.[6]

A critic writing in 1913 noted: "A few years ago, Mr. Chase lived in Brooklyn, and wandered into the nearby park, sitting down almost anywhere in the lawn, beside the park road, with one or more buildings in sight. The canvases being small, one half day was devoted to each."[7] In fact, it may well be that the "nearby park" into which Chase wandered was *not* Prospect Park. Ronald G. Pisano has acknowledged that some of the

184

ABOVE
146. *South Terrace, Concert Grove*, from the folio "Views in Prospect Park, Brooklyn," 1887. Brooklyn Historical Society.

BELOW
147. William Merritt Chase (1849–1916). *Prospect Park, Brooklyn (South Terrace, Concert Grove)*, c. 1886. Pastel on paper, 9⁵⁄₁₆ x 13¹³⁄₁₆ in. (25.2 x 35.1 cm). National Museum of American Art, Smithsonian Institution, Washington, D.C.

Some landscapes from the strange region, as picturesque as anything in Holland or Normandy, between Prospect Park and the city of Brooklyn, might indeed suggest to our wandering landscape artists that they should not keep their eyes hermetically sealed while in their own country. . . . [Chase's] views of . . . Prospect Park scenery had the charm of life-like portraits, so true were they to the localities represented.

"The Slaughter of Mr. Chase's Pictures," *Art Amateur* 24 (April 1891): 116.

pictures "that have been identified as Prospect Park do not seem to conform in some of their details to the layout of the park; perhaps the setting for these works is another park."[8] And Dr. Barbara Gallati has suggested that a number of Chase's best-known Brooklyn park pictures actually feature Tompkins Park, in Bedford-Stuyvesant, a small Olmsted and Vaux park bordered on one side by Marcy Avenue, where Chase's parents may have lived.[9] Soon after Chase and Alice Gerson married in 1886, they lived with his parents in Brooklyn for a few months;[10] while there he began his celebrated series of scenes in Prospect and other parks. (He and Alice were soon back in Manhattan, but in the winter of 1886–87 Chase tightened his ties with the Brooklyn art world by teaching at the Brooklyn Art Association School.)

At least once Chase specifically designated Tompkins Park as his subject; in April 1888, at the Tenth Annual Exhibition of the Society of American Artists, he exhibited *In Tompkins Square, Brooklyn* (location unknown). Of course, Chase may also have painted in other Brooklyn parks, such as Fort Greene Park, and he is known to have painted the park at the Brooklyn Navy Yard. In 1888 he showed *A Little City Park, Brooklyn* at the Fourth Prize Fund Exhibition at the American Art Association, which by its title could not have been painted in Prospect Park.

A number of Chase's scenes of park visitors—often mothers with their young children or older children in groups (an emphasis surely related to Chase's new role as husband and father)—that have been previously designated as Prospect Park, such as *Prospect Park, Brooklyn* (c. 1886–89; Colby College, Waterville, Maine), may well be Tompkins Park pictures; this is true also of *A City Park* (plate 148). Chase used that title for a number of works included in early exhibitions of Brooklyn park scenes.[11] It seems likely that if these were in fact Prospect Park, he would have titled them as such, since Prospect Park had national renown. But for a small, pocket-size bit of greenery, he seems to have preferred the anonymous *A City Park*, particularly since there was the likelihood of confusion between Tompkins Square Park in Manhattan and Tompkins Park in Brooklyn.

The same buildings, presumably edging Tompkins or another Brooklyn park, appear in the background of *A City Park* and *Prospect Park, Brooklyn* as well as in the slightly desolate *Summer Scene in the Park* (formerly, Charles A. Green, Rochester).[12] The long, straight pathways in these works are very different from Olmsted's curves in both

185

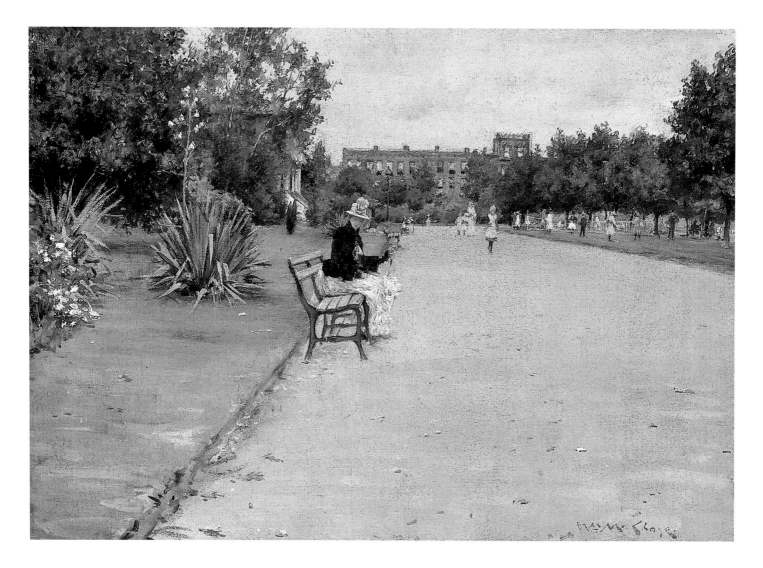

148. William Merritt Chase (1849–1916). *A City Park*, c. 1888. Oil on canvas, 13⅝ x 19⅝ in. (34.5 x 49.8 cm). The Art Institute of Chicago; Bequest of Dr. John J. Ireland.

Prospect and Central Park; Tompkins Park, however, is laid out in a series of such arteries.[13] The long, broad pathway rushing back into the distance was a compositional device favored by American and European painters during the 1870s and 1880s, and Chase used it in his pictures of smaller Brooklyn parks, thereby linking the park's landscape to the city around it. This is not an especially picturesque device, and Chase pretty much abandoned it when he began to paint in Central Park, but critics found it distinctive. One, admiring two paintings in a Chase sale in 1891 (each entitled *A City Park*), noted that "pictorial dignity is given by long straight lines of path running away from the eye."[14]

At the time, these Brooklyn park pictures aroused some admiration, often expressed in nationalistic terms. The writer for *Studio* (very likely its editor, Clarence Cook) contended: "Mr. Chase lives in his own time, belongs to it, and paints it as he sees it. . . . His best work is inspired by what he has found here at home; and while many an artist wanders helplessly about . . . we find Mr. Chase painting landscapes in Prospect Park, that need no ticket to proclaim them American."[15] When some of these pictures appeared in the Chicago Inter-State Exposition in September 1889, the critics were ecstatic. One writer noted the "series of richly colored studies of Brooklyn parks and docks, pictures gay, and joyous, and brilliant as a June festival, giving us the splendor of flowers, the brightness of sunshine on grass and walks, the vivacity of crowds in gala colors—scenes of richly colored life and pleasure."[16]

By 1889 Chase had begun painting Central Park, and the following year a controversy ensured his final abandonment of Prospect Park. Permits, which allowed only a few weeks' activity, were required for professional painters and photographers to work in the park. In June 1890 Aneurin Jones, park superintendent since 1887, refused a permit to Chase and his colleague Otto Toaspern, claiming that only amateur artists were allowed to sketch there. Jones—who had taken offense when Chase presented a Central Park permit for the whole season and demanded a similar privilege for Prospect Park—was later to admit that he had never seen such a regulation and could not recall how he learned of it.[17] The press had a field day castigating the superintendent as "Anachronism" Jones; he appears, in fact, to have been both ruthlessly restrictive and destructive, banishing bicyclists to barren areas of the park and cutting down trees to make new vistas.[18]

The Lexington, Kentucky, painter Paul Sawyier, who studied with Chase in New York at the Art Students League in the early 1890s, moved to Brooklyn in the autumn of 1913 and was active in Prospect Park during the next several years, painting oils and watercolors there. His pictures are very different from those of his former teacher, being almost totally focused on the natural elements of trees, lakes, and lawns, and usually eliminating the human presence. Sawyier's watercolor *Prospect Park, Brooklyn, New York* (plate 149) depicts a wooded area and a thin waterway, perhaps the Lullwater or more likely the natural stream that ends at Prospect Lake; in the far distance one can make out tiny figures and a bicyclist, which help identify this environment as a park. Sawyier's activities in the park were reported by an unnamed visitor to Edward Jackson, a successful art dealer at 320 Livingston Street, Brooklyn, who had offered Sawyier an exclusive contract and had sent the artist out to paint city scenes. The visitor said: "Do you know, Mr. Jackson, I saw this painting briefly one day . . . as it was being blocked in by the artist, while I was passing through Prospect Park. . . . He must certainly be some well-known artist, just relaxing like Mr. Chase used to do, they tell me, in our park."[19]

Sawyier was to emulate Chase also in painting pictures of the waterways surrounding Brooklyn, such as Jamaica Bay. Chase's Brooklyn harbor pictures are among his least documented and discussed, perhaps in part because it is almost impossible to match up presently located works with original records and to identify the coast and harbor sites. His original titles do indicate his extensive painting activity along the docks at the Brooklyn Navy Yard and Gowanus Bay. In most of these works Chase appears to have rejected the light and color that characterized his Prospect and Central Park pictures in favor of a gray, overcast atmosphere. When several of them were on view in 1891 one writer praised the "harbor views, where the tone is generally pale and gray and the mistiness of the atmosphere is excellently given."[20] These works, in fact, fared better with some critics than the more conventionally appealing park paintings: "The park scene and some of the figure subjects seem to us to have only a superficial interest. But the views along the Brooklyn docks, the Coney Island piers and stretches of summer sea, and many other local 'bits,' have been observed with the eye of a true artist and transferred to canvas with perfect skill."[21]

One of the best-known today of Chase's Brooklyn shore scenes is the pastel now called *Gravesend Bay* but correctly titled *Afternoon by the Sea* (plate 150).[22] More genre

149. Paul Sawyier (1865–1917). *Prospect Park, Brooklyn, New York,* 1914. Watercolor on paper, 11 x 17½ in. (27.9 x 44.4 cm). Kentucky Historical Society, Frankfort; Kentucky History Museum Collection.

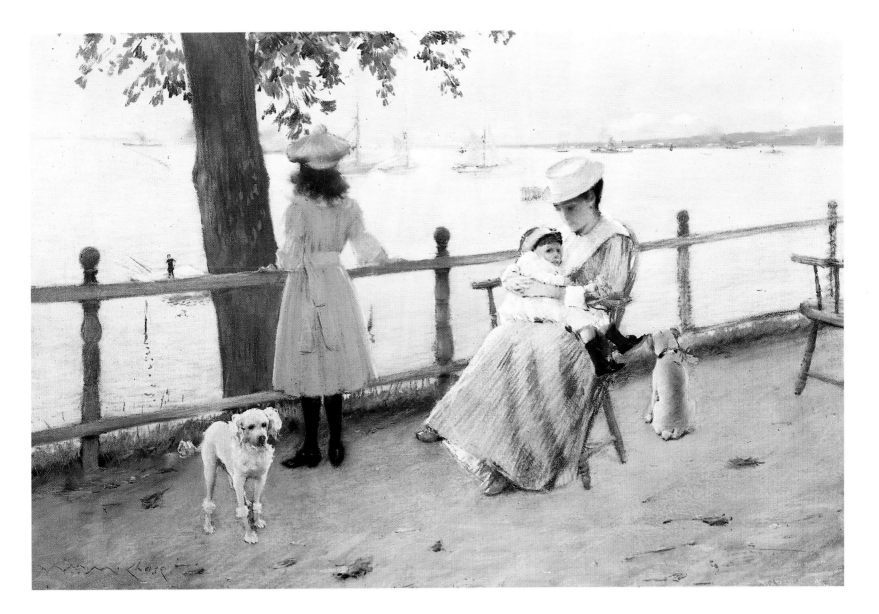

150. William Merritt Chase (1849–1916).
Afternoon by the Sea, c. 1889. Pastel on paper, 20 x
30 in. (50.8 x 76.2 cm). Courtesy of The Gerald
Peters Gallery, New York.

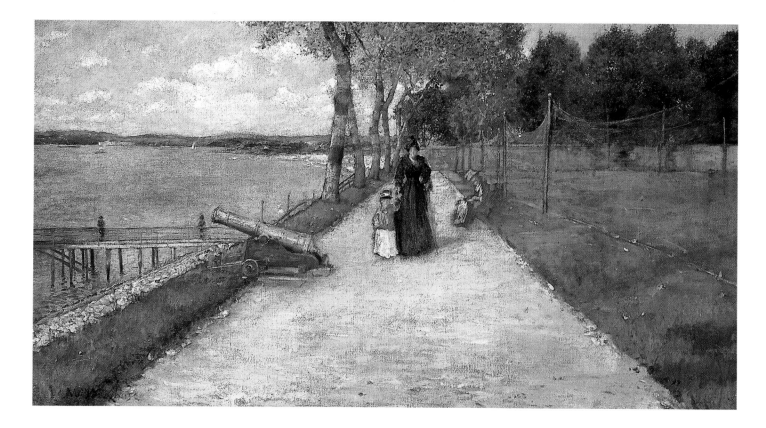

painting than landscape, it shares with Chase's Brooklyn harbor views the blue-gray Tonalist atmosphere. More personal than Chase's park or harbor scenes, this picture records the artist's summer interludes with his family in nearby Bensonhurst for several years beginning in 1887; one critic identified the site as overlooking the bay from a broad space on the cliff at Fort Hamilton.[23] This relatively remote vacation area had rich historic traditions, but whether Chase was at all cognizant that Henry Hudson had first dropped anchor in Gravesend Bay in September 1609 before exploring the Hudson River is not known. Gravesend Bay was also home to a much frequented race-track and posh hotels such as the Victoria Chateau, but Chase ignored all of that here to focus on an intimate family scene, with Mrs. Chase holding their firstborn child while Chase's sister, Hattie, stands at the rail overlooking the bay.[24] In the background the topography of the Bath Beach area, where the Chases summered, is carefully

151. William Merritt Chase (1849–1916). *Bath Beach, Bensonhurst,* c. 1887. Oil on canvas, 27 x 49¾ in. (68.6 x 126.4 cm). The Parrish Art Museum, Southampton, New York; Littlejohn Collection.

recorded. The specific site may be below the Marine and Field Club on Cropsey Avenue, near Bay Twelfth and Fifteenth Streets. The bay is filled with small sailboats, and farther out, steamships ply Lower New York Bay, with the distant coast of Staten Island visible beyond.

Chase's Bensonhurst residence was established to spare him the travails of domestic life, and *Bath Beach, Bensonhurst* (plate 151) reflects his remoteness from his professional world in the heart of Manhattan.[25] This picture was described years later in the Chase estate-sale catalog: "On the left is the blue-gray bay, looking up toward Fort Hamilton and across Forts Lafayette and Wadsworth to the Staten Island hills in the distance, and steamers appear dimly at the entrance to the Narrows."[26]

Peace, Fort Hamilton (plate 153) was probably painted in the summer of 1887, not far from the site of *Bath Beach, Bensonhurst.* Just to the west of Gravesend Bay, located at the present terminus of the Verrazano-Narrows Bridge, Fort Hamilton was a summer resort in the 1880s and 1890s, with the celebrated Grand View Hotel accommodating vacationers traveling on the Brooklyn City Railroad. Chase, however, concentrated on the military post, which was established in 1825 and completed in 1831, and still is in operation (plate 152). The fort, with its counterpart Fort Wadsworth on Staten Island,

commanded the waters between the Upper and Lower Bays, and it still had strategic significance during the 1880s. Improvements for stronger defenses at Fort Hamilton were recommended to keep up with advances in military science, and tests of the pneumatic dynamite torpedo gun took place at the fort in 1888.[27] Chase presents only a distant view of the fort in plate 153, ignoring the parade ground and large barracks and concentrating instead on the old cannons—the "twenty-four-pounders which recline peacefully in a hoary corner of the patched-up parapet."[28]

Chase was also active in depicting scenes along Brooklyn's beaches. Exhibition records document pictures by him of Coney Island, which would have been painted in the mid-1880s, but few of these have been located today. As the earliest Impressionist to record Coney Island, Chase may have been inspired to paint there by the recent activities of his close colleague Robert Blum, who provided illustrations for one of the most influential articles describing the resort, published in the summer of 1880.[29] Blum's illustration *Along the Beach* is nearly a reverse composition of Chase's *At the Shore* (Pfeil Collection). Blum's experiences at Coney Island would likely have been a topic of conversation at the Julius Gerson home, where Blum and Chase were among the many artist guests, and the two friends subsequently traveled to Europe together in June 1881.[30]

For later artists the Brooklyn beaches—Norton's Point (now Sea Gate), Coney Island (also known as West Brighton), Brighton Beach, and Manhattan Beach, along with Rockaway Beach in Queens—were less popular than might be expected of artists so enthusiastic about recording scenes saturated with bright sunlight. Since beaches often tend to look very much alike, the particular locales are usually difficult to identify, and it is not always clear that the scenes take place in greater New York. Coney Island is, and was, the most renowned of the beaches, and so it is likely that some pictures designated as Coney Island may actually have been painted in a neighboring beach community, although each had its own distinct features.[31]

New ideas about the health benefits of swimming and the salt air made beach recreation increasingly popular after the middle of the nineteenth century. The development of the railroad system during the 1870s gave the city dweller easy access to the popular seaside areas along Brooklyn's south shore. Between 1869 and 1877 five railway lines were built across Brooklyn leading to the ocean, and one could also board

To Coney Island hie ourselves and have a very pleasant afternoon and evening. The concert halls with their tawdry, gaudy, bawdy beauties are fine—and on the beach, the sand covered bathing suits of the women who look and "cavort" are great—look like soft sculptures full of real "vulgar" human life.

Sloan, in Bruce St. John, ed.,
John Sloan's New York Scene (New York: Harper and Row, 1965),
pp. 140–41.

a boat at the Battery and arrive an hour later at Locust Grove, Norton's Point, or Coney Island's famous iron pier. During the summer prosperous New Yorkers could join their families on the Brooklyn shore each evening and return to the city the next morning, refreshed and ready for business. But upper-class families began to abandon Coney Island as it was increasingly frequented by people of lesser means, and by the turn of the century it had become more an entertainment center than a residential enclave.

Bathing houses lined the beach, minstrel bands played on the boardwalk, and everywhere the shrill cry of barkers advertised carousels, shooting galleries, dance halls, and freak shows. Coney Island acquired a reputation for moral laxity, with Norton's Point at the far western end known as a refuge for criminals, gamblers, and prostitutes. The vice and crime associated with this end of Coney Island were mitigated by the electrification of the area, which added to its popularity as an entertainment area for the working class; by 1903 the amusement park had replaced the disreputable establishments as Coney Island's main attraction. It should have been a natural subject for members of the Eight and their followers, but even though some of them did paint beach scenes, they were not generally of Brooklyn.[32]

The eastern end of the shore, Brighton Beach and especially Manhattan Beach, was considerably more genteel than Coney Island itself, offering an upper- and middle-class environment for seaside recreation, though this area did enjoy the presence of a popular racetrack until 1910.[33] Brighton Beach had the Brighton Beach Hotel, and Manhattan Beach (which originally could be reached only by a quarter-mile marine railroad) offered the Oriental Hotel for permanent guests and the Manhattan Beach Hotel for visitors; all three hotels were erected between 1877 and 1880.

Manhattan Beach (plate 154), by Edward Potthast, documents the recreational activity in that community in the early twentieth century, though with no sign of its upper-class exclusivity. The general aura is nonetheless very different from the crowds recorded at Coney Island (plate 155). In Potthast's painting the folk are nicely if informally dressed, and the mood is one of casual summer recreation. Potthast is the American Impressionist most celebrated for his concentration on primarily urban beach scenes, which are happy, animated compositions in full sunlight and bright

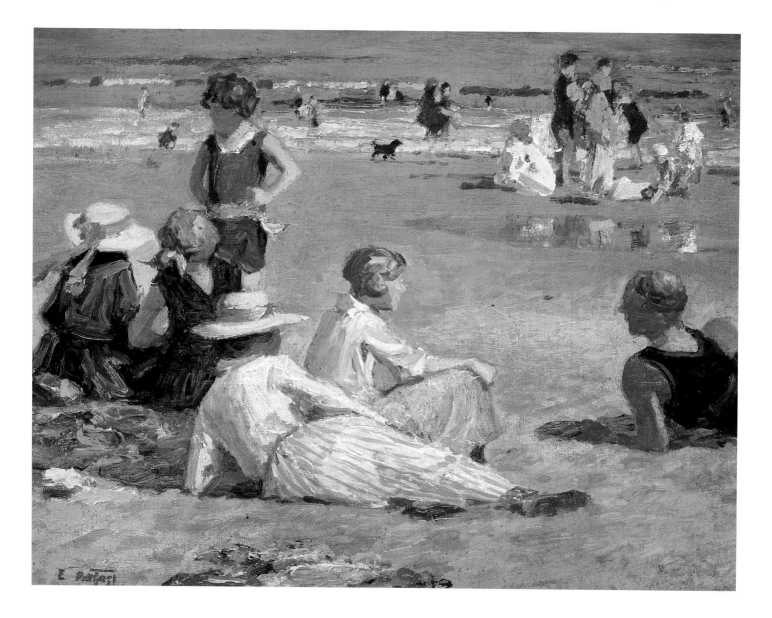

154. Edward Potthast (1857–1927). *Manhattan Beach*, c. 1919. Oil on canvas, 12 x 16 in. (30.5 x 40.6 cm). Mr. and Mrs. Merrill J. Gross, Orlando, Florida.

colors. Though these are sometimes said to have been painted soon after the turn of the century, there is no indication that he embraced this theme until around 1914 or so.[34] He was probably inspired by the popular exhibition of work by the Spanish painter Joaquin Sorolla y Bastida, held at the Hispanic Society in New York in 1909, which included a number of Sorolla's acclaimed paintings of young people on sunny Spanish beaches.

Potthast gave no indication of the specific locales of his beach scenes. Many of his pictures today bear titles indicating Manhattan Beach, Brighton Beach, or Coney Island, but there are no distinguishing hotels, boardwalk entertainments, or amusement piers to establish location. For the most part Potthast's original titles were generic: *A Day at the Seashore, At the Seaside, Bathing Beach, Low Tide.* And when a rare geographic identification is made, it seems never to be a Brooklyn beach. Potthast did exhibit *Rockaway Beach* (a Queens, rather than Brooklyn, locale) at the Pennsylvania Academy annual in 1924, and it may be that few of his paintings were actually done around Coney Island. Critical commentary was equally vague; one writer commented on his "painting the happy groups which crowd the beaches near New York."[35]

By zeroing in on his "happy groups," Potthast forewent the sense of place that was later captured by Harry Roseland in his many paintings of Coney Island (plate 156).

ABOVE
155. *The Beach, Coney Island,* 1896. Photograph. Museum of the City of New York; The Byron Collection.

RIGHT
156. Harry Roseland (1867–1950). *Coney Island,* 1933. Oil on canvas, 28 x 40 in. (71.1 x 101.6 cm). Courtesy Sotheby-Parke-Bernet Galleries, New York.

Roseland, a Brooklyn artist, appears to have turned to this subject matter only around 1930, when he was living on Fulton Street and presumably had an easy ride to the beach by subway, which had reached Coney Island in 1920. Roseland's paintings are quite large and remarkable for the crowds of figures he was able to pack into them. At the same time, he was able to suggest the expanse of the beach and the boardwalk, and he often included some of the bathhouses and amusement buildings—the antithesis of Potthast's intimate close-ups. Though somewhat belated for our study, Roseland's Coney Island pictures document a different aspect of the New New York, beyond the city's physical enlargement and modernization. Symbolizing a revolt against genteel standards and an appeal to the masses, Coney Island represented something very American, a new and expansive cultural freedom. As Edward E. Slosson wrote in 1904, "It is the ordinary American crowd, the best natured, best dressed, best behaving and best smelling crowd in the world; not vulgar unless we mean by that, as many do, being obviously and audibly amused."[36]

The other borough that received some limited pictorial attention in the early twentieth century was the Bronx. Ernest Lawson frequently painted the Bronx from Manhattan, and in many cases it was the landscape itself that interested him, not the spans across the river. Lawson's undated *University Heights, New York* (plate 158) is such a view. Here he divided his composition into three distinct zones and endowed each with a different character. The foreground path and tree-filled knolls, located around 201st Street in upper Manhattan, are quite rustic, whereas the river is filled with small-boat traffic. And in the distance, on the edge of Fordham Heights and towering above the Harlem River, is the Hall of Fame for Great Americans—a semicircular colonnade designed by the architect Stanford White, which is one of the most celebrated monuments in the Bronx (plate 157). The Hall of Fame, which opened in 1901, was part of New York University's Bronx campus, located at 181st Street and Sedgwick Avenue; since 1973 this facility has been home to Bronx Community College.[37] The Gould Memorial Library, also designed by White, stands imposingly behind the Hall of Fame; to the right is Language Hall. In the Hall of Fame are recorded on bronze tablets the names of America's immortals in science, literature, art, law, politics, and other fields of endeavor, who were selected by a committee of their peers; later, sculptured busts of the commemorated were placed above the plaques, in the spaces between the

157. *Borough of the Bronx Looking across the River from Washington Heights,* from E. Idell Zeisloft, *The New Metropolis,* 1899.

158. Ernest Lawson (1873–1939). *University Heights, New York,* c.1905. Oil on canvas, 25 x 30 in. (63.5 x 76.2 cm). Berry-Hill Galleries, New York.

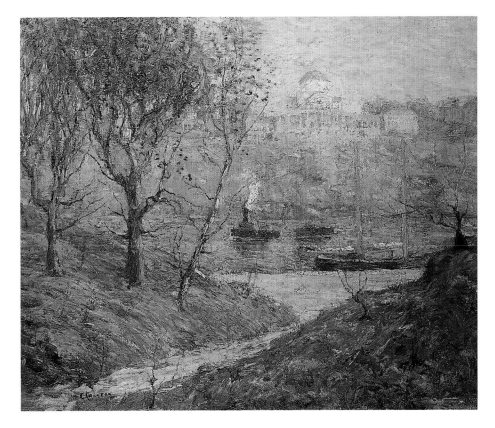

columns. Thus, Lawson's tripartite division can also be read philosophically as combining nature, active commerce, and education along with national achievement.

A different, more casually composed view across the Harlem River can be seen in Lawson's undated *On the Harlem* (plate 159). Again, several imposing monuments stand on the distant heights in the Bronx, the focus of attention. These are the Catholic Orphan Asylum, which became the United States Veterans Hospital in 1922, situated at 192d Street and Kingsbridge Road at the left; the two-towered building at the right is Webb's Academy and Home for Ship Builders, which opened in 1889 at Sedgwick Avenue and Fordham Road.[38] These structures are some blocks north of the Hall of Fame, but the oblique angle suggests that Lawson positioned himself very close to where he painted *University Heights, New York.* Just as in his several depictions of Saint

John the Divine on Morningside Heights (plate 82), Lawson was preoccupied here with two imposing institutions of philanthropy—and not only in terms of their architectural majesty. All these examples exhibit Lawson's favorite compositional formula of depicting isolated structures of some grandeur, symbols of man's achievement, rising out of a rather scrubby landscape.

Lawson executed his views of the Bronx from Manhattan and apparently ventured inside the borough to paint only rarely, unlike his fellow Canadian David Milne, who was, for a short while around 1914–15, something of the artist laureate of the Bronx.[39] Milne painted Van Cortlandt Park and the Botanical Garden in Bronx Park as well as the borough's major thoroughfares, as in *Grand Concourse, Bronx* (Art Gallery of Ontario, Toronto) and *Gray, Brown, and Black* (National Gallery of Canada, Ottawa), which depicts Jerome Avenue in the foreground and centers on the Church of the Sacred Heart, located on Shakespeare Avenue.[40] In the last decade of the nineteenth century Jerome Avenue—then known as Central Avenue—was a dirt road, but two decades later, after the Lexington Avenue subway line was extended into the Bronx, it was densely packed with residential buildings, as indicated by Milne.

159. Ernest Lawson (1873–1939). *On the Harlem,* c. 1910. Oil on canvas, 30 x 40 in. (76.2 x 101.6 cm). The Nelson-Atkins Museum of Art, Kansas City, Missouri; Gift of Mr. and Mrs. Albert R. Jones.

160. George Luks (1867–1933). *Roundhouse at High Bridge*, c. 1913. Oil on canvas, 30⅜ x 36¼ in. (77 x 92.1 cm). Munson-Williams-Proctor Institute, Museum of Art, Utica, New York.

In 1913 Lawson's colleague among the Eight, George Luks, had moved to a studio-residence at Jumel Place and Edgecombe Road, near the Manhattan terminus of the Putnam Bridge.[41] In addition to painting numerous scenes in nearby Highbridge Park, he also painted scenes of the Bronx itself, in works such as *Sandstorm in the Bronx* (1907; Mr. and Mrs. Edward Flower) and *Roundhouse at High Bridge* (plate 160).[42] This is a rare industrial landscape of New York, with the roundhouses and their chimneys painted in black tones over a reddish underpainting that glows through the darkness. A single tug, with steam discharging from its smokestack, makes its way down the Harlem River, but the emphasis is on the power of industry here, since the real subject appears to be the thick swirls of smoke (today read as pollution) emitted by the chimneys.[43] The pink glow in the sky suggests that dawn is just breaking, so that the work activity at the roundhouse has been going on through the night. In mid-nineteenth-century American painting, godly light often formed the link between the land and the sky; but in the New New York it is human accomplishments that forge the bridge between earth and the heavens, whether soaring skyscrapers or, as here, the blackened smoke of industry.

INTRODUCTION (pages 7–9)

1. See, for instance, "Painters' Motifs in New York City," *Scribner's Magazine* 20 (July 1896): 127–28.

2. H. G. Dwight, "An Impressionist's New York," *Scribner's Magazine* 38 (November 1905): 554.

3. The most recent study to address this issue of Impressionist involvement—or noninvolvement—with the urban scene is Hubert Beck, "Urban Iconography in Nineteenth-Century American Painting," in *American Icons: Transatlantic Perspectives on Eighteenth- and Nineteenth-Century American Art*, ed. Thomas W. Gaehtgens and Heinz Ickstadt (Santa Monica, Calif.: Getty Center for the History of Art and the Humanities, 1992), pp. 318–47. The images chosen by Beck, however, are partial and skewed, ignoring both the ideological concerns and most of the sort of paintings illustrated in the present volume. The most pertinent study of French Impressionist involvement with contemporary Paris is Robert L. Herbert's brilliant and definitive *Impressionism: Art, Leisure, and Parisian Society* (New Haven, Conn., and London: Yale University Press, 1988).

4. This refers to the rebuilding of modern Paris during the reign of Napoleon III, after the uprisings of 1848, under the supervision of Baron Georges-Eugène Haussmann. Narrow streets and bridges were replaced by wide avenues and unobstructed spans; long, straight rows of modern commercial and residential structures were created, replacing whole quarters of the ancient city; and new quais were built along the Seine.

5. See especially Timothy J. Gilfoyle, "City of Eros: New York City, Prostitution, and the Commercialization of Sex, 1790–1920" (Ph.D. diss., Columbia University, 1987), and its adaptation as a book of the same title, published by W. W. Norton in 1992.

6. Those living in New York during this period were, of course, well aware of the poverty and degradation of the city's underclass, memorably photographed, described, and illustrated by Jacob A. Riis, first in his article, "How the Other Half Lives: Studies among the Tenements," *Scribner's Magazine* 6 (December 1889): 643–62, and then in his book, *How the Other Half Lives* (New York: Charles Scribner's Sons, 1890).

The American painters traditionally associated with the Impressionist movement basically avoided the seamy side of New York life, and even those artists of the Eight whom we identify here with Impressionism dealt with truly sordid aspects of urban existence only tangentially. Interestingly, among the most poignant illustrations published by Riis were those provided by the arch-classicist Kenyon Cox. For the underside of New York life in this period, see also the classic study by Mrs. Helen Campbell, Colonel Thomas W. Knox, and Superintendent of Police Thomas Byrnes, *Darkness and Daylight* (Hartford, Conn.: Hartford Publishing Company, 1896).

1. THE NEW NEW YORK (pages 11–23)

1. John C. Van Dyke, *The New New York* (New York: Macmillan Co., 1909). Van Dyke's book had been preceded by E. Idell Zeisloft, *The New Metropolis* (New York: D. Appleton and Co., 1899)—the most fully illustrated volume devoted to New York City during this period. "The New New York" was also the title of numerous articles of the period.

In this chapter I have drawn on Reba White Williams, "What Was New about 'The New New York?'" seminar paper, City University Graduate School, January 1992.

2. The City Beautiful movement, inaugurated in this country in the wake of the World's Columbian Exposition of 1893 in Chicago, constituted an aesthetic renaissance that sought to redress the haphazardness, chaos, and ugliness that many associated with the modern city. This subject is not integral to our study here, though its ramifications can be seen in a number of individual illustrations.

3. Van Dyke, *New New York*, p. 7.

4. Robert Shackleton, *The Book of New York* (Philadelphia: Penn Publishing Co., 1917), p. 5.

5. Frederic C. Howe, *The City: The Hope of Democracy* (New York: Charles Scribner's Sons, 1905).

6. *Cliffs of Manhattan* (plate 3) is not dated, but it was reproduced in Cooper's article, "Skyscrapers and How to Build Them in Paint," *Palette and Bench* 1 (January–February 1909): 106.

7. I have drawn here upon Stephanie Wile, "New York Skyscrapers and Skylines in Impressionist Paintings," seminar paper, City University Graduate School, January 1992. See also the important study by Merrill Schleier, "The Image of the Skyscraper in American Art, 1890–1931" (Ph.D. diss., University of California, Berkeley, 1983).

8. Donald A. Mackay, *The Building of Manhattan* (New York: Harper and Row, 1987), p. 35; John A. Kouwenhoven, *The Columbia Historical Portrait of New York* (New York: Doubleday, 1953), pp. 394–95. The competition for the title of the tallest building in the world is discussed by Gardner Richardson in "The Great Towers of New York," *Independent*, August 6, 1908, pp. 301–5; he focuses on the Singer Building.

The sequence of New York's tallest buildings is: Saint Paul Building, 1899; Park Row Building, later in 1899; Singer Building, 1908; Metropolitan Life Tower, 1909; Woolworth Building, 1913. (Robert A. M. Stern, Gregory Gilmartin, and John Montague Massengale, *New York 1900: Metropolitan Architecture and Urbanism, 1890–1915* [New York: Rizzoli International Publications, 1983], p. 146.) See also the discussion of the ever-upward ascension of "tallest" structures by the renowned architectural writer, Montgomery Schuyler, "The Towers of Manhattan and Notes on the Woolworth Building," *Architectural Record* 33 (February 1913): 98–122.

9. Ernest Flagg, "The Dangers of High Buildings," *Cosmopolitan* 21 (May 1896): 70–79; Montgomery Schuyler, "To Curb the Skyscraper," *Architectural Record* 24 (October 1908): 300–302; F. Hopkinson Smith, *Charcoals of New and Old New York* (Garden City, N.Y.: Doubleday, Page and Co., 1912), p. 9; Henry James, *The American Scene*, ed. Leon Edel, from the 1907 London and American editions (Bloomington and London: Indiana University Press, 1968), pp. 76, 87. Even James recognized some degree of beauty in the skyscrapers, crediting their "felicity of carrying out the fairness of tone, of taking the sun and the shade in the manner of towers of marble." (Ibid., p. 76.)

10. "About the World: A Halt Called on 'Skyscrapers,'" *Scribner's Magazine* 19 (March 1896): 395.

11. The search for the "picturesque" in New York at the turn of the century is an interesting study; see, for instance, Mariana G. Van Rensselaer, "Picturesque New York," *Century Magazine* 45 (December 1892): 164–75; Charles Henry White, "In the Street," *Harper's New Monthly Magazine* 110 (February 1905): 365–76.

12. "Towered Cities," *Living Age* 42 (January 2, 1909): 47.

13. Donelson Hoopes, *Childe Hassam* (New York: Watson-Guptill Publications, 1979), p. 62. The "hovel" also may have been introduced in the title to jog the memories of viewers who might have remembered the shantytown that had previously existed in this area; squatters had remained a problem in the park until the mid-1890s.

14. Louis Sullivan, "The Tall Office Building Artistically Considered," *Lippincott's Magazine* 57 (March 1896): 403.

15. Barr Ferree, "The High Building and Its Art," *Scribner's Magazine* 15 (March 1894): 318.

16. Cooper, "Skyscrapers."

17. Cleveland Moffett, "Mid-Air Dining Clubs," *Century Magazine* 62 (September 1901): 642–52. Otto Bacher's delightful illustrations of this article document the other high buildings that diners could view from the windows of the Arkwright, the Midday Club, the Aldine Club, the Drug Club, the Hardware Club, and the New York Business Woman's Club.

18. James, *American Scene*, p. 275. It would be interesting to determine if there were any commercial factors in this new emphasis on the vertical format. Was the art-buying public attracted to this format because it *was* new, and were such works accommodated as easily (or more easily) in the decorative schemes of the buyers?

19. "Two Views of New York," *Harper's Weekly*, August 11, 1894, p. 759 and illustrations; "New York Sky-Scrapers—The Effective Change Wrought by These Buildings on the City's Appearance within a Few Years," *Harper's Weekly*, March 20, 1897, pp. 292–93, 295.

20. Henry Blake Fuller, *The Cliff Dwellers* (New York: Harper and Brothers, 1893).

21. Some families even lived on rooftops; see Theodore Waters, "The Roof-Dwellers of New York," *Harper's Weekly*, August 8, 1903, p. 1300.

These were not necessarily slum dwellers; in 1903 people were living on the roof of the twenty-five-story Empire Building at Broadway and Rector Street, which had been constructed five years earlier.

22. Rowland Elzea, *John Sloan's Oil Paintings: A Catalogue Raisonné*, 2 vols. (Newark: University of Delaware Press, 1991), vol. 1, p. 68.

23. See Marianne Doezema, *George Bellows and Urban America* (New Haven, Conn., and London: Yale University Press, 1992), pp. 19–65.

24. John Sloan recorded in his diary that at the auction of the Café Francis pictures on April 27, 1908, "paintings by Lawson sold at dirt cheap prices" and that his friend Frank Crane purchased the "Excavation." (Bruce St. John, ed., *John Sloan's New York Scene* [New York: Harper and Row, 1965], p. 216.)

25. Bayard Boyesen, "The National Note in American Art," *Putnam's Monthly and the Reader* 6 (May 1908): 133–34. Boyesen here refers to Lawson's painting *The Pennsylvania Tunnel*. There is some confusion between this picture and *Excavation—Penn Station* (plate 13). Doezema (*George Bellows*, p. 206 nn. 57, 58) suggests that they are the same picture, but in fact Lawson exhibited both *Excavation* and *The Pennsylvania Tunnel* in his one-artist show at the Pennsylvania Academy of the Fine Arts, Philadelphia, in March 1907 (presumably both had recently been painted).

Subway construction began during this period too—the first section of the system running from the Brooklyn Bridge to 145th Street and Broadway was opened on October 27, 1904—but this was addressed by artists of a later generation, such as Joseph Stella.

26. Charlotte Adams, "Color in New York Streets," *Art Review* 2 (September–November 1887): 17–19.

27. Edward Robb Ellis, *The Epic of New York City: A Narrative History* (New York: Old Town, 1966), p. 363; Bayard Still, *Mirror for Gotham* (New York: New York University Press, 1956), p. 209.

28. "An Electric City: New York's Sky Illuminated at Night by Thousands of Signs," *New York Daily Tribune*, September 22, 1906, p. 13.

29. Ezra Pound, "Patria Mia," *Selected Prose, 1909–1965*, ed. William Cookson (New York: New Directions, 1973), p. 107.

30. Thomas Folk, *Edward Redfield: First Master of the Twentieth Century Landscape* (Allentown, Pa.: Allentown Art Museum, 1987), p. 43.

31. Edward S. Martin, "Manhattan Lights," *Harper's New Monthly Magazine* 114 (February 1907): 360–62, 367. The photographic urban nocturne has recently been perceptively studied by William Sharpe, "New York, Night, and Cultural Mythmaking: *The Nocturne in Photography, 1900–1925*," *Smithsonian Studies in American Art* 2 (fall 1988): 2–21.

2. THE ARTISTS (pages 25–43)

1. See Dominic Ricciotti, "The Urban Scene: Images of the City in American Painting, 1890–1930" (Ph.D. diss., Indiana University, 1977). Emphasizing the more genteel imagery of the period is the excellent study by Kathleen Burnside, "New York City as Subject in the Gilded Age: The Proliferation of Genteel and Picturesque Urban Imagery," seminar paper, City University Graduate School, 1989.

2. A. E. Gallatin, "Childe Hassam: A Note," *Collector and Art Critic* 5 (January 1907): 102. Eighteen years after Hassam first addressed himself to New York City, Gallatin wrote (p. 93), "Hassam's street scenes in New York . . . constitute one favorite phase of his work." See also Ronald N. Bukoff, "Childe Hassam: Cityscapes, 1885–1900" (M.A. thesis, Indiana University, 1979).

3. Hassam recalled that he left Paris in October 1889, landing in New York City; he then went up to Boston and returned to New York "before December." (DeWitt Lockman interview, January 31, 1927, typescript, New-York Historical Society, and microfilm, Archives of American Art, Smithsonian Institution, Washington, D.C. [hereafter A A A], p. 20.)

4. See, for instance, such comments as: "His facility at suggesting the movement of a crowd of figures is equal to that of Edouard Manet and superior to that of Jean Béraud." ("The Fine Arts: Mr. Hassam's Exhibition [at Doll and Richards Gallery, Boston, January 1893]," *Boston Evening Transcript*, January 28, 1893, p. 4.)

In 1883, just as Hassam was emerging as a significant figure in the Boston art world, the then acclaimed American expatriate Henry Bacon published his *Parisian Art and Artists* (Boston: James R. Osgood and Co.), in which Béraud and de Nittis were singled out for the kind of urban subject matter to which Hassam was shortly to turn. It seems extremely likely that Hassam was acquainted with the book, which may have guided him toward the work of these artists when he first visited Paris that same year.

5. See the superb discussion of this picture by Kathleen Burnside in *Sotheby's Art at Auction, 1988–89* (London and New York: Sotheby's Publications, 1989), pp. 167–69.

6. "Greta," "The Etching Club Exhibition," *Art Amateur* 24 (March 1891): 92.

7. A. E. Ives, "Talks with Artists: Mr. Childe Hassam on Painting Street Scenes," *Art Amateur* 27 (October 1892): 116–17.

8. These include Thomas Curtis Clarke, "Rapid Transit in Cities," *Scribner's Magazine* 11 (May 1892): 566–78; Julian Ralph, "The City of Brooklyn," *Harper's New Monthly Magazine* 86 (April 1893): 650–71; Mariana G. Van Rensselaer, "Fifth Avenue with Pictures by Childe Hassam," *Century Magazine* 47 (November 1893): 5–17; Royal Cortissoz, "Landmarks of Manhattan," *Scribner's Magazine* 18 (November 1895): 531–44.

9. Hassam, in "New York the Beauty City," *New York Sun*, February 23, 1913, p. 16.

10. Hassam, in "New York Beautiful," *New York Commercial Advertiser*, January 15, 1898, p. 1.

11. Childe Hassam, *Three Cities* (New York: R. H. Russell, 1899).

12. Adeline Adams, *Childe Hassam* (New York: American Academy of Arts and Letters, 1938), pp. 60, 70.

13. Bayard Boyesen, "The National Note in American Art," *Putnam's Monthly and the Reader* 6 (May 1908): 134–35.

14. "Painting America: Childe Hassam's Way," *Touchstone* 5 (July 1919): 272–80.

15. Ronald G. Pisano, the recognized Chase authority, has suggested a Central Park identification for this painting (plate 20) due to its intensely colorful palette; Chase's palette became more vivid over time, and the Central Park pictures tend to postdate those painted in Prospect Park. (Pisano, telephone conversation with Pauline Arama-Streit, December 24, 1991.) However, the distinctive planters in the painting seem unlike any identified with Central Park at this time.

16. A. E. Ives, "Suburban Sketching Grounds," *Art Amateur* 25 (September 1891): 80.

17. *Studio* 5 (September 27, 1890): 425.

18. Albert W. Barker, "A Painter of Modern Industrialism," [Appleton's] *Booklover's Magazine* 5 (March 1905): 326–37, contrasts Cooper's Gothic and modern imagery. I am tremendously grateful to Dr. Joy Sperling and to the artist's descendant Sherrill Seeley Henderson for their assistance and their willingness to share much material on Cooper.

19. Hassam, in "New York the Beauty City," p. 16.

20. Mahonri Sharp Young, *The Eight: The Realist Revolt in American Painting* (New York: Watson-Guptill Publications, 1973), p. 11.

21. John Sloan, *Gist of Art* (New York: American Artists Groups, 1939), p. 215.

22. Lloyd Goodrich research papers, 1952, Lloyd Goodrich Papers, AAA, reel 688, folio 24.

23. "The Impressionists," *Art Age* 3 (April 1886): 165–66.

24. "The Fine Arts. The French Impressionists," *Critic* 5 (April 17, 1886): 195–96.

25. "Six Impressionists: Startling Works by Red-Hot American Painters," *New York Times*, January 20, 1904, p. 9.

26. "That Tragic Wall," *New York Sun*, March 16, 1907, p. 8.

27. Shinn, in Bennard B. Perlman, *The Immortal Eight* (New York: Exposition Press, 1962); p. 107; A. E. Gallatin, "Studio-Talk," *International Studio* 30 (November 1906): 85–86.

28. A. E. Gallatin, "The Art of William J. Glackens: A Note," *International Studio* 40 (May 1910): lxviii.

29. The conclusion that this work (plate 22) was exhibited in the Macbeth show as *Snow in New York* is based on Charles de Kay's description in his review, "Pictures by Robert Henri," *New York Times*, April 9, 1902: "'Snow in New York' tells the story of a blizzard in one of the up-town streets where the brown-stone front lingers in serried ranks, while the skyscraper

already has begun to change the vistas." Bennard B. Perlman locates *Snow in New York* as a view of West Fifty-fifth Street, looking toward Fifth Avenue. (Perlman, *Robert Henri: His Life and Art* [New York: Dover Publications, 1991], p. 55.)

30. Birge Harrison, *Landscape Painting* (New York: Charles Scribner's Sons, 1909), p. 251.

31. John Corbin, "The Twentieth Century City," *Scribner's Magazine* 33 (March 1903): 259–72, offers a Tonalist interpretation of New York City, illustrated by Stieglitz's photographs. See the analysis of this in Alan Trachtenberg, "Image and Ideology: New York in the Photographer's Eye," *Journal of Urban History* 10 (August 1984): 453–64.

32. First published in "Notes on '291,'" in Stieglitz's *Camera Work*, nos. 42–43 (April–July 1913): 18. Marin expanded upon this in his essay, "The Living Architecture of the Future," *New York American*, February 16, 1913, p. 4-CE.

33. See Abraham Walkowitz, *Improvisations of New York: A Symphony in Lines* (Girard, Kans.: Haldeman-Julius Publications, 1948); and *Abraham Walkowitz, 1878–1965* (Salt Lake City: Utah Museum of Fine Arts, University of Utah, 1974), essay by Martica Sawin, especially pp. 13–16.

34. Leon Kroll Papers, AAA, pp. 49–50.

35. Nancy Hale and Fredson Bowers, eds., *Leon Kroll: A Spoken Memoir* (Charlottesville: University Press of Virginia, 1983), pp. 27–32.

36. Giles Edgerton [Mary Fanton Roberts], "How New York Has Redeemed Herself from Ugliness: An Artist's Revelation of the Beauty of the Skyscraper," *Craftsman* 11 (January 1907): 470–71. Much of my discussion of Pennell is derived from Anne Cannon Palumbo, "Joseph Pennell and the Landscape of Change" (Ph.D. diss., University of Maryland, College Park, 1982).

37. Colin Campbell Cooper, "Autobiography" (unpublished manuscript, privately owned), p. 86.

38. Edward Bryant, introduction to Joseph Pennell, *Pennell's New York Etchings* (New York: Dover Publications, 1980), p. xi.

39. Joseph Pennell, *The Great New York* (London and Edinburgh: T. N. Foulis, 1912). This etching is listed in Louis A. Wuerth, *Catalogue of the Etchings of Joseph Pennell* (Boston: Little, Brown and Co., 1928), no. 349, p. 119. Pennell's etching *The Golden Cornice, II* (ibid., no. 672, p. 230) was created much later, in 1915, and is a contrasting aerial view. I am grateful to Christopher Gray, Architectural Historian of New York City, for identifying this structure, in a letter of January 27, 1992.

The controversy regarding the American Surety Building is evident in "Four 'Skyscrapers,'" *Harper's Weekly*, March 3, 1894, pp. 200, 210; "The Field of Art: High Buildings," *Scribner's Magazine* 19 (January 1896): 127–28, (March 1896): 389–90.

40. Henry Tyrell, in "Pennell's Masterly Etchings of 'The American Scene,'" *Current Literature* 47 (September 1909): 288.

41. Joseph Pennell, "New York," in *Sketching Grounds*, ed. Charles Holme (London: Studio, 1909), pp. 131–32.

3. THE GREAT THOROUGHFARES: FIFTH AVENUE AND BROADWAY (pages 45–63)

1. I have drawn here upon Lorraine T. Kuczek, "Fifth Avenue: Street and Symbol," seminar paper, City University Graduate School, January 1992.

2. *Fifty Years on Fifth, 1907–1957* (New York: Fifth Avenue Association, 1957), p. 10.

3. Hassam, in "New York the Beauty City," *New York Sun*, February 23, 1913, p. 16. For comparisons between Fifth and various Parisian avenues, see: "A Vacation on Fifth Avenue," *Outlook* 83 (May 1906): 200; and Temple Scott, "Fifth Avenue and the Boulevard Saint-Michel," *Forum* 44 (December 1910): 665–85. Theodore Dreiser believed that "Fifth Avenue is all that it should be—the one really perfect show street in the world." (Dreiser, *A Traveller at Forty*, illustrated by William Glackens [New York: Century Company, 1913], p. 512.)

4. Simeon Strunsky, "The Lane That Has No Turning," *Harper's New Monthly Magazine* 131 (September 1915): 490.

5. John C. Van Dyke, *The New New York* (New York: Macmillan Co., 1909), p. 61; Alan Trachtenberg, "The Rainbow and the Grid," *American Quarterly* 16 (spring 1964): 8–9.

6. Strunsky, "The Lane That Has No Turning," p. 490.

7. "Childe Hassam and the Americanization of Fifth Avenue," *New York Sun*, November 24, 1918, sec. 1, p. 10.

8. E. Idell Zeisloft, *The New Metropolis* (New York: D. Appleton and Co., 1899), p. 494.

9. Belden Seymour Day, "Fads and Frivolities of Fifth Avenue," in "Fifth Avenue, 1824–1924," *New York Telegram and Evening Mail*, November 1924, special sec., p. 3.

10. Mariana G. Van Rensselaer, "Fifth Avenue with Pictures by Childe Hassam," *Century Magazine* 47 (November 1893): 13; Hassam's illustration is entitled here *Sunday on Fifth Avenue*, p. 16.

11. Ibid., p. 11.

12. Edgar Saltus, "New York from the Flatiron," *Munsey's Magazine* 33 (July 1905): 389.

13. Charles L. Borgmeyer, "Birge Harrison—Poet Painter," *Fine Arts Journal* 29 (October 1913): 601.

14. "The Picturesqueness of New York Streets: Illustrated in the Paintings of Birge Harrison," *Craftsman* 13 (January 1908): 397.

15. The Gotham Apartment-Hotel was constructed in 1905, giving a *terminus ante quem* for the date of the painting. I am puzzled by the building in the near foreground right, which should be the Cornelius Vanderbilt II mansion, but the fenestration and the outline of the building are inconsistent with George B. Post's enlargement of the house in the 1890s, although the general Neo-Gothic style is correct. Actually, the architecture more closely resembles that of the General Theological Seminary of the Protestant Episcopal Church, situated on Chelsea Square, between Twentieth and Twenty-first Streets, and Ninth and Tenth Avenues—which, if true, marks quite a geographic transposition for Harrison. (See, for comparison, *Chelsea Square, Winter* [formerly, J. D. Wright], by Paul Cornoyer.) On November 29, 1910, Harrison wrote to Armand Griffith, director of the Detroit Institute of Arts, that the building was the Vanderbilt mansion, but then, he also incorrectly identified the Gotham Apartment-Hotel as the University Club.

16. "Editor's Easy Chair," *Harper's New Monthly Magazine* 118 (February 1909): 479.

17. Van Dyke, *The New New York*, pp. 182–83.

18. Robert A. M. Stern, Gregory Gilmartin, and John Montague Massengale, *New York 1900: Metropolitan Architecture and Urbanism, 1890–1915* (New York: Rizzoli International Publications, 1983), pp. 91–95.

19. "Childe Hassam and the Americanization of Fifth Avenue," p. 10.

20. The definitive study, upon whose superb scholarship I have depended here, is Ilene Susan Fort, *The Flag Paintings of Childe Hassam* (Los Angeles: Los Angeles County Museum of Art, 1988). See also "Painting America: Childe Hassam's Way," *Touchstone* 5 (July 1919): 272–80, which concentrates on a patriotic interpretation of the Flag series.

21. "Here and There in the Art Galleries," *New York Times*, June 16, 1918, p. 15.

22. The association with Monet's serial imagery was noted at the time; see "Flag Pictures by Childe Hassam," *New York Times*, June 1, 1919, sec. 3, p. 4.

23. The location depicted in Hassam's *Fifth Avenue* (plate 37) is curiously problematic. The open plaza at lower left marks the steps to the New York Public Library, just below Forty-second Street, and that location is confirmed by several other buildings, including the new white-columned edifice on the southeast corner of Forty-second Street and Fifth Avenue, built in 1916. But the omission, up one block at Forty-third Street, of Temple Emanu-el with its monumental facade—the most distinctive building on this section of Fifth Avenue—raises disturbing questions of Hassam's motivations and/or his perceptions of his potential clientele. I am grateful to Christopher Gray for his help in identifying this location.

24. Strunsky, "The Lane That Has No Turning," p. 489.

25. I have drawn here upon Loretta C. Ganim, "Impressionist Broadway," seminar paper, City University Graduate School, January 1992.

26. Richard Harding Davis, "Broadway," *Scribner's Magazine* 9 (May 1891): 585.

27. Wanda M. Corn notes, "The most characteristic of city sky to the Impressionist eye were the steam pockets which hung like banners over New York, still known worldwide for its clean air and unsooted white facades!" (Corn, "The New New York," *Art in America* 61 [July–August 1973]: 61.)

28. Cooper, in Louis Baury, "The Message of Manhattan," *Bookman* 33 (August 1911): 595; *Broadway from the Post-Office* (plate 40) was reproduced on the opposite page.

29. Aymar Embury II, "From Twenty-third Street Up: The Architectural Development of Fifth Avenue and Intersection Streets in New York City," *Architectural Record* 25 (October–November 1916): 255–60, 281–86; "Fifth Avenue—The New Retail Shopping District," in Henry Collins Brown, *New York of To-Day* (New York: Old Colony Press, 1917), pp. 73–81.

For a discussion of shopping (and shoplifting) in New York along Broadway to Twenty-third Street and then in the newer commercial district on Fifth Avenue up to Forty-seventh Street, see Lillie Hamilton French, "Shopping in New York," *Century Magazine* 61 (March 1901): pp. 644–58.

30. Saltus, "New York from the Flatiron," p. 382.

31. M. Christine Boyer, *Manhattan Manners: Architecture and Style, 1850–1900* (New York: Rizzoli International Publications, 1985), pp. 50–54; Nancy Jean Carrs, "Madison Square, the Eno Family, and the Fifth Avenue Hotel," manuscript, Columbia University, 1981.

32. Historians such as Merrill Schleier have concluded that, in regard to such tough urban imagery, the "popular illustrator was able to take more risks than his academic counterpart." (Schleier, "The Image of the Skyscraper in American Art, 1890–1931" [Ph.D. diss., University of California, Berkeley, 1983], p. 37.)

33. Richard Le Gallienne, "The Philosopher Walks Up-Town," *Harper's New Monthly Magazine* 123 (July 1911): 237–38. On their walk uptown in 1911 Le Gallienne and his friend traversed Broadway from the Battery to Madison Square, then continued on Fifth Avenue to Forty-second Street, and went east to Times Square, "because Broadway, 'like a lane of fallen stars,' is in this section more itself at night" (p. 237). Given the prevalence of articles guiding the reader on such walks from the Battery up Broadway and then over and up Fifth Avenue at Twenty-third Street, this was probably common practice.

34. John Corbin, "The Lights and Stars of Broadway," *Scribner's Magazine* 37 (February 1905): 129.

35. Charles Battell Loomis, "Broadway by Night," *Harper's Weekly*, January 20, 1894, p. 54.

36. "The Field of Art: Painters' Motifs in New York City," *Scribner's Magazine* 20 (July 1896): 127. Ironically, even though trolleys and cable cars are ubiquitous in Hassam's New York pictures, his illustrations for Thomas Curtis Clarke's "Rapid Transit in Cities," *Scribner's Magazine* 11 (May 1892): 566–78, depict scenes only in Boston and Chicago.

4. THE SQUARES, THE CIRCLES, AND THE ARCHES (pages 65–89)

1. Herald Square, at the crossing of Sixth Avenue and Broadway, elicited a good deal of written attention and illustration, but it appears to have had less interest for painters, perhaps in part because it lacked the parklike ambience of the squares farther south and the nocturnal excitement of Times Square.

2. Arthur M. Barnes, "Washington Square," *Harper's Weekly*, July 14, 1894, pp. 660–61.

3. *Washington Arch, Spring* (plate 45) was reproduced under the title *The Washington Arch* in Mariana G. Van Rensselaer, "Fifth Avenue with Pictures by Childe Hassam," *Century Magazine* 47 (November 1893): 6.

4. William Ireland Howe Downes and Frank Torrey Robinson, "Childe Hassam," *Art Interchange* 34 (May 1895): 133.

5. I have drawn here on Gina M. D'Angelo, "The Arches of New York: The Washington Arch and the Dewey Arch," seminar paper, City University Graduate School, January 1992.

6. "The Washington Triumphal Arch," *Harper's Weekly*, May 4, 1889, p. 343.

7. See *The History of the Washington Arch in Washington Square, New York* (New York: Ford and Garnett Publishers, 1896) for this and other details about the arch's chronology.

8. "Promising Good Results," *New York Times*, February 17, 1891, p. 8. Hassam's painting also underscores the significance that street cleaning

and its municipal organization and governance assumed at just this time. See the 153-page study by Morris K. Jesup et al., *An Examination of the Subject of Street Cleaning in the City of New York* (New York, 1891). This led to a reform in street cleaning with the appointment of Colonel George E. Waring as Commissioner of Street Cleaning, and celebrated in the Parade of the Street-Cleaners up Fifth Avenue on May 26, 1896. Hassam may have intended some of his inclusions of street cleaners as a tribute to Waring; he knew the Waring family, and when he went abroad in 1897 he sublet his apartment on Fifty-seventh Street to Waring's daughter (Effie B. Waring?). (Hassam, interview with De Witt Lockman, January 31, 1927, typescript, New-York Historical Society, p. 33.)

9. "What Is the Most Beautiful Spot in New York?" *New York Times*, June 18, 1911, magazine sec., pt. 5, pp. 4, 10.

10. Glackens had lived at 3 Washington Square until 1908, then for a few years he lived at 23 Fifth Avenue, just north of the square.

Also, see Walter Prichard Eaton, "Washington Square: A Meditation," *Atlantic Monthly* 104 (July 1909): 130: "As I sit here by my open window looking out over the treetops toward the west, the sound of a hurdy-gurdy floats up to me, detaching itself from the ceaseless rumble of traffic. . . . As I reached the centre of the Square and sat down on a bench . . . the ragged children ran with shrill cries." Such a scene might well have been rendered by Glackens or Shinn; there were no hurdy-gurdys or ragged children in Hassam's earlier world at Washington Square!

11. I have drawn here upon Jenny Carson, "The Impressionists' View of Union Square, 1890–1915," seminar paper, City University Graduate School, January 1992.

12. Delmonico's, New York's most famous eatery, had begun as a tiny restaurant on William Street in 1825; after moving in that vicinity several times, it relocated to Broadway, nearer City Hall, before moving to Union Square. After shifting to the northern edge of Madison Square on Twenty-sixth Street, in 1897 it moved north yet again, to Fifth Avenue and Forty-fourth Street. Delmonico's appears in what seems to be its Twenty-sixth Street guise in Childe Hassam's *Three Cities*.

13. John C. Van Dyke, *The New New York* (New York: Macmillan Co., 1909), p. 192.

14. "The Perils of Union Square in the Midst of a Blizzard—Drawn by Otto Stark," *Harper's Weekly*, March 24, 1888, pp. 210, 217–19.

15. Of the two central public vehicles, the one at left is plainly horse-drawn; it is unclear if the one at the right is a cable car. The last horse-drawn car was withdrawn by the city only in 1917.

16. Grace M. Mayer (*Once upon a City* [New York: Macmillan Co., 1958], p. 293) states that the cable cars were introduced in 1893, but John A. Kouwenhoven (*The Columbia Historical Portrait of New York* [New York: Doubleday, 1953], p. 405) illustrates a scene of cable-track laying in the square in 1891.

17. The statue was later moved to the rear of the square, nearer to Seventeenth Street.

18. Bayard Still, *Mirror for Gotham* (New York: New York University Press, 1956), p. 222.

19. Georges Sauvin, *Autour de Chicago: Notes sur les Etats-Unis* (Paris: E. Plon, Nourrit, et Cie., 1893), p. 4.

20. Henry Collins Brown, *Fifth Avenue Old and New, 1824–1924* (New York: Fifth Avenue Association, 1924), p. 73.

21. The Conkling statue was intended for Union Square, where Conkling had perished in the blizzard of 1888, but the Park Commissioners felt that he was not of sufficient national significance for that site and relegated the statue to Madison Square. (*New York Times*, April 8, 1893, p. 9.)

22. "What Is the Most Beautiful Spot in New York?" p. 4.

23. Hassam seldom depicted Madison Square, or any part of New York, in summer since he was always out of town—traveling in New England or abroad. Madison Square was relatively deserted in that season, as noted by Mrs. Schuyler [Mariana G.] Van Rensselaer, who suggested that during the summer Fifth and Madison Avenues might be taken for "a city stricken by the plague." (See her "Midsummer in New York," *Century Magazine* 62 [August 1901]: 495.)

24. A. E. Ives, "Talks with Artists: Mr. Childe Hassam on Painting Street Scenes," *Art Amateur*

27 (October 1892): 116. "Dunlap's" was probably Robert Dunlap and Company, a hatter at 178 Fifth Avenue.

25. The Jerome mansion was leased by the Union League Club from 1868 until 1881; it was later home first to the University Club and then, from March 1899, to the Manhattan Club, still under lease from Lady Randolph Churchill.

26. *Fifth Avenue at Madison Square*, in Royal Cortissoz, "Landmarks of Manhattan," *Scribner's Magazine* 18 (November 1895): 539.

27. In 1913 Greacen had become a member of the National Arts Club, located only a few blocks from Madison Square; his home on East Eighteenth Street was not much farther away.

28. Moses King, *The Dewey Reception and Committee of New York City: An Album of 1,000 Portraits, Scenes, Views, Etc.* (New York: Moses King, 1899).

29. The Washington and Dewey Arches were the most famous to be erected in New York City during this period but not the only ones. A temporary arch designed by Henry B. Herts was erected at Fifth Avenue and Fifty-eighth Street in 1892 to mark the four-hundredth anniversary of the landing of Christopher Columbus. There was also J. H. Duncan's Soldiers' and Sailors' Memorial Arch in Grand Army Plaza in Brooklyn, constructed between 1889 and 1892, but at that time, Brooklyn was still a separate community. In 1901 a Naval Arch was proposed for construction by Ernest Flagg at the foot of Broadway, but this was never carried out. (Robert A. M. Stern, Gregory Gilmartin, and John Montague Massengale, *New York 1900: Metropolitan Architecture and Urbanism, 1890–1915* [New York: Rizzoli International Publications, 1983], pp. 122–25.)

30. Raffaëlli published his remarks on America and American art: "Raffaelli's Impressions of America," *Arts* 4 (August 1895): 19; and "Raffaelli on American Art," *Collector* 6 (September 1895): 294–95. Much later Sadakichi Hartmann also published an interview he had with Raffaëlli in New York in the spring of 1894: "Should an Artist Be National or Cosmopolitan?" *Greenwich Village*, June 12, 1915, pp. 7–9.

31. *Paintings, Drypoints and Etchings by Jean François Raffaëlli* (Boston: Saint Botolph Club, 1899), p. 3.

32. "The Week in Art," *New York Times Saturday Review of Books and Art*, March 3, 1900, p. 139. The writer noted that "even Childe Hassam has not given as good an idea and impression of the streets of New York in Winter as does Mr. Shinn."

33. Published under the title *Across Twenty-fourth Street—Madison Square and the Dewey Arch*, in Jesse Lynch Williams, "The Cross Streets of New York," *Scribner's Magazine* 28 (November 1900): 582. No attempt was made to integrate the illustrations with the text of this article.

34. Cooper had originally intended *Columbus Circle* (plate 61) for the Eighth Venice International Biennale, which opened in April 1909, but his record book is annotated "not sent." Perhaps he had not been able to complete the picture in time. I am grateful to Sherrill Seeley Henderson and Dr. Joy Sperling for providing a copy of Cooper's record book, as well as for much other assistance in regard to Cooper.

35. Jules Guerin, in "What Is the Most Beautiful Spot in New York?" p. 4.

36. "The Columbus Monument in New York," *Harper's Weekly*, August 20, 1892, pp. 801–2.

37. Helen W. Henderson, *A Loiterer in New York* (New York: George H. Doran Co., 1917), p. 345.

38. Peter Salwen, *Upper West Side Story: A History and Guide* (New York: Abbeville Press, 1989), pp. 148–49.

39. Milne also depicted the city's skyscrapers and bridges, but these most celebrated forms of the modern city appear to have had limited appeal to him; such subjects appeared in his etchings rather than in oil paintings and were probably undertaken for commercial success. For Milne in New York, see Lora Senechal Carney, "David Milne's New York," in *David Milne*, ed. Ian M. Thom (Vancouver: Douglas and McIntyre, 1991), pp. 37–61.

40. Charles Lockwood, *Manhattan Moves Uptown* (Boston: Houghton Mifflin Co., 1976), p. 173.

41. Harrison Rhodes, "New York—City of Romance," *Harper's New Monthly Magazine* 119 (November 1909): 921.

42. The church formerly had spires on its towers, but these weakened and were removed.

Visible behind the church in Lawson's painting (plate 63) is the peaked roof of Saint George's Memorial House, an agency of the church erected in 1888 and a center for philanthropic work in the neighborhood.

5. LOWER MANHATTAN (pages 91–103)

1. I have drawn here upon Vivian Gill, "Lower Manhattan," seminar paper, City University Graduate School, January 1992.

2. John Gilmer Speed, "Summer Nights Down-Town," *Harper's Weekly*, August 27, 1892, p. 826.

3. Warner also produced innovative aerial paintings such as the pastel *New York from a Seaplane* (Mr. and Mrs. Arthur C. Riley; Warner destroyed the large version and probably the oil sketch of this subject), believed to be the first pictures created during flight.

4. For Castle Garden, see A. Everett Peterson, *Thirty Historic Places in Greater New York* (New York: City History Club of New York, 1939), pp. 16–19, 24–25.

5. Richard Harding Davis, "A Summer Night on the Battery," *Harper's Weekly*, August 2, 1890, p. 594.

6. "The Council of Ten," *New York Times*, April 22, 1903, p. 9, identifies the Washington Building as Metcalf's perch for painting this work, but mistakes Castle Williams for Castle Garden.

7. Cooper, in "What Is the Most Beautiful Spot in New York?" *New York Times*, June 18, 1911, magazine sec., pt. 5, p. 4.

8. See "The Picture That First Helped Me to Success," *New York Times*, January 28, 1912, sec. 5, p. 5. The oil version was reproduced in one of the first articles to celebrate Cooper's turn to modern urban subjects: Albert W. Barker, "A Painter of Modern Industrialism," *[Appleton's] Booklover's Magazine* 5 (March 1905): 326.

9. Anne Cannon Palumbo, "Joseph Pennell and the Landscape of Change" (Ph.D. diss., University of Maryland, College Park, 1982), pp. 265–72.

Stock Exchange (plate 75) was frequently reproduced, even abroad. See, for instance, Frank Weitenkampf, "Joseph Pennell," *Die graphischen Künste* (Vienna) 33 (1900): 12.

10. Philip Gibbs, *People of Destiny: Americans as I Saw Them at Home and Abroad* (New York and London: Harper and Brothers, 1920), pp. 17–19.

11. " 'Ten Painters' Show Pictures," *New York Herald*, March 18, 1908, p. 9.

12. "Among the Galleries," *New York Sun*, March 25, 1908, p. 6.

13. Arthur Hoeber, "Art and Artists," *New York Globe and Commercial Advertiser*, March 17, 1908, p. 6.

6. STATELY MANSIONS OF MAN, GOD, AND COMMERCE (pages 105–23)

1. This work is mentioned in "Gossip of the Studios . . . Something about Childe Hassam's Methods," undated newspaper clipping from the *New York Recorder*, probably published in May 1891, Hassam Papers, American Academy of Arts and Letters, New York. The club took over the Stewart mansion only in December 1890, but it is conceivable that Hassam painted the picture that year and then adopted the Manhattan Club title prior to its exhibition at the Blakeslee Galleries in the spring of 1891. (See the essay on this painting by Patricia Gardner Clark in *The Preston Morton Collection of American Art*, ed. Katherine Harper Mead [Santa Barbara, Calif.: Santa Barbara Museum of Art, 1981], pp. 180–85.)

2. Arthur Bartlett Maurice, *Fifth Avenue* (New York: Dodd, Mead and Co., 1918), pp. 244–45.

3. *Harper's Weekly*, August 14, 1869, pp. 525–26. For criticism of the building's grandiosity by another architect, see P. B. Wright, "A Millionaire's Architectural Investment," *American Architect and Building News* 1 (May 6, 1876): 148–49.

4. "Mr. Stewart's New Residence," *Harper's Weekly*, August 14, 1869, p. 525.

5. It was in Mrs. Astor's house that Ward McAllister, New York's self-appointed social arbiter, assisted his hostess in trimming an invitation list for a party to a select group of four hundred guests—hence the designation of "The Four Hundred" as the cream of New York society.

6. I have drawn here upon Thomas Parker, "City Without a God? The Meaning of Churches as Depicted by New York Artists at

the Turn-of-the-Century," seminar paper, City University Graduate School, January 1992.

7. Charles Lockwood, *Manhattan Moves Uptown* (Boston: Houghton Mifflin Co., 1976), p. 181.

8. The picture was retrospectively misdated to 1892; its correct date is confirmed in Elisabeth Luther Cary, "Childe Hassam's Work: The Painting of a Decade," *New York Times*, September 29, 1935, sec. 5, p. 9.

9. Robert M. Fogelson, *American Armories: Architecture, Society, and Public Order* (Cambridge, Mass.: Harvard University Press, 1989), pp. 84–86, 173–74, 225. I want to thank both Lorraine T. Kuczek and Christopher Gray for their help in identifying this structure.

10. Ray S. Baker, "The Godlessness of New York," *American Magazine* 68 (June 1909): pp. 117–18, 125.

11. Robert Ellis Jones, "A Great American Cathedral," *World's Work* 12 (July 1903): 7766.

12. Christie's, *The American Impressionist Collection of John J. McDonough*, New York, December 4, 1992, no. 62.

13. H. M. Riseley, "America's Greatest Monument to Christianity," *Overland Monthly* 45 (May 1905): 410–12. In Jones, "Great American Cathedral," published July 1903, the eight pillars of the choir are not yet in place; this suggests that Lawson must have painted *Morningside Heights* (plate 82) after 1903. On the other hand, the choir walls, which had been constructed by early spring 1907, do not appear in *Morningside Heights*. The press attention given to the size, weight, and majesty of the eight pillars may have spurred Lawson to paint the cathedral. See also George Macculloch Miller and George F. Nelson, *Cathedral Church of St. John the Divine* (New York: Saint Bartholomew's Press, 1916).

14. Maxwell F. Marcuse, *This Was New York!* (New York: LIM Press, 1969), pp. 415–17. See also the splendid illustrations entitled *The New Group of Buildings near Morningside Drive*, in Royal Cortissoz, "Landmarks of Manhattan," *Scribner's Magazine* 18 (November 1895): 534–35, anticipating the actual vista on Morningside Heights.

15. I have drawn here upon Stephanie Wile, "New York Skyscrapers and Skyline in Impressionist Paintings," seminar paper, City University Graduate School, January 1992.

16. The structure was officially named the Fuller Building, after the George A. Fuller Construction Company, which financed and erected the edifice and had its headquarters there until 1929.

A thorough review of the pictorial imagery of the Flatiron Building can be found in Bruce Weber, *The Proud Tower* (New York: Berry-Hill Galleries, 1991); I have drawn upon this study for much of the following material. See also Barbara Meyer, "The Flatiron Building—An American Icon" (M.A. thesis, Hunter College of the City University of New York, 1987). For a perceptive estimate of the building itself, see Royal Cortissoz, *Art and Common Sense* (New York: Charles Scribner's Sons, 1913), pp. 428–29.

17. "A Wonderful Building," *New-York Tribune Illustrated Supplement*, June 29, 1902, p. 3.

18. Mariana G. Van Rensselaer, "Picturesque New York," *Century Magazine* 45 (December 1892): 170.

19. See, for instance, "The Flat Iron Building," *Architect and Builder's Magazine* 3 (August 1902): 392–96.

20. Sadakichi Hartmann [Sidney Allan, pseud.], "The 'Flat-Iron' Building—An Esthetical Discussion," *Camera Work*, no. 4 (October 1903): 36–37.

21. *Camera Work*, no. 14 (April 1906): 31.

22. Pennell's two etchings of triangular buildings were among the six prints published the following year in "Skyscrapers of New York," *Century Magazine* 69 (March 1905): 775–86.

23. John Corbin, "The Twentieth Century City," *Scribner's Magazine* 33 (March 1903): 260.

24. Rupert Hughes, *The Real New York* (London: Hutchinson and Co., 1905), p. 26.

25. "The Picturesqueness of New York Streets: Illustrated in the Paintings of Birge Harrison," *Craftsman* 13 (January 1908): 399. The dates of Harrison's Flatiron images are unknown, but they seem all to have been painted in the second half of this century's first decade. The first reference I find is to the display of *The Flatiron Building in the Rain* (then called *The Flatiron after Rain*) at the annual exhibition of the Pennsylvania Academy of the Fine Arts in January 1906; if the writer in the *Craftsman* is correct, this would have been painted in April 1905.

In choosing this subject on Madison Square, Harrison was following the advice given him by George Inness: "Why, there is material for an artist's lifetime within a quarter of a mile of Madison Square." (Ibid., p. 398.)

26. "What Is the Most Beautiful Spot in New York?" *New York Times*, June 18, 1911, magazine sec., pt. 5, p. 4.

27. "Flatiron Is Our 'Worst Atrocity,'" *New York American*, March 31, 1911, p. 5.

28. "'Flatiron's' Fallen Stone," *New York Times*, September 17, 1903, p. 14; "Firmness of High Buildings," *New-York Daily Tribune*, February 20, 1903, p. 9.

29. "Whirling Winds Play Havoc with Women at Flatiron," *New York Herald*, January 31, 1903, p. 7.

30. Sloan, in Bruce St. John, ed., *John Sloan's New York Scene* (New York: Harper and Row, 1965), pp. 122–23.

31. Sloan, ibid., p. 40.

32. "The Academy Exhibition," *New York Sun*, December 27, 1906, p. 7. Huneker, who admired the picture immensely, referred to it as "impressionistic."

33. Louis A. Wuerth, comp., *Catalogue of the Etchings of Joseph Pennell* (Boston: Little, Brown and Co., 1928), nos. 490 and 491, p. 169.

34. Montgomery Schuyler, "The Towers of Manhattan and Notes on the Woolworth Building," *Architectural Record* 33 (February 1913): 98–122.

35. Reverend S. Parkes Cadman, foreword to *The Cathedral of Commerce*, by Edwin A. Cochran (New York: Broadway Park Place Co., 1916), n.p.

36. Stieglitz, in Dorothy Norman, *Alfred Stieglitz: An American Seer* (New York: Random House, 1960), p. 99.

37. Sheldon Reich, *John Marin: A Stylistic Analysis and Catalogue Raisonné*, 2 vols. (Tucson: University of Arizona Press, 1970), vol. 1, p. 60.

38. "Fifty-five Story Building Opens in a Flash," *New York Times*, April 25, 1913, p. 20; in Merrill Schleier, "The Image of the Skyscraper in American Art, 1890–1930" (Ph.D. diss., University of California, Berkeley, 1983), p. 110.

39. Van Rensselaer, "Picturesque New York," pp. 164, 172.

40. Rowland Elzea, *John Sloan's Oil Paintings: A Catalogue Raisonné*, 2 vols. (Newark: University of Delaware Press, 1991), vol. 1, p. 212.

41. Sloan, in *John Sloan's New York Scene*, pp. 383–84. Other visits are documented on pp. 313–14, 316.

7. CENTRAL PARK (pages 125–47)

1. I have drawn here upon Pauline Arama-Streit, "Images of Central Park," and Elizabeth L. Clark, "The New, New York: Seasonal Images within Central Park, c. 1898–1928," seminar papers, City University Graduate School, January 1992.

2. Olmsted, in *Creating Central Park, 1857–1861*, vol. 3 of *The Papers of Frederick Law Olmsted*, ed. Charles E. Beveridge and David Schuyler (Baltimore: Johns Hopkins University Press, 1983), p. 22.

3. Designed by Calvert Vaux and Jacob Wrey Mould, and constructed in 1859–60, Bow Bridge is the most revered of all the Central Park bridges. The vases atop the end posts of the original bridge, no longer present, can be seen in Culverhouse's representation. (Henry Hope Reed, Robert M. McGee, and Esther Mipaas, *Bridges of Central Park* [New York: Greensward Foundation, 1990], p. 60.)

4. I would like to thank Ronald G. Pisano, the foremost scholar on William Merritt Chase, for his assistance through discussions of Chase's landscapes, and Deborah Epstein Solon for access to her unpublished essay, "The Urban Landscapes of William Merritt Chase," 1987.

For Chase's activities in Brooklyn parks, see chapter 9 in this volume. Though undated, his Central Park scenes should probably be dated to 1889–90. It has sometimes been adduced that he began painting in Central Park in 1890, but the exhibition at the Chicago Inter-State Industrial Exposition, September 1889, included Chase's *The Terrace, Central Park, New York* and *The Common, Central Park, New York*, in addition to a number of Prospect Park scenes. Chase was documented as painting in Central Park again in the summer of 1890, in *Studio* 5 (September 27, 1890): 425.

5. Charles de Kay, "Mr. Chase and Central Park," *Harper's Weekly*, May 2, 1891, p. 327.

6. Beverly Rood, the foremost Beckwith scholar, has early records of only two Central Park pictures by Beckwith; the other is the unlocated *On the Lake in Central Park*, which appeared in the Beckwith estate sale at the American Art Galleries, March 14, 1918. Rood believes that Beckwith, unlike Chase, did not work out of doors seriously until his 1891 summer in Giverny, France. I am much indebted to Rood for this information. (Letter to the author, December 3, 1991, and telephone conversation, July 27, 1993.)

7. The Angel of the Waters bestowed healing powers on the pool of Bethesda in Jerusalem. The figures on the middle tier of Stebbins's bronze fountain, visible in Chase's picture, represent Temperance, Purity, Health, and Peace, all appropriate not only for the original conception of Central Park but for Chase's picture.

8. Chase appears to have bent the perspective somewhat, so that Fifth Avenue swings around to the left, but Charles de Kay confirmed that the view was taken from the south, with Fifth Avenue on the right, and that the rooftops were those of buildings on that avenue. (De Kay, "Mr. Chase and Central Park," p. 327.)

9. Clare Booth (later Luce) lived in this house, having married George Brokaw, one of Isaac's sons. (Kate Simon, *Fifth Avenue: A Very Social History* [New York and London: Harcourt Brace Jovanovich, 1978], p. 221.)

10. The Lawrence house was built in 1890, though only completed in 1891. (Paul R. Baker, *Richard Morris Hunt* [Cambridge, Mass.: MIT Press, 1980], pp. 340–42.)

11. Roy Rosenzweig and Elizabeth Blackmar, *The Park and the People: A History of Central Park* (Ithaca, N.Y., and London: Cornell University Press, 1992), pp. 316–17.

12. De Kay, "Mr. Chase and Central Park," pp. 327–28. De Kay's article was prompted by the first major New York showing of Chase's Central Park pictures, at the Thirteenth Annual Exhibition of the Society of American Artists that April. In that show the painting now titled *The Nursery* (plate 101) was called *A Visit to the Garden*; this identification was made in "Society of American Artists," *New York Times*, April 26, 1891, p. 5.

13. Keith L. Bryant, Jr., identifies these two figures with certainty in *William Merritt Chase: A Genteel Bohemian* (Columbia and London: University of Missouri Press, 1991), p. 118.

14. Discussed by Ronald G. Pisano in *American Paintings from the Manoogian Collection* (Washington, D.C.: National Gallery of Art, 1989), pp. 140–43.

15. Rosenzweig and Blackmar, *Park and the People*, p. 295.

16. It is difficult to date Lawson's picture (plate 103); it may be an early work, perhaps from the first decade of the century, as suggested by the pale tonality. In July 1914 Lawson exhibited *Central Park en fête (printemps)* at the Galerie Levesque in Paris, which may have been this picture.

17. Mariana G. Van Rensselaer, "Places in New York," *Century Magazine* 53 (February 1897): 508.

18. See Ellen Marie Glavin, "Maurice Prendergast: The Development of an American Post-Impressionist, 1900–1915" (Ph.D. diss., Boston University, 1988), especially pp. 51–61. Glavin has recently published this material in "Maurice Prendergast and Central Park," *Archives of American Art Journal* 31, no. 4 (1991): 20–26.

19. David Lansing, "Mimic Royalties of May Day," *Outing* 51 (May 1895): 144, 150. See also "May Queens Ruled Tiny Subjects in City Parks," *New York World*, May 8, 1904, p. 2.

20. Beekman, in Rosenzweig and Blackmar, *Park and the People*, p. 335. A discussion of carriage driving through the park is featured in William Dean Howells, "Letters of an Altrurian Traveller," *Cosmopolitan* 16 (January 1894): 272–76.

21. See the Gifford Beal reminiscence of the Eight, written to Roland Kraushaar in the early 1950s, typescript, Kraushaar Galleries, New York. I am grateful to Carole M. Pesner, director of the galleries, for sharing this material with me.

22. Christopher Gray, "Portrait of the Artist's Studio," *Avenue* 13 (February 1988): 106–12.

23. Richard Boyle, "The Art," in Elizabeth de Veer and Boyle, *Sunlight and Shadow: The Life and Art of Willard L. Metcalf* (New York: Abbeville Press, 1987), p. 237. De Veer (ibid., p. 104) states that the picture (plate 109) was painted from Metcalf's studio window, but unless this

was a high-floor side window, above the neighboring buildings (including the cooperative studio building at 27 West Sixty-seventh Street), this would not have been possible. Metcalf's vantage point appears rather to be right *on* Central Park West. His view into the park is very close to that adopted by Hassam in *The Hovel and the Skyscraper* (plate 6), but Metcalf turned slightly to the north and took a more panoramic approach, whereas Hassam chose a plunging vista.

24. There was a good deal of discussion about horseback riding in the park. See, for instance, John Gilmer Speed, "Horsemanship in Central Park," *Harper's Weekly*, June 24, 1893, p. 603. Questions regarding safety, fashion, and especially the propriety of women riding astride rather than sidesaddle continued to be debated over the years. See John W. Carrington, "Horsewomanship," *Appleton's Journal* 8 (August 10, 1872): 151–52; Elizabeth Yorke Miller, "Should Woman Ride Astride?" *Munsey's Magazine* 25 (July 1901): 553–57. It is unclear as to the method adopted by the woman in the tiny couple in Metcalf's picture (plate 109), but I believe she is shown riding astride in appropriate costume— the "progressive" posture.

25. Rosenzweig and Blackmar, *Park and the People*, pp. 400–401. The bridle path still survives, though in degraded condition.

26. Other tall apartment houses, such as the 1889 Beresford at Eighty-first Street and the 1894 Majestic, opposite the Dakota on the south corner of Seventy-second Street, appeared only gradually. These were actually hotels, or really apartment hotels, since the 1885 law restricting the height of apartment buildings did not apply to hotels. (M. Christine Boyer, *Manhattan Manners: Architecture and Style, 1850–1900* [New York: Rizzoli International Publications, 1985], pp. 163–65.)

27. Mariana G. Van Rensselaer, "Picturesque New York," *Century Magazine* 45 (December 1892): 173.

28. Frank Weitenkampf, "New York City in Recent Graphic Art," *Print Connoisseur* 1 (October 1920): 66.

29. Reed, McGee, and Mipaas, *Bridges of Central Park*, pp. 46–47.

30. J. Horace McFarland, "Beautiful America," *Ladies' Home Journal* 21 (January 1904): 15. See also William H. Wilson, *The City Beautiful Movement* (Baltimore and London: Johns Hopkins University Press, 1989), especially pp. 9–34, 78–95.

8. THE WATERFRONT AND THE BRIDGES
(pages 149–79)

1. I have drawn here upon Alan Moore, "New York Harbor under the Eye of American Impressionists," seminar paper, City University Graduate School, January 1992.

2. James McCabe, *Lights and Shadows of New York Life: Or, The Sights and Sensations of the Great City* (Philadelphia: National Publishing Co., 1872), p. 835. Probably the most trenchant article on the waterfront, published at just the time Twachtman painted it, was Charles H. Farnham, "A Day on the Docks," *Scribner's Monthly* 18 (May 1879): 32–47, which may have inspired his choice of subject.

3. Eliot Clark, *John Twachtman* (New York: privately printed, 1924), pp. 32–33.

4. Farnham, "Day on the Docks," p. 38.

5. I am greatly indebted to Lisa Peters, coauthor and director of research for the John Henry Twachtman Catalogue Raisonné Project, Spanierman Gallery, New York, for her generous and perceptive contribution in connection with Twachtman's New York subjects, and particularly for her identification of the oyster boats in his paintings; Ms. Peters proposes a date of c. 1879 for *Dredging in the East River* (plate 117), which was reproduced in "Dredging in New York Harbor," *Harper's Weekly*, June 10, 1882, pp. 356, 364–65.

6. W. Mackay Laffan, "The Material of American Landscape," *American Art Review* 1 (1880): 29–30.

7. "Two Views of New York," *Harper's Weekly*, August 11, 1894, p. 759 and illustrations; "New York Sky-Scrapers—The Effective Change Wrought by These Buildings on the City's Appearance within a Few Years," *Harper's Weekly*, March 20, 1897, pp. 292–93, 295.

8. Jesse Lynch Williams, "The Water-Front of New York," *Scribner's Magazine* 26 (October 1899): 384. The patriotic implication of the flag

is not accidental; in referring to this illustration as a "notable sight of the newest New York," she mentions (p. 391) "the spirit of our own new, vigorous, fearless republic."

9. McCarter was a well-known illustrator of urban scenes of this period, often associated with Glackens, Shinn, and Luks; his work appeared frequently in *Scribner's Magazine*. He provided all the illustrations for Julian Ralph, "Coney Island," *Scribner's Magazine* 20 (July 1896): 3–20.

10. Williams, "Water-Front of New York," pp. 394–97.

11. Mildred Stapley, "The City of Towers," *Harper's New Monthly Magazine* 123 (October 1911): 705.

12. James B. Connolly, "New York Harbor," *Harper's New Monthly Magazine* 111 (July 1905): 236, 234, 231. In 1899 army engineers had decided to build a new channel to replace the inadequate sea approaches to New York Harbor, and in 1904 two immense dredges were built and work was begun to allow the passage of the great ocean liners into the harbor. (Arthur Hewitt, "A Canal at Sea," *Outlook* 91 [April 24, 1909]: 961–62.)

13. Had Ranger chosen another street just a few blocks north or south, the church would have been marginalized or even eliminated. The church was integral to his conception (plate 122), and I believe for more than compositional purposes. If the church *is* Saint Anthony's, it crowns a district with some of Brooklyn's most elegant late nineteenth-century houses, which contrasts vividly with the more workaday section of Manhattan just below Twenty-third Street, from which this view was visible. I wish to thank Lorraine T. Kuczek, Christopher Santiago, and Dr. Marcia Wallace for assisting in the search to identify this church.

14. I have not located a catalog of Butler's 1900 show, but the critical reviews, most of them quite negative, give some idea of the content of the show, including the New York canvases. See "The Week in Art," *New York Times Saturday Review of Books and Art*, March 10, 1900, p. 155.

15. Ibid. Another, less charitable writer suggested that Butler had positioned himself in a

balloon. (*Collector and Art Critic* 11 [March 15, 1900]: 163.)

16. "Liberty Enlightening the World," *Harper's Weekly,* October 30, 1886, pp. 702–3, illustration by Harry Fenn; Louis A. Wuerth, comp., *Catalogue of the Etchings of Joseph Pennell* (Boston: Little, Brown and Co., 1928), no. 503, p. 173 (a reversed composition).

17. Henri to Macbeth, September 10, 1900; in Bennard B. Perlman, *Robert Henri: His Life and Art* (New York: Dover Publications, 1991), p. 45.

18. Linda Craige Henri to Emilia Cimino; in William Innes Homer, *Robert Henri and His Circle* (Ithaca, N.Y., and London: Cornell University Press, 1969), p. 99.

19. Opposition was also growing against further encroachment on the Hudson River, with the attendant hazards of crowding, increasingly rapid current, and tidal reduction; opponents petitioned instead for digging back into Manhattan. See, for example, "New York Harbor," *Outlook* 103 (January 25, 1913): 154–55.

20. E. Idell Zeisloft, *The New Metropolis* (New York: D. Appleton and Co., 1899), p. 106. See, for instance, "A New Pile-Driver," *Scientific American* 84 (April 13, 1901): 232; Waldon Fawcett, "Modern Pile Drivers," *Scientific American* 87 (October 4, 1902): 219–20.

21. Macrum's pile driver, with a small shed on the pier, is strikingly similar to the one in George Bellows's *A Morning Snow—Hudson River* (1910; Brooklyn Museum). This is one of a series of upper Manhattan riverscapes that Bellows painted in 1908–10; a pile driver also appears in one of the earliest of these, *North River* (Pennsylvania Academy of the Fine Arts, Philadelphia) of 1908. This and another of that year, *Rain on the River* (Museum of Art, Rhode Island School of Design, Providence), are set along Riverside Park. Since Bellows painted that entire series in the same vicinity, it offers an approximate area for the setting of Macrum's picture (plate 127), though not necessarily Henri's. For Bellows's paintings of this area of New York, see Marianne Doezema, *George Bellows and Urban America* (New Haven, Conn., and London: Yale University Press, 1992), pp. 55–64.

22. This picture (plate 126) is first recorded in Henri's diary on December 6 and again,

reworked, on December 20. No location is given, but on December 15 he sketched a second derrick picture (unlocated), this one including a boat at a pier, and noted that this was executed "at the foot of 23rd St." (Henri Papers, AAA. I am grateful to Janet Le Clair for access to this material.)

23. Katherine Harper Mead, ed., *The Preston Morton Collection of American Art* (Santa Barbara, Calif.: Santa Barbara Museum of Art, 1981), pp. 202–3.

24. Neither *East River* nor *East River from Brooklyn* (plate 128) is listed in the catalog, but *East River* is mentioned as being on view at the club, along with *East River Park*—possibly *Park on the River* (Brooklyn Museum)—in [Charles de Kay], "Six Impressionists," *New York Times,* January 20, 1904, p. 9.

25. Warships do appear in Joseph Pennell's etching *Sunset, from Williamsburg Bridge* (1915), a scene overlooking the entrance to the old Brooklyn Navy Yard, and also in his *Warship Coming In* (1921). (Wuerth, comp., *Catalogue of the Etchings of Joseph Pennell,* no. 674, p. 230, and no. 770, p. 264.)

26. I have drawn here upon Ita G. Krebs, "The Brooklyn Bridge: History and Art," seminar paper, City University Graduate School, January 1992.

27. John C. Van Dyke, *The New New York* (New York: Macmillan Co., 1909), p. 295.

28. "New York Topics," *Boston Daily Evening Transcript,* May 26, 1883, p. 23.

29. Dominic Ricciotti, "The Urban Scene: Images of the City in American Painting, 1890–1930" (Ph.D. diss., Indiana University, 1977), pp. 267–69.

30. Van Dyke, *New New York,* pp. 305–6.

31. Henry James, *The American Scene,* ed. Leon Edel, from the 1907 London and American editions (Bloomington and London: Indiana University Press, 1968), p. 75.

32. H. G. Wells, *The Future of America* (New York: Harper and Brothers, 1906), pp. 35–43. Wells, incidentally, wrote the foreword for Alvin Langdon Coburn's *New York* (London: Duckworth and Company, 1910), and in turn, ten of Coburn's photogravures illustrated Wells's *Door in the Wall and Other Stories* (New York: Mitchell Kennerley, 1911).

33. This (plate 130) is a puzzling view. Lewis Kachur states that it is taken from the Brooklyn side, looking toward Manhattan. (Kachur, "The Bridge as Icon," in *The Great East River Bridge, 1883–1983* [New York: Brooklyn Museum; Harry N. Abrams, 1983], p. 155.) If that is the case, then Sonntag has removed the entire Manhattan skyline at the left, except for the tall, towerlike form there, which may be the Shot Tower near Beekman, Water, and Pearl Streets (possibly connected to the Beebe Furnaces). It is possible, of course, that this is sunrise rather than sunset and that we are looking east, toward Brooklyn.

34. The painting is undated but it was reproduced in an article in 1888: John Bogart, "Feats of Railway Engineering," *Scribner's Magazine* 4 (July 1888): 2. A drawing by Twachtman, dated 1888, formerly said to be of the Brooklyn Bridge (private collection), actually depicts the Cincinnati Bridge.

35. A second *Brooklyn Bridge* by Butler is in the Borje Vagenius collection; there appears to have been at least one more, since a critic reviewing his one-artist show at the Durand-Ruel Galleries in 1900 referred to "a view of the Brooklyn Bridge in a snowstorm." ("The Week in Art," *New York Times Saturday Review of Books and Art,* March 10, 1900, p. 155.)

36. [Everett Longley Warner], "The Story of a Prize Picture," *Carnegie Magazine* 10 (May 1937): 40–42.

37. See Helen K. Fusscas, *A World Observed: The Art of Everett Longley Warner, 1877–1963* (Old Lyme, Conn.: Florence Griswold Museum, 1992), pp. 13–14, 23–25.

38. See the illustration by William Louis Sonntag, Jr., *The Proposed Hudson River Suspension Bridge,* in "The North River Bridge," *Harper's Weekly,* March 16, 1895, p. 248.

39. "The New East River Bridge," *Harper's Weekly,* January 19, 1895, p. 52.

40. The controversy between proponents of suspension (with arches and networks of flexible steel) versus cantilever (with rigid metal struts and beams) is the essence of the article by John De Witt Warner, "The City of Bridges" (*Municipal Affairs* 3 [December 1899]: 651–63). It also pitted engineers against aestheticians.

41. This was given as the locale for both nocturnes by William A. Coffin in his introduction to *Memorial Exhibition of the Works of Julian Alden Weir* (New York: Metropolitan Museum of Art, 1924), p. xvii. The other is *The Plaza: Nocturne* (1911; Hirshhorn Museum and Sculpture Garden, Smithsonian Institution, Washington, D.C.).

42. Van Dyke, *New New York*, p. 306.

43. Moses King, *King's Handbook of New York City* (Boston: Moses King, 1893), p. 192; Mrs. Burton Harrison, *History of the City of New York: Externals of Modern New York* (New York: A. S. Barnes and Co., 1896), p. 814.

44. This point is emphasized in John De Witt Warner, "City of Bridges," p. 658.

45. Williams, "Water-Front of New York," p. 399; the two bridges are illustrated on p. 396.

46. "Art," *New York Mail and Express*, April 2, 1902, p. 9.

47. I have drawn here upon Nanci Shapiro, "Ernest Lawson's Harlem River Landscapes," seminar paper, City University Graduate School, January 1992.

48. Lawson exhibited *High Bridge: Winter* in January 1903, at the Annual Exhibition of the Pennsylvania Academy of the Fine Arts, Philadelphia.

49. The introduction of the term has been ascribed to James Huneker, critic for the *New York Sun* and an admirer of Lawson's painting; see "Palette of Crushed Jewels," *Art Digest*, April 1, 1932, p. 2. However, the earliest use of the phrase that has been located is by F. Newlin Price, "Lawson, of the 'Crushed Jewels,'" *International Studio* 78 (February 1924): 367.

9. BEYOND MANHATTAN (pages 181–99)

1. The painter and critic Roger Riordan likened Manet's pictures in the Durand-Ruel show to those by Chase, though "minus his [Chase's] barbaric splendor of color." (Roger Riordan, "The Impressionist Exhibition," *Art Amateur* 15 [June 1886]: 14.)

2. I have drawn here upon Derin Tanyol, "Prospect Park: History and Impressions," seminar paper, City University Graduate School, January 1992.

3. Julian Ralph, "The City of Brooklyn," *Harper's New Monthly Magazine* 86 (April 1893): 651–52.

4. *Sixth Annual Report of the Brooklyn Park Commission* (Brooklyn: Brooklyn Park Commission, 1866), p. 89.

5. Ellen Marie Snyder, introduction to *Art and Nature: Views of Prospect Park, 1870–1915* (Brooklyn: Long Island Historical Society, 1985), n.p.

6. All of the Prospect Park pictures shown in Boston in 1886 were oils, which suggests that the pastels he executed in the park, such as the two renderings of Concert Grove, are later works. The earliest reference I have to a Prospect Park pastel by Chase is *Sunlight and Shadow in Prospect Park*, shown in December 1887 at the Annual Fall Exhibition at the galleries of the American Art Association; it presumably had been painted the previous summer.

7. James William Pattison, "An Art Lover's Collection," *Fine Arts Journal* 27 (February 1913): 99.

8. Ronald G. Pisano, *Summer Afternoons: Landscape Paintings of William Merritt Chase* (Boston: Little, Brown and Co., 1993), p. 11. Pisano has pointed out that Chase may also have painted parks in New Jersey, when visiting his in-laws in Hoboken.

9. Chase's father was David Hester Chase; Dr. Barbara Gallati has found that a David Chase lived on Marcy Avenue, Brooklyn, in the mid-1880s. I am tremendously grateful to my good friend and colleague Dr. Gallati for sharing with me her thoughts and discoveries on Chase, in and out of Prospect Park, during conversations on August 12 and 13, 1993.

10. See Katherine Metcalf Roof, *The Life and Art of William Merritt Chase* (New York: Charles Scribner's Sons, 1917), p. 151, for reference to Chase and his new wife residing with his parents in Brooklyn.

11. The earliest *A City Park* I can find appeared in the Inter-State Industrial Exposition in Chicago, September 1889, no. 125.

12. Pattison, "Art Lover's Collection," p. 99.

13. Dr. Gallati has pointed out that where there *are* straight paths in Prospect Park, they are too far from the perimeter to allow for the view of nearby buildings that appear in these and other

pictures designated as *Prospect Park*; see also *Prospect Park* (Halff Collection). In addition, the terrain at the edges of Prospect Park rises and falls in ways not evident in this group of paintings.

14. "Some Questions of Art: Pictures by William M. Chase," *New York Sun*, March 1, 1891, p. 14. This was Chase's sale at the Fifth Avenue Art Galleries, New York, March 6, 1891. It is possible that the present picture (plate 148) may be one of the works then identified as *A City Park* and that the other is one now assigned to Prospect Park.

15. "Exhibition of Pictures, Studies and Sketches by Mr. Wm. M. Chase," *Studio* 2 (December 1886): 99.

16. "Mr. Chase's Pictures," *Chicago Tribune*, September 15, 1889.

17. "By Jones' Edict," *Brooklyn Daily Eagle*, June 19, 1890, p. 6. See also "Jones's Ridiculous Order," *New York Times*, June 19, 1890, p. 8; "Big Politics in Brooklyn," *New York Times*, June 22, 1890, p. 20.

18. "'Anachronism' Jones," *Brooklyn Daily Graphic*, June 20, 1890, p. 4, in which it was explained to Chase that Jones had not responded to his request for a permit because he had neglected to enclose a two-cent stamp. Jones's antipathy toward painters was attributed to the negative artistic reaction to his destruction of the trees. ("Chase's Story," *Brooklyn Daily Eagle*, June 20, 1890, p. 6.)

19. Quoted in Willard Rouse Jillson, *Paul Sawyier: American Artist: A Brief Biographical Sketch* (Lexington, Ky.: Keystone Printers, 1961), p. 44.

20. "Some Questions of Art," p. 14.

21. "Paintings and Pastels by William M. Chase," *Critic* 15 (March 7, 1891): 128.

22. *Gravesend Bay*, then titled *Afternoon by the Sea* (plate 150), was shown in the fourth and final exhibition of the Painters in Pastel, at the Wunderlich Gallery, New York, in May 1890; Chase may have painted the picture the previous year. Chase's pastel entitled *Gravesend Bay* (private collection), which was also on view, is *not* the present work of that title; that pastel was described as "a most charming study of silvery gray water beyond a rough pier." ("Painters in Pastel," *New-York Daily Tribune*, May 2, 1890, p. 7.)

23. "The Painters in Pastel," *Critic* 13 (May 10, 1890): 239.

24. The familial identification is made by Keith L. Bryant, Jr., *William Merritt Chase: A Genteel Bohemian* (Columbia and London: University of Missouri Press, 1991), p. 122.

25. Ibid., pp. 106–7. Katherine Roof recalled a near-fatal incident that occurred at Bath Beach. Chase returned late from a dinner hosted by the architect Stanford White and entered through the bedroom window, rather than the door, in order not to awaken his wife. She, in turn, anxious about the behavior of an employee on the place, was sleeping with a revolver under her pillow; hearing an "intruder," she was about to shoot when she recognized the ring on Chase's hand at the window. (Roof, *Life and Art of William Merritt Chase*, pp. 152–53.)

26. *The Works of the Late William Merritt Chase, N. A.* (New York: American Art Galleries, 1917), no. 100.

27. Asa R. Runyon, "History of Fort Hamilton," typescript, New York, 1928.

28. James W. Shepp and Daniel B. Shepp, *Shepp's New York City Illustrated* (Chicago and Philadelphia: Globe Bible Publishing Co., 1894), p. 54.

29. Blum provided three of the illustrations for William H. Bishop's "To Coney Island," *Scribner's Monthly* 20 (July 1880): 353–65; *Along the Beach* is on p. 356.

30. I am indebted here to the definitive study by Bruce Weber, "Robert Frederick Blum" (Ph.D. diss., Graduate School of the City University of New York, 1985).

31. I have drawn here upon Giovanna Fiorino, "Images of New York Beaches at the Turn of the Century," seminar paper, City University Graduate School, January 1992.

32. Perhaps the most famous Coney Island picture painted in the spirit of the Eight is George Bellows's rowdy *Beach at Coney Island* (Mr. and Mrs. Albert H. Gordon), based on visits he made in 1906–8. The other great pictorial icon of Coney Island, antithetical to Bellows's primarily realist view, is Joseph Stella's *Battle of Lights, Coney Island* (1913; Yale University Art Gallery).

33. Brighton Beach and Manhattan Beach received their distinctive names in order to distinguish them from the unsavory elements associated with the Norton's Point area of Coney Island. (Walter Creedmoor, "The Real Coney Island," *Munsey's Magazine* 21 [August 1899]: 745–46.)

34. In November 1915 the Art Institute of Chicago purchased a typical Potthast beach scene, *A Holiday*, from its Annual Exhibition of American Painting and Sculpture. Potthast showed *In Summertime* at the Winter Exhibition of the National Academy of Design in November 1914, and in February 1915, at the 109th Annual Exhibition of the Pennsylvania Academy of the Fine Arts, he exhibited pictures with beach-scene titles. These are the earliest records I have found of such subject matter by Potthast, whose pictures tend to be undated. Furthermore, a bathing picture was illustrated in the summer of 1915 as "one of a series of sea shore pictures painted recently by Edward Potthast." (Harvey B. Fuller, Jr., "Artists of the Northwest," *American Magazine of Art* 6 [July 1915]: 317.)

35. J. W. Young, introduction to *Potthast* (Chicago: J. W. Young Galleries, 1920).

36. Edward E. Slosson, "The Amusement Business," *Independent*, July 21, 1904, p. 135.

37. Christopher Gray, "Streetscapes: The Busts in the Hall of Fame," *New York Times*, September 27, 1992, real estate sec., p. 7.

38. My thanks to Laura Tosi, librarian, Bronx County Historical Society, for the information about the asylum and to Christopher Gray for his help in identifying the academy.

39. Although numerous writers during Milne's years in New York, as well as his more recent biographers, have allied his art to that of Maurice Prendergast (who had been born in Saint John's, Newfoundland), it was Milne and Lawson (born in Halifax, Nova Scotia) who were actively painting the urban landscape of the Bronx at much the same time. The possible link between these two Canadian-born artists might repay investigation.

40. My thanks to Laura Tosi for this information.

41. His studio is discussed and pictured in Stanley L. Cuba, "George Luks (1866–1933)," in *George Luks: An American Artist* (Wilkes-Barre, Pa.: Sordoni Art Gallery, Wilkes College, 1987), p. 32.

42. *Roundhouse at High Bridge*, 1909–10, are the title and date normally assigned to this picture (plate 160), which appear to be a consensus among Antoinette Kraushaar (Luks's dealer), Harris Prior (director of the Munson-Williams-Proctor Institute, Utica), and Joseph S. Trovato (curator at the institute, who organized the exhibition *George Luks, 1866–1933*, held there in 1973). However, since the picture seems to have first been exhibited at the Kraushaar Gallery in New York in May 1914, and since Luks had moved to upper Manhattan in the Highbridge Park area in 1912, it may well be that the picture actually dates from about 1913. In the 1914 show the title of the picture was *Round Houses at High Bridge*, which seems a more accurate designation.

43. If this is the section of the Bronx known as Highbridge, the abrupt curve of the river is not, in fact, true to the actual topography; I presume the bridge here is the Putnam Bridge. I'm also uncertain as to Luks's position when painting this scene from on high; it is possible that he may have done so from the Highbridge Water Tower. However, the topography here suggests much more the Mott Haven area, south of Highbridge, with the extensive Lake Erie and Western Railroad freight depots at Park Avenue and 135th Street. It is possible that Luks (and Lawson) may have called the entire area south of High Bridge the High Bridge community.

ACKNOWLEDGMENTS

The material presented here was originated in a carefully calculated way, and so this book must be recognized as a group effort. Having decided to organize this book into chapters devoted to aspects and regions of the city, rather than to individual artists or periods, I outlined the structure of this treatise and then designated one or more of these themes as term-paper assignments to students enrolled in a seminar on American Impressionism held in fall 1991 at the Graduate School of the City University of New York. I informed the students that their work might well be the basis for my own ensuing text, and the results of their efforts were uniformly superb. Each is recognized in endnotes crediting his or her specific topic, but I am also delighted to acknowledge them here: Pauline Arama-Streit, Jenny Carson, Elizabeth L. Clark, Gina M. D'Angelo, Giovanna Fiorino, Loretta C. Ganim, Vivian Gill, Ita G. Krebs, Lorraine T. Kuczek, Alan Moore, Thomas Parker, Nanci Shapiro, Derin Tanyol, Stephanie Wile, and Reba White Williams. Their efforts provided both ideas and information for my subsequent writing of this text, as did the hundreds of period sources (far too numerous to be cited in entirety in the notes and bibliography) that I consulted in the course of my own research.

Others who have been instrumental in the evolution of this study are Jeffrey W. Andersen; Kathleen Burnside; Teresa Carbone; Dr. David Dearinger; Debra Force; Helen K. Fusscas; Dr. Barbara Dyer Gallati; Sherrill Seeley Henderson; Janet Le Clair; Lisa Peters; Ronald G. Pisano; Beverly Rood; Rona Schneider; Deborah Solon; Dr. Joy Sperling; Dr. Bruce Weber; Laura Tosi, librarian of the Bronx County Historical Society; Christine Hennessey and Robin T. Dettre, of the Inventories of American Painting and Sculpture, National Museum of American Art, Smithsonian Institution, Washington, D.C.; Christopher Gray, Office for Metropolitan History, New York City; Sara Cedar Miller, historian/photographer, Central Park Conservancy; and James Tottis, American Art Department, Detroit Institute of Arts; along with the good folk at New York Bound, Barbara Cohen and Judith Stonehill, who enriched both my knowledge and my library in regard to the literature on the New and Not-So-New New York. Lorraine Kuczek also worked with me in researching the material and the bibliography for this volume throughout its preparation, uncovering much pertinent data.

Finally, as with so many projects that I have undertaken in the past, I owe an infinite debt of gratitude for the unwavering support, not unmixed with sound critical perception, of my inestimable editor, Nancy Grubb, and my inestimable wife, Abigail.

GENERAL

Books, Dissertations, and Theses

An Album of Selected Views of Greater New York. New York: Isaac H. Blanchard, 1903.

Alden, Cynthia M. Westover. *Manhattan Historic and Artistic.* New York: Morse Co., 1897.

Allyn, Donald. *Short Historical Sketch of the High Bridge Neighborhood.* New York: New York Public Library, 1958.

Alpern, Andrew. *Luxury Apartment Houses of Manhattan.* New York: Dover Publications, 1992.

The Artist Celebrates New York. Bronx, N.Y.: Bronx Museum of Art, 1985.

Beck, Hubert. "Urban Iconography in Nineteenth-Century American Painting." In *American Icons: Transatlantic Perspectives on Eighteenth- and Nineteenth-Century American Art,* edited by Thomas W. Gaehtgens and Heinz Ickstadt, pp. 318–47. Santa Monica, Calif.: Getty Center for the History of Art and the Humanities, 1992.

Black, Mary. *Old New York in Early Photographs.* New York: Dover Publications, 1976.

Bogart, Michele H. *Public Sculpture and the Civic Ideal in New York City, 1890–1930.* Chicago: University of Chicago Press, 1989.

Boyer, M. Christine. *Manhattan Manners: Architecture and Style, 1850–1900.* New York: Rizzoli International Publications, 1985.

Brown, Henry Collins. *New York of To-Day.* New York: Old Colony Press, 1917.

———. *In the Golden Nineties.* Hastings-on-Hudson, N.Y.: Valentine's Manual, 1928.

Bruce, H. Addington. *Above the Clouds and Old New York.* New York: privately printed, 1913.

Bukoff, Ronald N. "Childe Hassam: Cityscapes, 1885–1900." M.A. thesis, Indiana University, 1979.

Byron, Joseph. *New York Life at the Turn of the Century in Photographs.* New York: Dover Publications, 1985.

Campbell, Helen; Thomas W. Knox; and Thomas Byrnes. *Darkness and Daylight.* Hartford, Conn.: Hartford Publishing Co., 1896.

Chase, W. Parker. *New York the Wonder City, 1932.* New York: Wonder City Publishing Co., 1932.

Chwast, Seymour, and Steven Heller. *The Art of New York.* New York: Harry N. Abrams, 1983.

The City in American Painting. Allentown, Pa.: Allentown Art Museum, 1973.

Coburn, Alvin Langdon. *New York.* London: Duckworth and Co.; New York: Brentano's, 1910.

Conrad, Peter. *The Art of the City: Views and Versions of New York.* New York and Oxford: Oxford University Press, 1984.

Ellis, Edward Robb. *The Epic of New York City: A Narrative History.* New York: Old Town, 1966.

Etchings of New York by Charles F. W. Mielatz. New York: New York Public Library, 1934.

Fogelson, Robert M. *American Armories: Architecture, Society, and Public Order.* Cambridge, Mass.: Harvard University Press, 1989.

Fuller, Henry Blake. *The Cliff Dwellers.* New York: Harper and Brothers, 1893.

Fusscas, Helen K. *A World Observed: The Art of Everett Longley Warner, 1877–1963.* Old Lyme, Conn.: Florence Griswold Museum, 1992.

Goldstone, Harmon H., and Martha Dalrymple. *History Preserved.* New York: Schocken, 1976.

Gordon, John, and L. Rust Hills, eds. *New York, New York.* New York: Shorecrest, 1965.

Grafton, John. *New York in the Nineteenth Century.* New York: Dover Publications, 1977.

Harrison, Mrs. Burton. *History of the City of New York: Externals of Modern New York.* New York: A. S. Barnes and Co., 1896.

Hassam, Childe. *Three Cities.* New York: R. H. Russell, 1899.

Henderson, Helen W. *A Loiterer in New York.* New York: George H. Doran Co., 1917.

Hills, Patricia. *Turn-of-the-Century America.* New York: Whitney Museum of American Art, 1977.

Hornung, Clarence Pearson. *The Way It Was, 1850–1890.* New York: Schocken, 1977.

Hughes, Rupert. *The Real New York.* London: Hutchinson and Co., 1905.

James, Henry. *The American Scene.* Edited by Leon Edel, from the 1907 London and American editions. Bloomington and London: Indiana University Press, 1968.

Kies, Emily Bardack. "The City and the Machine: Urban and Industrial Illustration in America, 1880–1900." Ph.D. diss., Columbia University, 1971.

King, Moses. *King's Handbook of New York City.* Boston: Moses King, 1893.

———. *The Dewey Reception and Committee of New York City: An Album of 1,000 Portraits, Scenes, Views, Etc.* New York: Moses King, 1899.

Kouwenhoven, John A. *The Columbia Historical Portrait of New York.* New York: Doubleday, 1953.

Lightfoot, Frederick S. *Nineteenth-Century New York in Rare Photographic Views.* New York: Dover Publications, 1981.

Lockwood, Charles. *Manhattan Moves Uptown.* Boston: Houghton Mifflin Co., 1976.

Mackay, Donald A. *The Building of Manhattan.* New York: Harper and Row, 1987.

Marcuse, Maxwell F. *This Was New York!* New York: LIM Press, 1969.

Mayer, Grace M. *Once upon a City.* New York: Macmillan Co., 1958.

Morris, Lloyd. *Incredible New York.* New York: Arno Press, 1975.

Moss, Frank. *The American Metropolis.* 3 vols. New York: Peter Fenelon Collier, 1897.

New York: Empire City in the Age of Urbanism (1875–1945). New York: Grand Central Art Galleries, 1988.

New York, New York. New York: Grand Central Art Galleries, 1981.

Norton, Thomas E., and Jerry E. Patterson. *Living It Up.* New York: Atheneum, 1984.

Ober, Carolyn Faville, and Cynthia M. Westover. *Manhattan Historic and Artistic.* New York: Lovell, Coryell and Company, 1892.

Patterson, Jerry E. *The City of New York.* New York: Harry N. Abrams, 1978.

Pennell, Joseph. "New York." In *Sketching Grounds*, edited by Charles Holme. London: Studio, 1909.

———. *The Great New York.* London and Edinburgh: T. N. Foulis, 1912.

———. *Pennell's New York Etchings.* New York: Dover Publications, 1980.

Peterson, A. Everett. *Landmarks of New York.* New York: City History Club of New York, 1923.

———. *Thirty Historic Places in Greater New York.* New York: City History Club of New York, 1939.

Picturing New York: Images of the City, 1890–1955. Hanover, N.H.: Dartmouth College, 1992.

Piron, Alice O'Mara. "Urban Metaphor in American Art and Literature, 1910–1930." Ph.D. diss., Northwestern University, Evanston, Ill., 1982.

Ricciotti, Dominic. "The Urban Scene: Images of the City in American Painting, 1890–1930." Ph.D. diss., Indiana University, 1977.

Salwen, Peter. *Upper West Side Story: A History and Guide.* New York: Abbeville Press, 1989.

Shackleton, Robert. *The Book of New York.* Philadelphia: Penn Publishing Co., 1917.

Sharp, Lewis I. *New York City Public Sculpture by Nineteenth-Century American Artists.* New York: Metropolitan Museum of Art, 1974.

Shepp, James W., and Daniel B. Shepp. *Shepp's New York City Illustrated.* Chicago and Philadelphia: Globe Bible Publishing Co., 1894.

Silver, Nathan. *Lost New York.* New York: American Legacy Press, 1967.

Smith, F. Hopkinson. *Charcoals of New and Old New York.* Garden City, N.Y.: Doubleday, Page and Co., 1912.

Stern, Robert A. M., Gregory Gilmartin, and John Montague Massengale. *New York 1900: Metropolitan Architecture and Urbanism, 1890–1915.* New York: Rizzoli International Publications, 1983.

Stevens, Thomas Wood. *The Etching of Cities.* Chicago: Chicago Society of Etchers, 1913.

Stieglitz, Alfred. *Picturesque Bits of New York.* New York: R. H. Russell, 1897.

Still, Bayard. *Mirror for Gotham.* New York: New York University Press, 1956.

Stokes, I. N. Phelps. *The Iconography of Manhattan Island, 1498–1909.* 6 vols. New York: Robert H. Dodd, 1916.

This Is Our City. New York: Whitney Museum of American Art, 1941.

Town Views: A Photographic Collection of New York's Most Beautiful Views. New York: Home Life Publishing, 1899.

Van Dyke, John C. *The New New York.* New York: Macmillan Co., 1909.

Watson, Edward B. *New York Then and Now.* New York: Dover Publications, 1976.

Whitehouse, Roger. *New York: Sunshine and Shadow.* New York: Harper and Row, 1974.

Willensky, Elliot, and Norval White. *AIA Guide to New York City.* San Diego: Harcourt Brace Jovanovich, 1988.

Wilson, Rufus Rockwell. *New York Old and New: Its Story, Streets, and Landmarks.* Philadelphia: J. B. Lippincott Company, 1902.

Wolfe, Gerard R. *New York: A Guide to the Metropolis.* New York: McGraw-Hill, 1983.

Zeisloft, E. Idell. *The New Metropolis.* New York: D. Appleton and Co., 1899.

Periodicals

Adams, Charlotte. "Color in New York Streets." *Art Review* 2 (September–November 1887): 17–19.

Alper, M. Victor. "American Mythologies in Painting, Part 2: City Life and Social Idealism." *Arts Magazine* 46 (December 1971): 31–34.

"American Artists Paint the City." *Arts Magazine* 30 (June 1956): 25–29.

"Approaches to New York." *Harper's New Monthly Magazine* 69 (July 1884): 266–73.

Barker, Albert W. "A Painter of Modern Industrialism." *[Appleton's] Booklover's Magazine* 5 (March 1905): 326–37.

Baur, John I. H. "John Marin's 'Warring, Pushing, Pulling' New York." *Artnews* 80 (November 1981): 106–10.

Baury, Louis. "The Message of Manhattan." *Bookman* 33 (August 1911): 592–600.

Baxter, Sylvester. "The New New York." *Outlook* 83 (June 1906): 409–24.

Benson, E. M. "The American Scene." *American Magazine of Art* 27 (February 1934): 53–66.

Blackshaw, Randall. "The New New York." *Century Magazine* 64 (August 1902): 493–513.

Blashfield, Edwin H. "A Word for Municipal Art." *Municipal Affairs* (Municipal Art Society, New York) 3 (December 1899): 582–93.

Bowles, J. M. "A New New York." *World's Work* 13 (December 1906): 8301–6.

Boyesen, Bayard. "The National Note in American Art." *Putnam's Monthly and the Reader* 6 (May 1908): 131–40.

Cady, Thomas. "New York's Riverside Park." *Munsey's Magazine* 20 (October 1898): 73–89.

Carrington, James B. "New York at Night." *Scribner's Magazine* 27 (March 1900): 326–36.

Casson, Herbert N. "New York, the City Beautiful." *Munsey's Magazine* 38 (November 1907): 178–86.

Clarke, Thomas Curtis. "Rapid Transit in Cities." *Scribner's Magazine* 11 (May 1892): 566–78.

Collins, Francis Arnold. "The Cosmopolitanism of New York." *Bookman* 26 (September 1907): 40–47.

Conant, William C. "Will New York Be the Final World Metropolis?" *Century Magazine* 26 (September 1883): 687–96.

Corbin, John. "The Twentieth Century City." *Scribner's Magazine* 33 (March 1903): 259–72.

Corn, Wanda M. "The New New York." *Art in America* 61 (July–August 1973): 58–65.

Cortissoz, Royal. "Landmarks of Manhattan." *Scribner's Magazine* 18 (November 1895): 531–44.

Croly, Herbert. "New York as the American Metropolis." *Architectural Record* 13 (March 1903): 193–206.

Dawley, Thomas R., Jr. "The Unification of New York." *Outlook* 69 (October 5, 1901): 272–87.

Dreiser, Theodore. "The Color of To-day." *Harper's Weekly*, December 14, 1901, pp. 1272–73.

Dwight, H. G. "An Impressionist's New York." *Scribner's Magazine* 38 (November 1905): 544–54.

Eaton, Walter Prichard. "Manhattan: An Island Outgrown." *American Magazine* 65 (July 1907): 245–56.

"Everett Warner's Paintings of New York." *American Magazine of Art* 15 (October 1924): 518–20.

"The Field of Art: Painters' Motifs in New York City." *Scribner's Magazine* 20 (July 1896): 127–28.

Fife, George Buchanan. "A Fantasy of City Lights." *Harper's Weekly*, February 8, 1913, pp. 3, 9–10.

"Four Midwinter Scenes in New York." *Century Magazine* 61 (February 1901): 521–25.

Gilder, Joseph B. "The City of Dreadful Height." *Putnam's Monthly and the Reader* 5 (November 1908): 131–43.

Gray, Christopher. "Portrait of the Artist's Studio." *Avenue* 13 (February 1988): 106–12.

Hill, C. T. "The Growth of the Upper West Side of New York." *Harper's Weekly*, July 25, 1896, pp. 730–31, 734.

Howells, William Dean. "The Gayety of New York." *Harper's New Monthly Magazine* 115 (August 1907): 481–83.

————. "Editor's Easy Chair [New York in Autumn]." *Harper's New Monthly Magazine* 116 (February 1908): 471–74.

Hughes, Rupert. "The Augean Stable of Art." *Harper's Weekly*, May 5, 1900, pp. 435–36.

Ives, A. E. "Suburban Sketching Grounds." *Art Amateur* 25 (September 1891): 80–82.

————. "Talks with Artists: Mr. Childe Hassam on Painting Street Scenes." *Art Amateur* 27 (October 1892): 116–17.

Jonston, William A. "A Metropolis in Miniature." *Harper's Weekly*, February 9, 1907, pp. 190–93.

Kantor, Harvey A. "The City Beautiful in New York." *New-York Historical Society Quarterly* 57 (April 1973): 148–71.

Kriehn, George. "The City Beautiful." *Municipal Affairs* (Municipal Art Society, New York) 3 (March 1899): 594–601.

Laffan, W. Mackay. "The Material of American Landscape." *American Art Review* 1 (1880): 29–32.

Lane, James W. "This Is Our City: New York by Its Painters." *Artnews* 40 (April 1941): 28, 35.

Lansing, David. "Mimic Royalties of May Day." *Outing* 51 (May 1895): 143–50.

Le Gallienne, Richard. "The Philosopher Walks Up-Town." *Harper's New Monthly Magazine* 123 (July 1911): 228–38.

"Lighting a Metropolis." *Harper's Weekly*, July 11, 1903, pp. 1156–57.

Martin, Edward S. "Manhattan Lights." *Harper's New Monthly Magazine* 114 (February 1907): 357–67.

Maurice, Arthur Bartlett. "About New York with O. Henry." *Bookman* 38 (September 1913): 49–57.

Mighels, Philip Verrill. "Oases in Gotham." *Harper's New Monthly Magazine* 120 (April 1910): 777–86.

Moffett, Cleveland. "Mid-Air Dining Clubs." *Century Magazine* 62 (September 1901): 643–52.

Nadal, E. S. "The New Parks of the City of New York." *Scribner's Magazine* 11 (April 1892): 439–55.

Neal, Robert Wilson. "New York's City of Play." *World To-Day* 11 (August 1906): 818–26.

"The New New York." *Outlook* 83 (June 1906): 409–24.

"New York Beautiful." *New York Commercial Advertiser*, January 15, 1898, p. 1.

"New York the Beauty City." *New York Sun*, February 23, 1913, p. 16.

O'Connor, T. P. "Impressions of New York." *Munsey's Magazine* 37 (June 1907): 387–91.

"A Painter of the City Tranquil." *Current Literature* 4 (July 1909): 54–56.

Parsons, Samuel, Jr. "The Parks and the People." *Outlook* 59 (May 1898): 22–34.

Pennell, Joseph. "The Most Wonderful Place in the World." *Outlook* 99 (October 1911): 462–66.

Phillips, Barnet. "At Play in New York Streets." *Harper's Weekly*, July 6, 1895, pp. 636–37.

"The Picturesqueness of New York Streets: Illustrated in the Paintings of Birge Harrison." *Craftsman* 13 (January 1908): 397–407.

Pisano, Ronald G. "William Merritt Chase: An Easel Beneath the Trees." *Victoria* 5 (July 1991): 44–47.

"The Poetry of Cities: Eight Paintings by Colin Campbell Cooper, N.A." *Century Magazine* 100 (October 1920): 793–800.

Reich, Sheldon. "John Marin: Paintings of New York, 1912." *American Art Journal* 1 (spring 1969): 43–52.

Rhodes, Harrison. "New York—City of Romance." *Harper's New Monthly Magazine* 119 (November 1909): 914–25.

Sanborn, Alvan F. "New York after Paris." *Atlantic Monthly* 98 (October 1906): 489–98.

Schuyler, Montgomery. "The Sky-line of New York." *Harper's Weekly*, March 20, 1897, p. 295.

Sharpe, William. "New York, Night, and Cultural Mythmaking: *The Nocturne in Photography, 1900–1925.*" *Smithsonian Studies in American Art* 2 (fall 1988): 2–21.

Slosson, Edward E. "The Amusement Business." *Independent*, July 21, 1904, pp. 134–39.

Smith, F. Hopkinson. "Picturesque New York." *World's Work* 24 (July 1912): 279–84; (August 1912): 434–43; (September 1912): 541–50.

"The Spectator." *Outlook* 9 (September 12, 1908): 64–66.

Speed, John Gilmer. "New Gateways to the Metropolis." *Harper's Weekly*, March 12, 1892, pp. 251–52.

Stapley, Mildred. "The City of Towers." *Harper's New Monthly Magazine* 123 (October 1911): 697–706.

———. "New York as Seen by Henry Deville." *International Studio* 51 (January 1914): clxv–clxvii.

"The Streets of New York at Night." *Harper's Weekly*, February 9, 1901, p. 141.

Strunsky, Simeon. "The Street." *Atlantic Monthly* 113 (February 1914): 221–28.

———. "When the City Wakes." *Harper's New Monthly Magazine* 129 (October 1914): 697–706.

———. "The Lane That Has No Turning." *Harper's New Monthly Magazine* 131 (September 1915): 489–99.

———. "The City's Ragged Edges." *Harper's New Monthly Magazine* 132 (February 1916): 437–47.

———. "Manhattan Labyrinths." *Harper's New Monthly Magazine* 134 (December 1916): 14–24.

Taylor, Warren. "The Small Parks of New York." *Munsey's Magazine* 8 (October 1892): 25–32.

"To Make New York Beautiful." *Outlook* 71 (August 23, 1902): 1005–6.

"Towered Cities." *Living Age* 42 (January 2, 1909): 45–47.

Trachtenberg, Alan. "The Rainbow and the Grid." *American Quarterly* 16 (spring 1964): 3–16.

———. "Image and Ideology: New York in the Photographer's Eye." *Journal of Urban History* 10 (August 1984): 453–64.

"Two Views of New York." *Harper's Weekly*, August 11, 1894, p. 759.

Van Rensselaer, Mariana G. "Picturesque New York." *Century Magazine* 45 (December 1892): 164–75.

———. "People in New York." *Century Magazine* 49 (February 1895): 534–48.

———. "Places in New York." *Century Magazine* 53 (February 1897): 501–16.

———. "Midsummer in New York." *Century Magazine* 62 (August 1901): 483–501.

Wakeley, Arthur. "The Playground of the Metropolis." *Munsey's Magazine* 13 (September 1895): 565–77.

Walker, John Brisben. "The Wonders of New York, 1903 and 1909." *Cosmopolitan* 36 (December 1903): 143–60.

Waring, George E. "The Cleaning of a Great City." *McClure's Magazine* 9 (September 1897): 911–24.

[Warner, Everett Longley]. "The Story of a Prize Picture." *Carnegie Magazine* 10 (May 1937): 40–42.

Warren, Whitney. "New York's Architectural Needs for Beauty and Convenience." *Harper's Weekly*, March 2, 1907, pp. 306–9.

Waters, Theodore. "The Roof-Dwellers of New York." *Harper's Weekly*, August 8, 1903, p. 1300.

———. "New York's New Playground." *Harper's Weekly*, July 8, 1905, pp. 976–80.

Weitenkampf, Frank. "Mielatz, an Etcher of New York." *International Studio* 44 (September 1911): xxxix–xlvi.

———. "New York City in Recent Graphic Art." *Print Connoisseur* 1 (October 1920): 64–92.

———. "An Etcher of New York: C.F.W. Mielatz." *Print Collector's Quarterly* 24 (October 1937): 236–52.

"The West Side." *Harper's Weekly*, January 26, 1889, pp. 67–69.

"West Side Is Itself a Great City." *New York Times*, March 10, 1895, pp. 20–22.

"West Side Number." *Real Estate Record and Builders Guide* 46 (December 20, 1890): supplement, pp. 1–64.

"What Is the Most Beautiful Spot in New York?" *New York Times*, June 18, 1911, magazine sec., pt. 5, pp. 4, 10.

White, Charles Henry. "In the Street." *Harper's New Monthly Magazine* 110 (February 1905): 365–76.

Williams, Jesse Lynch. "The Walk Up-Town in New York." *Scribner's Magazine* 27 (January 1900): 44–59.

———. "The Cross Streets of New York." *Scribner's Magazine* 28 (November 1900): 571–87.

———. "Rural New York City." *Scribner's Magazine* 30 (August 1901): 178–91.

THE GREAT THOROUGHFARES: FIFTH AVENUE AND BROADWAY

Benjamin, Charles Love. "Where Broadway Meets Fifth Avenue." *Century Magazine* 70 (August 1905): 639–40.

Brown, Henry Collins. *Fifth Avenue Old and New, 1824–1924.* New York: Fifth Avenue Association, 1924.

"Childe Hassam and the Americanization of Fifth Avenue." *New York Sun*, November 24, 1918, sec. 1, p. 10.

Clarke, B. L. *Over the Great Wide Way: From Washington Arch to Grant's Tomb.* New York: B. L. Clarke, 1910.

Corbin, John. "The Lights and Stars of Broadway." *Scribner's Magazine* 37 (February 1905): 128–42.

Davis, Richard Harding. "Broadway." *Scribner's Magazine* 9 (May 1891): 585–604.

Day, Belden Seymour. "Fads and Frivolities of Fifth Avenue," p. 3. In "Fifth Avenue, 1824–1924," *New York Telegram and Evening Mail*, November 1924, special sec.

Drechsler-Marx, Carin, and Richard F. Shepard. *Broadway from the Battery to the Bronx.* New York: Harry N. Abrams, 1988.

Embury, Aymar, II. "From Twenty-third Street Up: The Architectural Development of Fifth Avenue and Intersection Streets in New York City." *Architectural Record* 25 (October–November 1916): 255–60, 281–86.

"Fifth Avenue, 1824–1924." *New York Telegram and Evening Mail*, November 1924, special sec., pp. 1–16.

Fifth Avenue Glances. New York: Fifth Avenue Bank of New York, 1915.

Fifth Avenue, New York from Start to Finish. New York: Welles and Co., 1911.

Fifty Years on Fifth, 1907–1957. New York: Fifth Avenue Association, 1957.

Fort, Ilene Susan. *The Flag Paintings of Childe Hassam.* Los Angeles: Los Angeles County Museum of Art, 1988.

Hendrick, Burton J. "The New Fifth Avenue." *Metropolitan Magazine* 23 (November 1905): 233–46.

Jenkins, Stephen. *The Greatest Street in the World: Broadway.* New York and London: Knickerbocker Press, 1911.

"The Lights of Broadway." *Literary Digest* 47 (November 15, 1913): 977.

Loomis, Charles Battell. "Broadway by Night." *Harper's Weekly*, January 20, 1894, p. 54.

Maurice, Arthur Bartlett. *Fifth Avenue.* New York: Dodd, Mead and Co., 1918.

Phillips, David Graham. "The Union of Sixth Avenue and Broadway." *Harper's Weekly*, March 21, 1891, p. 210.

Reynolds, Louise Frances. *The History of a Great Thoroughfare*. New York: Thoroughfare Publishing Co., c. 1916.

Scott, Temple. "Fifth Avenue and the Boulevard Saint-Michel." *Forum* 44 (December 1910): 665–85.

Simon, Kate. *Fifth Avenue: A Very Social History*. New York and London: Harcourt Brace Jovanovich, 1978.

Titherington, Richard H. "Picturesque Points on Fifth Avenue." *Munsey's Magazine* 6 (November 1891): 122–33.

"A Vacation on Fifth Avenue." *Outlook* 83 (May 26, 1906): 198–203.

Van Rensselaer, Mariana G. "Fifth Avenue with Pictures by Childe Hassam." *Century Magazine* 47 (November 1893): 5–17.

THE SQUARES, THE CIRCLES, AND THE ARCHES

Balge, Marjorie P. "The Dewey Arch: Sculpture or Architecture." *Archives of American Art Journal* 23, no. 4 (1983): 1–6.

Barnes, Arthur M. "Washington Square." *Harper's Weekly*, July 14, 1894, pp. 660–61.

Brooks, J. Wilton. "The Dewey Arch." *Public Improvements* 1 (September 1899): 189–91.

Cantor, Mindy. *Around the Square, 1830–1890*. New York: New York University, 1982.

Coffin, William A. "The Tower of the Madison Square Garden." *Harper's Weekly*, October 24, 1891, pp. 819–20.

De Kay, Charles. "The Madison Square Garden." *Harper's Weekly*, July 18, 1891, p. 542.

"Dewey's Triumph." *Harper's Weekly*, October 7, 1899, pp. 1005, 1025–32.

Doyle, A. P. "Beautifying Columbus Circle." *Municipal Affairs* (Municipal Art Society, New York) 5 (September 1901): 722–25.

Eaton, Walter Prichard. "Washington Square: A Meditation." *Atlantic Monthly* 104 (July 1909): 130–34.

Ferree, Barr. "The Dewey Arch." Parts 1 and 2. *American Architect and Building News*, January 13, 1900, pp. 11–12; January 20, 1900, pp. 19–20.

The History of the Washington Arch in Washington Square, New York. New York: Ford and Garnett Publishers, 1896.

"Madison Square." *Harper's Weekly*, January 7, 1893, pp. 11, 14.

"Madison Square Garden." *American Architect* 128 (December 1925): 3–22.

Martin, Edward S. "Moods of a City Square." *Harper's New Monthly Magazine* 115 (August 1907): 406–14.

Meriden Britannia. *Historical Sketch of Madison Square*. Meriden Monographs, no. 1. New York: Meriden Britannia, 1894.

"The New Washington Square." *Studio* 6 (February 7, 1891): 90–93.

Parsons, Samuel, Jr. "The Evolution of a City Square." *Scribner's Magazine* 12 (July 1892): 107–16.

Van Rensselaer, Mariana G. "The Madison Square Garden." *Century Magazine* 47 (March 1894): 732–47.

Watrous, A. E. "Madison Square." *Harper's Weekly*, January 7, 1893, pp. 11, 14.

LOWER MANHATTAN

Davis, Richard Harding. "A Summer Night on the Battery." *Harper's Weekly*, August 2, 1890, pp. 589, 594.

"Down Town in New York." *Century Magazine* 86 (September 1913): 697–700.

Hill, Frederick Trevor. "The Story of a Street, VI.—Wall Street—the Financial Centre." *Harper's New Monthly Magazine* 117 (September 1908): 614–22.

"In the Public Eye: The New Stock Exchange." *Munsey's Magazine* 29 (July 1903): 554–57.

Janvier, Thomas A. "The Battery." *Harper's Weekly*, September 9, 1893, pp. 869–70.

King, Moses. *King's Views of the New York Stock Exchange*. New York and Boston: Moses King, 1897.

Lee, Ivy. "The New Centre of American Finance." *World's Work* 5 (November 1902): 2772–75.

Moody, John, and George Kibbe Turner. "Wall Street." *McClure's Magazine* 37 (May 1911): 73–87; (June 1911): 184–202.

Roseboro, Viola. "Down-town New York." *Cosmopolitan* 1 (June 1886): 217–23.

Speed, John Gilmer. "Summer Nights Down-Town." *Harper's Weekly*, August 27, 1892, p. 826.

Wall Street: Changing Fortunes. New York: Fraunces Tavern Museum, 1990.

STATELY MANSIONS OF MAN, GOD, AND COMMERCE

"The Art Critic and the Tall Building." *Scientific American* 7 (January 28, 1899): 50.

"Artistic Aspects of the Skyscraper." *Current Opinion* 54 (April 1913): 321–23.

"Call It the Prow." *Brooklyn Daily Eagle*, November 21, 1902, p. 4.

Cochran, Edwin A. *The Cathedral of Commerce*. New York: Broadway Park Place Co., 1916.

Cook, Leland A. *St. Patrick's Cathedral*. New York: Quick Fox, 1979.

Cooper, Colin Campbell. "Skyscrapers and How to Build Them in Paint." *Palette and Bench* 1 (January 1909): 90–92; (February 1909): 106–8.

Edgerton, Giles [Mary Fanton Roberts]. "How New York Has Redeemed Herself from Ugliness: An Artist's Revelation of the Beauty of the Skyscraper." *Craftsman* 11 (January 1907): 458–71.

Ferree, Barr. "The High Building and Its Art." *Scribner's Magazine* 15 (March 1894): 297–318.

"The Field of Art: High Buildings." *Scribner's Magazine* 19 (January 1896): 127–28; (March 1896): 389–90.

Flagg, Ernest. "The Dangers of High Buildings." *Cosmopolitan* 21 (May 1896): 70–79.

"The Flat Iron Building." *Architect and Builder's Magazine* 3 (August 1902): 392–96.

"Four 'Sky-scrapers.'" *Harper's Weekly*, March 3, 1894, pp. 200, 210.

Goldberger, Paul. *The Skyscraper*. New York: Alfred A. Knopf, 1992.

Hartmann, Sadakichi [pseud. Sidney Allan]. "The 'Flat-Iron' Building—An Esthetical Discussion." *Camera Work*, no. 4 (October 1903): 36–37.

Hirshler, Erica E. "The 'New New York' and the Park Row Building: American Artists View an Icon of the Modern Age." *American Art Journal* 21, no. 4 (1989): 26–45.

Jones, Robert Ellis. "A Great American Cathedral." *World's Work* 12 (July 1903): 7754–66.

Keppel, Frederick. *Mr. Pennell's Etchings of New York "Skyscrapers."* New York: Frederick Keppel and Co., 1905.

La Farge, C. Grant. "The Cathedral of St. John the Divine." *Scribner's Magazine* 41 (April 1907): 384–401.

———. "New York's Great New Cathedral." *Harper's Weekly*, December 24, 1910, pp. 11, 14–15.

"Lights and Shadows upon New York Churches: Impressionistic Studies of a Group of the City's More Famous Houses of Worship." *Harper's Weekly*, May 8, 1909, pp. 18–19.

Meyer, Barbara. "The Flatiron Building: An American Icon." M.A. thesis, Hunter College of the City University of New York, 1987.

Miller, George Macculloch, and George F. Nelson. *Cathedral Church of St. John the Divine.* New York: Saint Bartholomew's Press, 1916.

"Mr. Stewart's New Residence." *Harper's Weekly*, August 14, 1869, pp. 525–26.

"New York Sky-Scrapers: The Effective Change Wrought by These Buildings on the City's Appearance within a Few Years." *Harper's Weekly*, March 20, 1897, pp. 292–93, 295.

O'Gorman, James F., ed. *Skyscraperism.* Wellesley, Mass.: Wellesley College, 1979.

Richardson, Gardner. "The Great Towers of New York." *Independent*, August 6, 1908, pp. 301–5.

Riordan, Roger. "The Building of a Cathedral." *Century Magazine* 63 (February 1902): 562–71.

Riseley, H. M. "America's Greatest Monument to Christianity." *Overland Monthly* 45 (May 1905): 410–12.

Saltus, Edgar. "New York from the Flatiron." *Munsey's Magazine* 33 (July 1905): 381–90.

Schleier, Merrill. "The Image of the Skyscraper in American Art, 1890–1931." Ph.D. diss., University of California, Berkeley, 1983.

Schuyler, Montgomery. "Plans for the Cathedral." *Harper's Weekly*, April 4, 1891, pp. 247–48, 253–56.

———. "To Curb the Skyscraper." *Architectural Record* 24 (October 1908): 300–302.

———. "The Towers of Manhattan and Notes on the Woolworth Building." *Architectural Record* 33 (February 1913): 98–122.

"Skyscrapers of New York Shown in a Group of New Etchings by Joseph Pennell." *Century Magazine* 69 (March 1905): 775–86.

Sullivan, Louis. "The Tall Office Building Artistically Considered." *Lippincott's Magazine* 57 (March 1896): 403–9.

Tafuri, Manfredo. "The Disenchanted Mountain: The Skyscraper and the City." In Giorgio Ciucci et al., *The American City: From the Civil War to the New Deal.* London and New York: Granada, 1980.

Wade, Herbert T. "Tall Buildings and Their Problems." *American Review of Reviews* 38 (November 1908): 577–86.

Weber, Bruce. *The Proud Tower.* New York: Berry-Hill Galleries, 1991.

Wright, P. B. "A Millionaire's Architectural Investment." *American Architect and Building News*, May 6, 1876, pp. 148–49.

CENTRAL PARK

The Artist in the Park. New York: Hirschl and Adler Galleries, 1980.

Artists' Views of Central Park, 1814–1914. New York: New-York Historical Society, 1983.

Barlow, Elizabeth. *The Central Park Book.* New York: Central Park Task Force, 1977.

Cook, Clarence C. *A Description of the New York Central Park.* New York: F. J. Huntington and Co., 1869.

De Kay, Charles. "Mr. Chase and Central Park." *Harper's Weekly*, May 2, 1891, pp. 327–28.

Glavin, Ellen Marie. "Maurice Prendergast and Central Park." *Archives of American Art Journal* 31, no. 4 (1991): 20–26.

Graff, M. M. *Central Park, Prospect Park.* New York: Greensward Foundation, 1985.

Hamilton, J. Crawford. "Snap Shots in Central Park." *Munsey's Magazine* 6 (October 1891): 2–10.

Kinkead, Eugene. *Central Park: The Birth, Decline, and Renewal of a National Treasure.* New York: W. W. Norton and Co., 1990.

Meyer, Annie Nathan. *My Park Book.* New York: Edwin W. Dayton, 1898.

Olmsted, Frederick Law. *Creating Central Park, 1857–1861.* Vol. 3 of *The Papers of Frederick Law Olmsted.* Edited by Charles E. Beveridge and

David Schuyler. Baltimore: Johns Hopkins University Press, 1983.

Olmsted, Frederick Law, Jr., and Theodora Kimball, eds. *Forty Years of Landscape Architecture: Central Park.* New York: G. P. Putnam's Sons, 1928.

Reed, Henry Hope. "Central Park as a Work of Art." *Antiques* 122 (August 1982): 276–83.

Reed, Henry Hope, and Sophia Duckworth. *Central Park: A History and Guide.* New York: Clarkson N. Potter, 1976.

Reed, Henry Hope; Robert M. McGee; and Esther Mipaas. *Bridges of Central Park.* New York: Greensward Foundation, 1990.

Richards, T. Addison. "The Central Park." *Harper's New Monthly Magazine* 23 (August 1861): 289–306.

———. *Guide to the Central Park.* New York: James Miller, 1866.

Rosenblum, Robert. "Paintings of Central Park." *Architectural Digest* 49 (November 1992): 174–77, 234.

Rosenzweig, Roy, and Elizabeth Blackmar. *The Park and the People: A History of Central Park.* Ithaca, N.Y., and London: Cornell University Press, 1992.

Spears, Raymond S. "Central Park in Winter." *Munsey's Magazine* 22 (February 1900): 633–41.

Tuckerman, James H. "Park Driving." *Outing* 46 (June 1905): 259–66.

THE WATERFRONT AND THE BRIDGES

"Architectural Details of the Queensboro Bridge." *Architect and Building* 42 (October 1909): 9–18.

Brinton, Willard C. "Contrasts of New York and Foreign Harbors." *American Review of Reviews* 49 (May 1914): 577–86.

Brooklyn Bridge. New York: Robert Schoelkopf Gallery, 1973.

Brooklyn Bridge Seventy-fifth Anniversary Exhibition. Brooklyn: Brooklyn Museum, 1958.

Brown, Francis Williams. *Big Bridge to Brooklyn.* New York: Aladdin Books, 1956.

Connolly, James B. "New York Harbor." *Harper's New Monthly Magazine* 111 (July 1905): 228–36.

"Crossing Brooklyn Ferry": The River and the Bridge. Brooklyn: Museum of the Borough of Brooklyn at Brooklyn College, 1983.

Cudahy, Brian J. *Over and Back: The History of Ferryboats in New York Harbor.* New York: Fordham University Press, 1990.

"Dredging in New York Harbor." *Harper's Weekly,* June 10, 1882, pp. 356, 364–66.

Eaton, Walter Prichard. "The Harbor." *Scribner's Magazine* 49 (February 1911): 129–41.

Farnham, Charles H. "A Day on the Docks." *Scribner's Monthly* 18 (May 1879): 32–47.

Foster, Maximilian. "The Waterways of New York." *Munsey's Magazine* 24 (November 1900): 200–215.

The Great East River Bridge, 1883–1983. Brooklyn: Brooklyn Museum; New York: Harry N. Abrams, 1983.

McCullough, David. *The Great Bridge.* New York: Simon and Schuster, 1972.

"New York Harbor." *Outlook* 103 (January 25, 1913): 154–55.

Reier, Sharon. *The Bridges of New York.* New York: Quadrant Press, 1977.

Schuyler, Montgomery. "Brooklyn Bridge as a Monument." *Harper's Weekly,* May 26, 1883, p. 326.

Shapiro, Mary J. *A Picture History of the Brooklyn Bridge.* New York: Dover Publications, 1983.

Skinner, Frank W. "Triumphs of American Bridge-Building." *Century Magazine* 64 (June 1902): 228–44.

Trachtenberg, Alan. *Brooklyn Bridge: Fact and Symbol.* Chicago and London: University of Chicago Press, 1979.

Warner, John De Witt. "The City of Bridges." *Municipal Affairs* (Municipal Art Society, New York) 3 (December 1899): 651–63.

Williams, Jesse Lynch. "The Water-Front of New York." *Scribner's Magazine* 26 (October 1899): 384–99.

BEYOND MANHATTAN

Art and Nature: Views of Prospect Park, 1870–1915. Brooklyn: Long Island Historical Society, 1985.

Bishop, William H. "To Coney Island." *Scribner's Monthly* 20 (July 1880): 353–65.

Cook, Harry T. *The Borough of the Bronx, 1639–1913.* New York: Harry T. Cook, 1913.

Cox, Richard. "Coney Island, Urban Symbol in American Art." *New-York Historical Society Quarterly* 60 (January–April 1976): 35–52.

Creedmoor, Walter. "The Real Coney Island." *Munsey's Magazine* 21 (August 1899): 745–49.

Davis, Charles Belmont. "The Renaissance of Coney." *Outing* 48 (August 1906): 513–22.

Denny, Edward. *The Story of Manhattan Beach . . . Also an Account of Coney Island.* New York: F. Hart and Co., 1879.

Gillman, Lucy P. "Coney Island." *New York History* 36 (July 1955): 255–90.

History of Coney Island. New York: Burroughs and Co., 1904.

Huneker, James. *New Cosmopolis.* New York: Charles Scribner's Sons, 1915.

Jenkins, Stephen. *The Story of the Bronx, from the Purchase Made by the Dutch from the Indians in 1639 to the Present Day.* New York: G. P. Putnam's Sons, 1912.

Kasson, John F. *Amusing the Millions: Coney Island at the Turn of the Century.* New York: Hill and Wang, 1978.

Lancaster, Clay. *The Prospect Park Handbook.* New York: Greensward Foundation, 1967.

Paine, Albert Bigelow. "The New Coney Island." *Century Magazine* 68 (August 1904): 528–38.

Paine, R. D. "Bathers of the City." *Outing* 46 (August 1905): 558–69.

Ralph, Julian. "The City of Brooklyn." *Harper's New Monthly Magazine* 86 (April 1893): 650–71.

———. "Coney Island." *Scribner's Magazine* 20 (July 1896): 3–20.

Russell, Thomas L., ed. *Thompson's Coney Island.* New York: J. P. Tracy, 1884.

Shanly, Charles Dawson. "Coney Island." *Atlantic Monthly* 34 (September 1874): 306–12.

Simon, Donald E. "The Public Park Movement in Brooklyn, 1824–1873." Ph.D. diss., New York University, 1972.

———. *Historical Prospect Park.* New York: Parks, Recreation and Cultural Affairs Administration, 1974.

Snow, Robert E., and David E. Wright. "Coney Island: A Case Study in Popular Culture and Technical Change." *Journal of Popular Culture* 9 (spring 1976): 960–75.

Tripp, E. B. *A Hand Book for Prospect Park.* New York: E. B. Tripp, 1874.

Ultan, Lloyd, and Gary Hermalyn. *The Bronx in the Innocent Years, 1890–1925.* New York: Harper and Row, 1964.

Wells, James L., et al., eds. *The Bronx and Its People.* 2 vols. New York: Lewis Historical Publishing Co., 1927.

Younger, William Lee. *Old Brooklyn in Early Photographs, 1865–1929.* New York: Dover Publications, 1978.

INDEX

❧

222

Photography Credits